Nikon® D3100

Digital Field Guide

J. Dennis Thomas

WILEY

Wiley Publishing, Inc.

Nikon® D3100 Digital Field Guide

Published by
Wiley Publishing, Inc.
10475 Crosspoint Boulevard
Indianapolis, IN 46256
www.wiley.com

WILEY

About the Author

J. Dennis Thomas is a freelance photographer and author based out of Austin, Texas. He has nearly 25 years of experience behind the lenses of Nikon cameras. His work has been published in regional, national, and international publications including *Rolling Stone, SPIN, Country Music Weekly*, and *SXSW World* magazines. He has written ten highly successful *Digital Field Guides* for Wiley publishing with more in the works.

Credits

Acquisitions Editor
Courtney Allen

Project Editor
Cricket Krengel

Technical Editor
Alan Hess

Editorial Director
Robyn Siesky

Editorial Manager
Rosemarie Graham

Business Manager
Amy Knies

Senior Marketing Manager
Sandy Smith

Vice President and Executive Group Publisher
Richard Swadley

Vice President and Executive Publisher
Barry Pruett

Project Coordinator
Kristie Rees

Graphics and Production Specialists
Samantha Cherolis
Jennifer Henry
Andrea Hornberger
Nikki Gately

Proofreading and Indexing
Melissa D. Buddendeck
Valerie Haynes Perry

Acknowledgments

Thanks to everyone at Wiley, especially Courtney and Carol, for all their help.

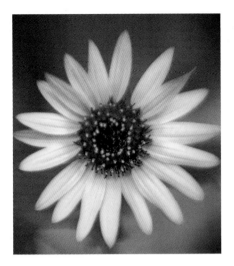

Contents

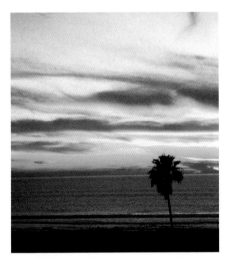

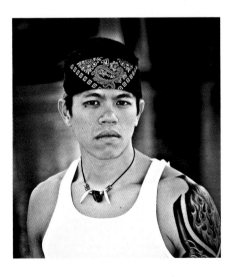

CHAPTER 3
Exploring the Nikon D3100 Menus 59

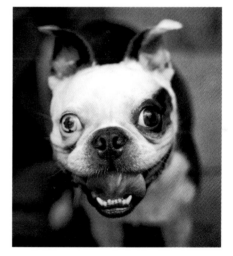

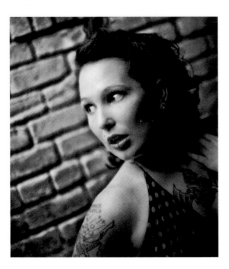

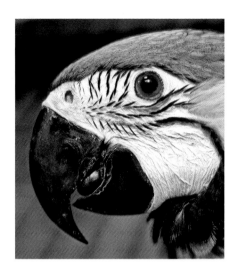

CHAPTER 4
Essential Photography Concepts 87

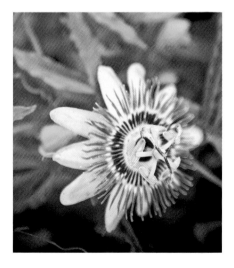

CHAPTER 5
Selecting and Using Lenses 109

CHAPTER 6
Working with Light 133

CHAPTER 7
Working with Live View and Video 161

CHAPTER 8
Real World Applications 175

CHAPTER 9
Viewing and In-camera Editing 225

APPENDIX A
Accessories

APPENDIX B
How to Use the Gray Card and Color Checker

Glossary

Index

Introduction

Welcome to the *Nikon D3100 Digital Field Guide*. This book is a handy reference for you to get started learning about all of the features and functions of your Nikon D3100 dSLR camera.

This *Digital Field Guide* isn't meant to replace the user's manual but to be an adjunct to it, explaining things more simply and in more detail than in the manual. The guide is aimed at D3100 owners who are just beginning in the world of digital SLRs up to advanced users with more hands-on knowledge of photography.

The *Nikon D3100 Digital Field Guide* covers not only the specifics of the D3100 but also many other facets of digital photography, from the basics of exposure to lighting and composition. There's also a chapter to help you get started with Nikon's Creative Lighting System and all of the possibilities that Nikon's Speedlights offer.

About This Book

The first few chapters cover the basics of the camera: the buttons and switches, the menu options, and the different settings. These are all described in detail with some tips on how to effectively use them.

Other chapters include information on lenses, how they work, and what applications specific lenses are best for. There's a primer on working with different lighting types as well as a chapter that teaches you how to take on different photographic tasks.

To put it simply, there's a lot of information in this book. There's a good bit of information for everyone, from the new photographer to the advanced hobbyist.

About the D3100

The D3100 is Nikon's newest and possibly its most innovative camera released since the D90. Nikon has finally included full 1080p HD video in a dSLR and, in addition, they have added a full time autofocus feature that no other camera manufacturer offers. Nikon took the small size of the D3000 camera body and built on it. The D3100 has many useful features to allow the beginning photographer to grow with the camera while also appealing to those more advanced photographers who have become accustomed to cameras that have buttons to adjust the setting rather than doing everything through the menu mode. If you are stepping up from the D3000 or similar camera, such as a D40, you will surely appreciate these added buttons. And, you will definitely notice that changing the settings is much quicker — with a simple flick of a switch or press of a button.

One big step up from the D3000 is the addition of a 14.2 megapixel CMOS sensor with the brand new EXPEED 2 image processor. This is the highest resolution camera Nikon offers with the exception of the top-of-the-line D3X. The EXPEED 2 image processor promises to deliver low noise images even at higher ISO settings.

The D3100 has also inherited the Multi-CAM 1000 autofocus (AF) module that was introduced with Nikon's semiprofessional D200. This is a very fast and accurate AF module that allows precise control of focus points. The D3100 also has 3D-tracking focus, which makes it a snap for shooting pictures of moving subjects without worrying about focus.

The D3100 has the Scene modes that make it simple to shoot in almost any situation as well as the more hands-on Manual and semiautomatic (Shutter and Aperture Priority) modes that are available on all professional cameras.

The Retouch menu allows you to do all of your editing in-camera using the big 3-inch LCD monitor. This allows you to process your pictures without ever touching a computer!

Nikon has made the D3100 available with the highly touted 18-55mm f/3.5-5.6 VR kit lens. This is a great all-around lens that covers the most used focal lengths. From the moderately wide 18mm for architecture, interiors, and landscapes to 55mm, which is perfect for portraits, this lens covers most of your basic photography needs. The added bonus of Nikon's Vibration Reduction allows you to handhold the camera at slower shutter speeds without worrying about blurry pictures caused by camera shake. The Silent Wave motor in the lens allows for quick, nearly silent focusing.

Another great thing about the D3100 is that, like all other Nikon SLRs, you can use almost all lenses manufactured by Nikon in the last 75 years, albeit some of them will have limited functionality. Nikon is known for having some of the highest quality optics in the industry.

One thing is for sure, you will enjoy your camera for many years to come and, with some help from this book, you will gain a deeper knowledge not only of your camera, but of photography as well.

Quick Tour

Welcome to the Quick Tour. This section is designed to go over the most basic functions you need to know to get you started using your D3100 right away. If you've already used a Nikon dSLR, a lot of this may be familiar to you. In fact, if you upgraded from a D3000, the setup for the D3100 is very similar. If you are upgrading from a compact digital camera, you probably should read the entire Quick Tour to familiarize yourself with the camera layout.

This Quick Tour assumes that you have already unpacked the camera, read the manual, charged the batteries, mounted a lens, and inserted the memory card. If you haven't done these things, do them now.

I'm sure you're ready to get out there and shoot some photos with your new D3100, so this chapter gets you going quickly.

The D3100 can be used to grab amazing shots right out of the box.

Getting Started

If you're anything like me, I'm sure you're ready to get out there and start taking pictures with your new camera. The great thing about the D3100 is that you can start taking great photos right out of the box. The D3100 has some automatic shooting modes that choose the proper settings for you. All you really have to do is point the camera at something and shoot!

The first thing you need to do is turn the camera on. The On/Off switch is located right on top of the camera surrounding the Shutter Release button. A quick flick of the switch to the right and your D3100 is fired up and ready to go.

Shooting Mode

To get started quickly, set the Shooting mode to Auto. Changing the Shooting mode is simple: Rotate the Mode dial located on the top of the camera. The Shooting mode is also shown on the top-left corner of the LCD when the shooting info is displayed. The Auto mode, which is depicted in green with a camera icon, is a simple "point and shoot" mode. Everything is adjusted for you; the shutter speed, aperture, ISO, and even the flash is activated if there isn't enough light. If you're not familiar with any of these terms, don't fret; they are all explained in the course of the book.

If you'd like to take a look at your settings, simply press the Info button, which is just behind the Shutter Release button on the left side (with the camera lens facing away from you). Press this button and the shooting information is displayed on the LCD screen. The Shooting info display shows everything you need to know about your settings. Double-pressing the Info button allows you to change the camera settings right there on the screen using the multi-selector, although in Auto mode your selections are limited (because the camera is choosing most of the settings for you).

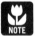
There is also an Info button on the rear of the camera at the bottom left side of the LCD screen.

Drive Mode

Located just below and to the right of the Mode dial is the Drive Mode switch. This controls how the shutter is released. The options are Single, Continuous, Self-timer, and Quiet. All of these modes are covered in Chapter 2. For now, set the Drive Mode to the top option, Single. This setting allows you to fire the shutter only once when the Shutter Release button is pressed, even if you continue to hold down the button.

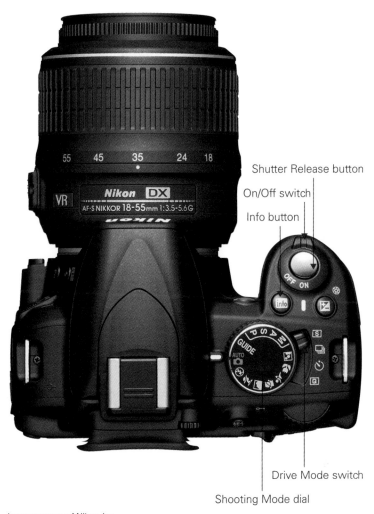

Image courtesy of Nikon, Inc.

QT.1 The Shooting Mode dial and the Drive Mode switch

Focus

Once you're all set with the Shooting and Drive modes it's time to focus. Put your eye up to the viewfinder and take a look through it. Point the camera lens at your intended subject and half-press the Shutter Release button to engage the autofocus. When the camera has locked focus you will notice that a red bracket in the viewfinder lights up quickly — this is the focus point. You will also hear a beep indicating the focus has locked. Another focus lock indicator is shown in the viewfinder on the bottom left of the Shooting info bar.

 Be sure that the lens switch is set to Autofocus. The switch is on the side of the lens. Set the switch to A.

Autofocus switch

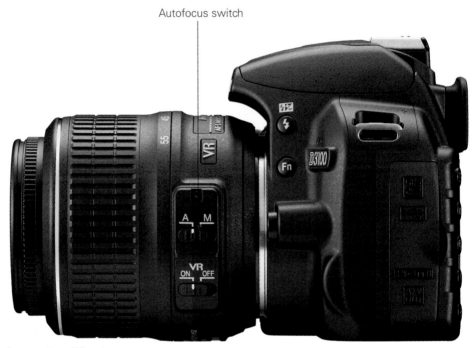

Image courtesy of Nikon, Inc.

QT.2 The A/M switch on the kit lens

By default, when in the Auto mode the autofocus focuses on the closest subject. Press the Shutter Release button half-way down to activate the autofocus system. Once focus has been achieved fully, press the Shutter Release button and the photo is taken. Voilà! Quite simple isn't it?

Playback

After you shoot some images with your D3100, you can look at them on the big bright 3-inch LCD screen. To view your images, press the Play button on the top rear of the camera to the left of the viewfinder. The most recent photo taken is the first image displayed. You can use the multi-selector left or right to scroll through the images or up or down to check the settings and histograms. Pressing the button to the right allows you to view the images in the sequence that they were taken. Pressing the button to the left displays the images in reverse order.

There are a few other options available to you when the camera is in Playback mode:

▶ **Press the Thumbnail/Zoom out button to view thumbnails.** You can choose to view 4, 9, or 72 images at a time, and you can also view the thumbnails in a calendar view. When in Thumbnail mode, use the multi-selector to navigate among the thumbnails to highlight one. You can then press the OK button to bring the selected image to a full-size preview.

▶ **Press the Zoom in button to magnify the image.** This button allows you to check for sharpness or look for details. Pressing this button also takes you out of the thumbnail preview.

▶ **Press the Protect button to save images from being deleted.** The AE-L / AF-L button doubles as the Protect button (denoted by a key). This locks the image to prevent you from accidentally erasing it when editing your images in the camera.

When the memory card is formatted, all images including the protected ones are erased.

▶ **Use the multi-selector to view image data.** To check to see what settings were used when the photograph was taken, press the multi-selector up or down. This also allows you to check the histogram, which is a visual representation of the tonality of the image.

▶ **Press the OK button to do in-camera photo editing.** Pressing the OK button displays a menu that allows you to do some rudimentary in-camera editing such as D-Lighting, fixing red-eye, and cropping.

For more detailed information on in-camera editing, see Chapter 9.

▶ **Press the Delete button to erase images.** The Delete button has an icon shaped like a trashcan on it. Press this button to permanently erase the image from your memory card. When the Delete button is pressed, the camera asks for confirmation. Press the Delete button again to complete the deletion.

For more detailed information on settings, see Chapter 2 for modes and Chapter 3 for menu settings.

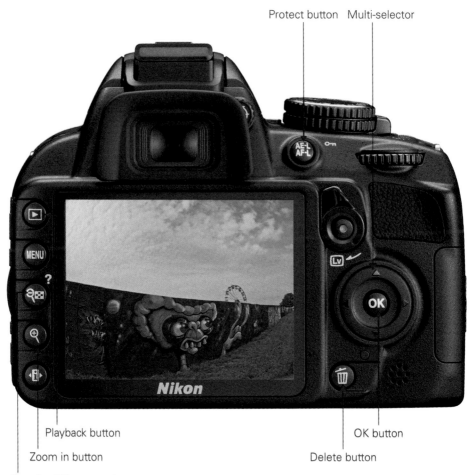

Protect button Multi-selector

Playback button

Zoom in button

Thumbnail/Zoom out button

OK button

Delete button

Image courtesy of Nikon, Inc.

QT.3 These buttons can be used in the Playback mode for a variety of functions.

Downloading

When you fill up a card or you're ready to do some post-processing of your images, you want to download them off of your SD card and onto your computer for storage. You can either download the images straight from the camera to your computer or you can remove the memory card from the camera and use a card reader to transfer the images.

To download from the camera using the USB cable, follow these steps:

1. **Turn off the camera.** Be sure that the camera is off when connecting it to the computer to ensure that the camera's or computer's electronics are not damaged.

2. **Open the rubber cover that conceals the D3100's output connections.** On the left side of the camera with the back facing you is a cover that has the camera's USB and Video out ports.

3. **Connect the camera to the USB cable.** Your D3100 comes with a USB cable. Plug the small end of the cable into the camera and plug the other end into a USB slot on your computer.

4. **Turn the camera on.** Once turned on, your computer should recognize the camera as a mass storage device. You can then drag and drop your files or you can use a software program, such as Adobe Bridge, iPhoto, or Nikon Transfer, to transfer your files.

To download using a card reader, follow these steps:

1. **Turn off the camera.** Be sure that the camera is off and the memory card access lamp (the small green LED near the card door) isn't blinking before removing the card.

2. **Remove the memory card.** Open the memory card door cover and press the SD card in to eject it.

3. **Insert the SD card into the card reader.** Be sure that the reader is connected to your computer. Your computer should recognize the card as a mass storage device. You can then drag and drop the files or you can use a software program, such as Adobe Bridge, iPhoto, or Nikon View, to transfer your files.

 Depending on your software and how your computer is set up, your computer may offer to automatically transfer the files to a predetermined destination.

Exploring the Nikon D3100

This chapter covers the key components of the Nikon D3100. These are the features that are most readily accessible because they are situated on the outside of the camera: the buttons, knobs, switches, and dials.

Although most Nikon dSLRs are relatively similar to each other, because D3100 has had an extensive redesign, even if you're familiar with other Nikon dSLR cameras you may want to read through the chapter to acquaint yourself with all of the new features of the D3100.

Getting to know all your camera's menus, buttons, and dials allows you to capture your images just as you envision them.

Key Components of the D3100

If you've gone through the Quick Tour, you should be fairly familiar with the buttons and switches that you use to change the most basic settings on your D3100. In this section, you look at the camera from all sides and review the layout so that you know what everything on the surface of the camera does or controls.

This section doesn't cover the menus, only the exterior controls. Although there are many features you can access with just the push of a button, oftentimes you can change the same setting inside of a menu option. Knowing exactly what these buttons do can save you loads of time and help you to not miss out on getting a shot.

Top of the camera

The top of the D3100 is where you find some of the most important buttons and dials. This is where you can change the Shooting mode and press the Shutter Release button to take your photo. Also included in this section is a brief description of some of the things you find on the top of the kit lens.

- ▶ **Shutter Release button.** In my opinion, this is the most important button on the camera. Halfway pressing this button activates the camera's autofocus and light meter. When you fully depress this button, the shutter is released and a photograph is taken. When the camera has been idle and has "gone to sleep," lightly pressing the Shutter Release button wakes up the camera. When the image review is on, lightly pressing the Shutter Release button turns off the LCD and prepares the camera for another shot.

- ▶ **On/Off switch.** This switch, located concentric to the Shutter Release button, is used to turn the camera on and off. Push the switch all the way to the left to turn off the camera. Pull the switch to the right to turn your camera on.

- ▶ **Mode dial.** This is an important dial. Rotating this dial allows you to quickly change your Shooting mode. You can choose one of the scene modes, one of the semiautomatic modes, or you can choose Manual exposure mode, which lets you pick the exposure settings.

CROSS REF

For a detailed description of all of the exposure modes, see Chapter 2.

- ▶ **Release Mode switch.** The D3100 is the first camera to have this feature and I expect to see it migrate to some of Nikon's high-end cameras as well. This allows you to change the Release mode very quickly with a simple flick of a

switch, whereas on previous cameras such as the D3000 you had to enter a menu screen. The Release mode controls how the shutter is released when the button is pressed. For more information see Chapter 2.

▶ **Info button.** Pressing this button brings up the Information Display (Info display), which is discussed in more detail later in this chapter.

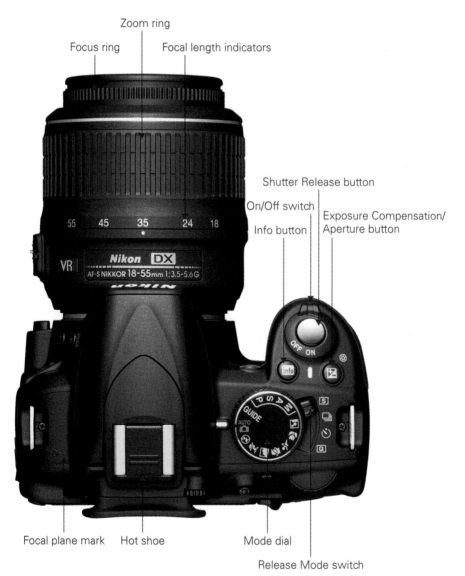

Image courtesy of Nikon, Inc.
1.1 Top-of-the-camera controls

▶ **Exposure Compensation/Aperture button.** Pressing this button in conjunction with spinning the Command dial allows you to modify the exposure that is set by the D3100's light meter when set to P, S, or A mode. Turning the Command dial to the right decreases exposure while turning the dial to the left increases the exposure. This button also doubles as the Aperture button when the camera is set to Manual exposure mode. Pressing the button while rotating the Command dial allows you to adjust your lens aperture. Additionally, when pressing this button in conjunction with the Flash mode, you can adjust your Flash Exposure Compensation by rotating the Command dial.

 The Exposure Compensation/Aperture button serves no functions when shooting in the automatic or scene modes.

▶ **Focal plane mark.** The focal plane mark shows you where the plane of the image sensor is inside the camera. The sensor is directly behind the shutter. When doing certain types of photography, particularly macro photography using a bellows lens, you need to measure the length of the bellows from the front element of the lens to the focal plane. When measuring distance for calculating flash output you measure the subject to focal plane distance. These are a couple of instances where the focal plane mark comes in handy.

▶ **Hot shoe.** This is where an accessory flash is attached to the camera body. The hot shoe has an electronic contact that tells the flash to fire when the shutter is released. There are also a number of other electronic contacts that allow the camera to communicate with the flash to enable the automated features of a dedicated flash unit such as the SB-700.

▶ **Focus ring.** Rotating the focus ring allows you to focus the lens manually. The location of the focus ring varies by lens. With old AF (non AF-S) lenses, and even older manual focus lenses, just turn the ring to focus the lens. With newer AF-S lenses, such as the kit lens, there's a switch on the lens labeled A and M. Select M before attempting to manually focus. If you don't switch it over first, you can damage the lens. Some higher-end AF-S lenses have a switch labeled A/M and M. With these lenses set to the A/M position, you can manually override the autofocus at any time without damaging the lens.

 For more information on lenses and compatibility, see Chapter 5.

▶ **Zoom ring.** Rotating the zoom ring allows you to change the focal length of the lens. Prime lenses do not have a zoom ring.

▶ **Focal length indicators.** These numbers indicate which focal length in millimeters your lens is zoomed to.

Back of the camera

The back of the camera is where you find the buttons that mainly control playback and menu options, although there are a few buttons that control some of the shooting functions. Most of the buttons have more than one function — a lot of them are used in conjunction with the Command dial or the multi-selector. On the back of the camera you also find several key features, including the all-important viewfinder and LCD.

▶ **LCD.** This is the most obvious feature on the back of the camera. This big 3-inch, 230,000-dot liquid crystal display (LCD) screen is a very bright, high-resolution screen. The LCD is where you view all your current camera settings, review your images after shooting, and display the video feed for Live View and video recording.

▶ **Viewfinder.** This is what you look through to compose your photographs. Light coming through the lens is reflected from a series of five mirrors (called a pentamirror) enabling you to see exactly what you're shooting. Around the viewfinder is a rubber eyepiece that serves to give you a softer place to rest your eye and to block any extra light from entering the viewfinder as you compose and shoot your images.

▶ **Diopter adjustment control.** Just to the right of the viewfinder (hidden behind the eyecup) is the Diopter adjustment control. Use this control to adjust the viewfinder lens to suit your individual vision differences (not everyone's eyesight is the same). To adjust this, look through the viewfinder, and press the Shutter Release button halfway to focus on something. If what you see in the viewfinder isn't quite sharp, slide the Diopter adjustment up or down until everything appears in focus. The manual warns you not to put your finger or fingernail in your eye. I agree that this might not be a good idea.

▶ **AE-L/AF-L/Protect button.** The Auto-Exposure/Autofocus Lock button is used to lock the Auto-Exposure (AE) and Autofocus (AF). When in Playback mode this button can be pressed to lock an image to protect it from being deleted. A small key icon is displayed in the upper left-hand corner of images that are protected. This button can be customized in the Setup menu (under Buttons) to provide AE Lock only, AF Lock only, AE Lock (hold), or AF-ON. AE Lock (hold) locks the exposure with one press of the button; the exposure is locked until the button is pressed again or the shutter is released. AF-ON engages the AF in the same way that half-pressing the shutter does.

▶ **Command dial.** This dial is used to change a variety of settings depending on which button you are using in conjunction with it. By default, it is used to change the shutter speed when in Shutter Priority and Manual mode or the aperture when in Aperture Priority. It is also used to adjust exposure compensation and change the flash mode. When in Manual exposure mode pressing the Exposure Compensation/Aperture button and rotating the dial changes the aperture settings.

▶ **Live View switch/Movie Record button.** This is a brand new button intro-
duced with the D3100 and sure to follow on all subsequent cameras. This is a
great feature that makes switching to Live View and recording video a breeze.
Flipping the switch to the right activates Live View and pressing the button
starts recording video. To end recording simply press the button again. To exit
Live View, flick the switch to the left. Quick and easy!

▶ **Multi-selector.** The multi-selector is another button that serves a few different
purposes. In Playback mode the multi-selector is used to scroll through the pho-
tographs you've taken, and it can also be used to view image information such
as histograms and shooting settings. When in certain shooting modes the multi-
selector can be used to change the active focus point when in Single-point or
Dynamic-area AF mode. It also serves to navigate through the menu options.

▶ **OK button.** When in the Menu mode, press this button to select the menu item
that is highlighted.

▶ **Memory card access lamp.** This light blinks when the memory card is in use.
Under no circumstances should you remove the card when this light is on or
blinking. You could damage your card or camera and lose any information in the
camera's buffer.

▶ **Delete button.** When reviewing your pictures, if you find some that you don't
want to keep, you can delete them by pressing this button marked with a trash-
can icon. To prevent accidental deletion of images, the camera displays a dialog
box asking you to confirm that you want to erase the picture. Press the Delete
button a second time to permanently erase the image.

▶ **Speaker.** This small speaker enables you to hear the audio recorded with the
video you have shot. I must admit that the fidelity of the speaker isn't that great
and it's quite hard to get an accurate representation of what the sound is going
to be like when played back through your TV or computer speakers.

▶ **Playback button.** Pressing this button activates the Playback mode and by
default displays the most recently taken photograph. You can also view other
pictures by pressing the multi-selector left and right.

▶ **Menu button.** Press this button to access the D3100 menu options. There are a
number of different menus, including Playback, Shooting, Custom Settings, and
Retouch. Use the multi-selector to choose the menu you want to view and press
OK to enter the specific menu screen.

▶ **Zoom out/Thumbnail/Help button.** In Playback mode, pressing this button
allows you to go from full-frame playback (or viewing the whole image) to viewing
thumbnails. The thumbnails can be displayed as 4, 9, or 72 images on a page. You
can also view images by calendar date. When viewing the menu options, pressing

this button displays a help screen that explains the functions of that particular menu option. When in Shooting mode, pressing this button explains the functions of that particular mode. When viewing the Information Display and a flashing question mark appears, you can press this button for help. This button also allows you to zoom out after you have zoomed in on a particular image.

▶ **Zoom in button.** When reviewing your images, you can press the Zoom in button to get a closer look at the details of your image. This is a handy feature for checking the sharpness and focus of your shot. When zoomed in, use the multi-selector to navigate within the image. To view your other images at the same zoom ratio, you can rotate the Command dial. To return to full-frame playback, press the Zoom out button. You may have to press the Zoom out button multiple times depending on how much you have zoomed in.

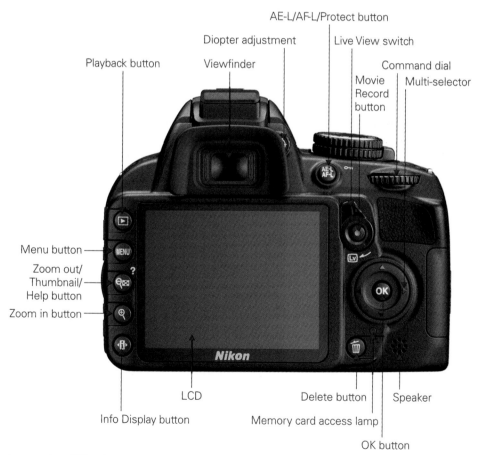

Image courtesy of Nikon, Inc.

1.2 Back-of-the-camera controls

► **Info Display button.** Pressing this button shows the Info display. When the Info display is shown, pressing this button again gives access to some settings that can be changed. Use the multi-selector to highlight the desired setting to change, and then press the OK button to access the options.

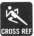

CROSS REF For more detailed information on changing settings in the Info display, see Chapter 3.

Front and sides of the camera

The front of the D3100 (lens facing you) is where you find the buttons to quickly adjust the flash settings as well as some camera-focusing options, and with certain lenses you will find some buttons that control focusing and Vibration Reduction (VR).

Image courtesy of Nikon, Inc.

1.3 Front of the Nikon D3100

▶ **Built-in flash.** This option is a handy feature that allows you to take sharp pictures in low-light situations. Although not as versatile as one of the external Nikon Speedlights such as the SB-600 or SB-400, the built-in flash can be used very effectively and is great for snapshots, although I highly recommend getting a flash diffuser if you plan on using it much.

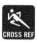 For more on using flash, see Chapter 6.

▶ **AF-assist illuminator.** This is an LED that shines on the subject to help the camera to focus when the lighting is dim. The AF-assist illuminator only lights when in Single Focus mode (AF-S) or Automatic Focus mode (AF-A). This is also lit when the camera is set to Red-Eye Reduction flash using the camera's built-in flash.

▶ **Built-in microphone.** This condenser microphone is what records the sound when recording HD video.

Right side

On the right side of the camera (lens facing you) are the output terminals on the D3100. These are used to connect your camera to a computer or to an external source for viewing your images directly from the camera. These terminals are hidden under a rubber cover that helps keep out dust and moisture.

▶ **Flash mode/FEC button.** When using P, S, A, or M exposure modes, press this button to open and activate the built-in Speedlight. Pressing this button and rotating the Command dial on the rear of the camera allows you to choose a flash mode. Depending on the Shooting mode, you can choose from among Front-Curtain Sync, Red-Eye Reduction, Red-Eye Reduction with Slow Sync, Slow Sync, and Rear-Curtain Sync. Once the flash is popped up, pressing this button in conjunction with the Exposure Compensation button and rotating the Command dial allows you to adjust the Flash Exposure Compensation (FEC). FEC allows you to adjust the flash output to make the flash brighter or dimmer depending on your needs. When shooting in Auto or scene modes, the flash is automatically activated and some Flash sync modes aren't available depending on the scene mode.

 • **Auto, Portrait, Child, Close-up.** When using these modes, you can select Auto-flash, Auto with Red-Eye Reduction, or set to Off.

 • **Night portrait.** With this mode you can select Auto with Slow Sync and Red-Eye Reduction, Auto with Slow Sync, or set to Off.

- **P, A.** With these modes you can select Fill flash, Red-Eye Reduction, Slow Sync with Red-Eye Reduction, Slow Sync, or Rear-Curtain with Slow Sync.

- **S, M.** These modes allow you to use Fill flash, Red-Eye Reduction, or Rear-Curtain Sync.

Flash mode/FEC button GPS input

Function button

AF/Manual focus switch USB port

VR switch Lens release button HDMI out

S-Video out

Image courtesy of Nikon, Inc.

1.4 The right side of the D3100

▶ **Function button.** This customizable button, labeled Fn, is a nice addition this entry-level camera. The Fn button can be set to a number of different settings so that you can access them quickly, saving you time that it takes to search through the menu options manually. You can set the button to quickly change the image quality, ISO sensitivity, white balance, or Active D-Lighting settings via the Info display. Pressing the Fn button and rotating the Command dial changes the settings. You can change the setting options in the Setup menu under the Buttons option.

▶ **Lens release button.** This button disengages the locking mechanism of the lens, allowing the lens to be rotated and removed from the lens mount.

▶ **GPS input.** This is an accessory port that allows you to connect the optional Nikon GP-1 for geo-tagging your images.

▶ **USB port.** This is where the USB cable plugs in to attach the camera to your computer to transfer images straight from the camera. The USB cable is also used to connect the camera to the computer when using Nikon's optional Camera Control Pro 2 software.

▶ **HDMI out.** This terminal is for connecting your camera to an HDTV or HD monitor. This requires a type C mini-pin HDMI cable that's available at any electronics store.

▶ **S-Video out.** This connection, officially called Standard video output, is used to connect the camera to a standard TV or VCR for viewing your images on-screen. The D3100 connects with the EG-D2 video cable that is available separately from Nikon.

▶ **AF/Manual focus switch.** This switch is used to choose between using the lens in Auto or Manual focus.

▶ **VR switch.** This allows you to turn the Vibration Reduction (VR) on or off. When shooting in normal or bright light it's best to turn the VR off to reduce battery consumption.

Left side

On the left side of the camera (lens facing you) is the memory card slot cover. Sliding this door toward the back of the camera opens it so you can insert or remove your memory card.

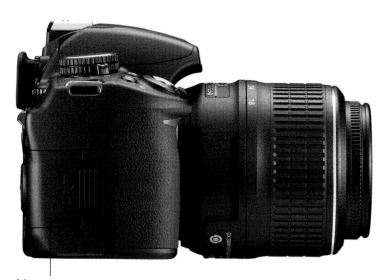

Memory card slot cover

Image courtesy of Nikon, Inc.

1.5 Memory card slot cover

Bottom

The bottom of the camera has a couple of features that are quite important.

▶ **Battery chamber cover.** This covers the chamber that holds the EN-EL15 battery that is supplied with your D3100. If you look closely at the battery chamber, there is a small rubber cover that can be moved out of the way to make way for the cord of the EH-5a AC adapter that is available separately from Nikon.

▶ **Tripod socket.** This is where you attach a tripod or monopod to help steady your camera.

Viewfinder Display

When looking through the viewfinder, you see a lot of useful information about the photo you are setting up. Most of the information is also displayed in the Information Display screen, but it is less handy when you are looking through the viewfinder composing a shot. Here is a complete list of all the information you get from the viewfinder display.

▶ **Low battery indicator.** This shows up when the battery is low. When the battery is completely exhausted, this icon blinks and the shutter release is disabled.

▶ **Focus points.** This shows you which AF point is chosen by showing a lit-up red dot in the focus point bracket. When set to Auto Area, no AF points are lit until the camera achieves focus, then one or more AF points will be displayed momentarily lit up with brackets.

▶ **Focus lock indicator.** This is a green dot that lets you know whether the camera detects that the scene is in focus. When focus is achieved, the green dot lights up; if the camera is not in focus, no dot is displayed.

▶ **AE lock indicator.** When this is lit, you know that the Auto-Exposure Lock button has been pressed. The exposure is now locked and remains so until the button is released.

▶ **Shutter speed.** This simply shows how long your shutter is set to stay open from 30 seconds (30″) up to 1/4000 (4000) second.

▶ **Aperture.** This shows what your current aperture setting is. The words *aperture* and *f/stop* are used interchangeably. Your aperture setting is how wide your lens opening is.

▶ **Remaining exposures/buffer/WB recording/EV/FEC/ISO sensitivity.** This set of numbers lets you know how many more exposures can fit on the memory card. The actual number of exposures may vary according to file information and compression. When the Shutter Release button is half-pressed, the display changes to show how many exposures can fit in the camera's *buffer* before the buffer is full and the frame rate slows down. The buffer is in-camera RAM that stores your image data while the data is being written to the memory card. This area also indicates that the WB is ready to be set by flashing PRE; it displays the amount of exposure compensation and FEC when the Exposure Compensation button is pressed. The ISO sensitivity is also displayed here when the Fn. button is set to ISO sensitivity.

▶ **Thousands indicator.** This lets you know that there are more than 1,000 exposures remaining on your memory card.

▶ **Flash ready indicator.** When this is displayed, the flash, whether it is the built-in flash or an external Speedlight attached to the hot shoe, is fully charged and ready to fire at full power.

▶ **Flexible program indicator.** When this icon shows, it lets you know that the exposure has been modified from the original settings defined when using the Programmed Auto exposure mode. To return to the default settings, rotate the Command dial until this indicator disappears or simply switch to another exposure mode setting and switch back.

▶ **Exposure meter/Exposure Compensation/Electronic rangefinder.** Although Nikon gives this feature a confusing moniker, in simpler terms this is your light meter. When the bars are in the center, you are at the proper settings to get a good exposure; when the bars are to the left, you are overexposed; and when the bars are to the right, you are underexposing your image. This feature is shown when using Manual exposure. When the Exposure Compensation button is set, this display is also shown indicating how much over- or underexposure is being set. When the Rangefinder option is turned on (you can find this in the Setup menu under Viewfinder options) and the lens is set to Manual focus, this shows you a bar graph that indicates distance. When the subject is in focus, the bars are even on both sides of a 0. When the bars are displayed to the left, this indicates that you are focused in front of the subject; bars to the right indicate that the focus is falling behind the subject. Use the focus ring to adjust the focus. The Rangefinder display is not available when shooting in Manual exposure mode.

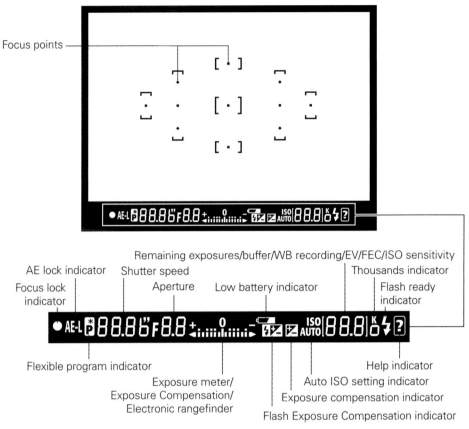

1.6 Viewfinder display

▶ **Flash Exposure Compensation indicator.** When this is displayed, your Flash Exposure Compensation is on. Flash Exposure Compensation is used to add or subtract light output from your flash. This applies to both the built-in flash and an accessory Speedlight.

▶ **Exposure compensation indicator.** When this appears in the viewfinder, your camera has exposure compensation activated, and you may not get a correct exposure. Exposure compensation is used to add or subtract from the overall exposure chosen by the camera meter.

▶ **Auto ISO setting indicator.** This is displayed when the Automatic ISO setting is activated to let you know that the camera is controlling the ISO settings.

▶ **Help indicator.** When this question mark icon is flashing, the camera is warning you that there may be a problem with your settings. Press the Help button to view the warning.

Information Display

The Information Display, which I refer to as the Info display for brevity, shows some of the same shooting information that appears in the viewfinder, but there are also quite a few settings that are only displayed here. When this is displayed on the LCD, you can view and change the settings without looking through the viewfinder. When the camera is turned on, the Shooting info is automatically displayed on the LCD monitor. The info remains on display until no buttons have been pushed for about 8 seconds (default) or the Shutter Release button is pressed. You can change the length of time this is displayed in the Setup menu under the Auto-off timers option Playback/menus.

You can also view the Info display by pressing the Information edit (i) button. Pressing the Info button twice brings up another screen, which allows you to change some key settings on the camera. These settings are detailed in figure 1.7.

This display shows you everything you need to know about your camera settings. Additionally, the camera has a sensor built in that tells it when the camera is being held vertically, and the Info display is shown upright no matter which way you are holding your camera.

The camera also allows you a number of options on how the information is displayed. You can choose between Classic or Graphic. You can also change the color of the Shooting info display. In Classic mode you can choose between black, blue, and orange. In Graphic mode, you can choose between green, black, or brown. You can also choose a different display for the scene and P, S, A, and M modes. These settings can be accessed in the Setup menu under the Info display format heading.

 For more info on the Setup menu, see Chapter 3.

▶ **Shooting mode.** This displays the Shooting mode that your camera is currently set to. This can be one of the scene modes, in which case the display will be the appropriate icon, or one of the semi-auto modes such as P, S, A, or M, in which case the display will show the corresponding letter. This display changes when the Mode dial is rotated.

▶ **Date imprint.** This icon is shown when the optional date imprint function is applied. This function prints the date at the bottom of the image as it's being recorded.

▶ **Manual flash indicator.** This icon appears when the built-in flash is set to Manual, but only when the flash is popped up. When an optional Speedlight is attached, this icon is displayed when FEC is applied directly on the Speedlight.

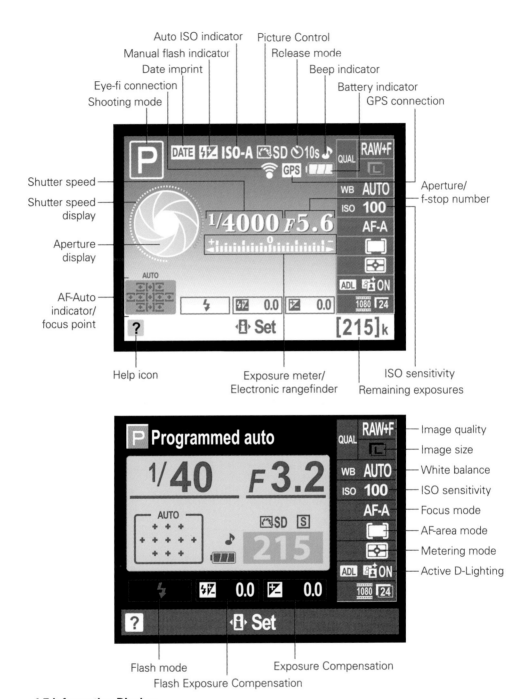

Auto ISO indicator
Manual flash indicator
Date imprint
Eye-fi connection
Shooting mode
Picture Control
Release mode
Beep indicator
Battery indicator
GPS connection

Shutter speed
Shutter speed display
Aperture display
AF-Auto indicator/ focus point

Aperture/ f-stop number

Help icon
Exposure meter/ Electronic rangefinder
ISO sensitivity
Remaining exposures

Image quality
Image size
White balance
ISO sensitivity
Focus mode
AF-area mode
Metering mode
Active D-Lighting

Flash mode
Flash Exposure Compensation
Exposure Compensation

1.7 Information Display

▶ **Auto ISO indicator.** This icon is displayed only when Auto-ISO is enabled.

▶ **Picture Control.** This section of the display shows you what Picture Control is being applied to your images. For more information on Picture Controls, see Chapter 3.

▶ **Eye-fi connection.** This icon only appears when using an Eye-fi wireless SD card.

▶ **Release mode.** This lets you know what Release mode your camera is set to: Single frame, Continuous, Self-timer, Delayed remote, or Quick response remote.

▶ **Beep indicator.** This icon (musical note) tells you whether you have the camera set to beep when focus is achieved in Single Focus mode. When the icon has a slash through it, the beep is turned off (recommended).

▶ **GPS.** This indicator is displayed when an optional GPS unit is attached to the D3100.

▶ **Battery indicator.** This shows you the remaining charge on your battery.

▶ **Aperture/f-stop number.** This tells you how wide your aperture or lens opening is. The terms *aperture* and *f-stop* are interchangeable. Higher f-numbers denote smaller openings, while lower f-numbers mean that the opening is wider, letting in more light.

▶ **Exposure meter/electronic rangefinder.** This acts as your light meter. When the bars are in the center, you are at the proper settings to get a good exposure; when the bars are to the left, you are overexposed; when the bars are to the right, you are underexposing your image. This feature is only displayed in Manual exposure. This display blinks when the light is too dark or too bright in P, S, A, or one of the scene modes. It is also displayed when exposure compensation is applied showing how much compensation is applied.

▶ **Shutter speed.** This shows in fractions of seconds or seconds how long your shutter stays open when the Shutter Release button is pressed.

▶ **K.** This icon appears when you have more than 1,000 exposures remaining on your memory card.

▶ **Remaining exposures.** This shows you approximately how many exposures can be saved to your memory card. When the Preset White Balance is ready to be set, this will blink PRE.

▶ **Help icon.** When this icon (shown as a question mark) is flashing, there may be a problem with one of your settings. Pressing the Help/Zoom out button will display information on rectifying the problem. When this icon appears and is not flashing, press the Help button to display information on the currently selected option.

▶ **AF area mode.** This tells you which AF area mode is selected: Auto-area, Dynamic-area, or Single-point. This also tells you when 3D-tracking is enabled and which focus point is selected when in Single-point AF.

▶ **Aperture display.** When set to Graphic mode, this shows you approximately what your lens opening looks like when the camera is held in the horizontal position.

The following are adjustable settings. Pressing the Info button twice allows access to these common settings so that they can be changed quickly.

▶ **Image quality.** This display shows the quality or compression of the JPEG or shows that you are recording a RAW image.

▶ **Image size.** This tells you the size of the image when you are shooting still photos using the jpg setting.

▶ **White balance.** This displays which white balance setting you are currently using.

▶ **ISO sensitivity.** This tells you what your current ISO setting is.

▶ **Focus mode.** This tells you which focus mode your camera is set to: AF-A (Automatic), AF-C (Continuous), AF-S (Single), or MF (Manual).

▶ **AF area mode.** This icon tells you which Autofocus area mode is set. The AF area modes determine how the focus point is chosen.

▶ **Metering mode.** This displays which metering mode your camera is set to: Matrix, Center-weighted, or Spot. For more information on metering, see Chapter 2.

▶ **Active D-Lighting.** This shows whether you have Active D-Lighting on or off. Active D-Lighting can be set in the Info display.

▶ **Exposure Compensation.** This shows the amount of exposure compensation, if any, that has been set. Exposure compensation is used to increase or decrease the amount of exposure to fine-tune your image.

▶ **Flash Exposure Compensation.** This shows you the amount, if any, of Flash Exposure Compensation (FEC), which is used to make the flash more or less bright. FEC is set by simultaneously pressing the Flash mode button, the Exposure Compensation button, and rotating the Command dial. Rotating to the right decreases flash exposure; rotating to the left increases the exposure.

▶ **Flash mode.** This shows which mode your flash is set to. You can change the Flash mode by pressing the Flash button and rotating the Command dial. For more information on Flash Sync modes, see Chapter 6.

Nikon D3100 Essentials

In this chapter I cover some of the most important settings of the camera, such as the exposure modes, metering, AF settings, and ISO. Knowing what all these settings do is essential because all of these settings control how your image is created and help reflect your artistic vision or simply make sure that your pictures come out exactly as you want, even in difficult lighting situations. Also covered in this chapter are Picture Controls and white balance, both of which affect the colors in your images.

The combination of different camera settings determines how your images look.

Exposure Modes

Exposure modes determine how the aperture and shutter speeds are chosen to get the desired exposure. The standard modes — P, S, A, and M — allow you to control the exposure settings and let you set the others as you see fit. In some cases, such as with the auto and scene modes, the ISO, flash, white balance, and autofocus settings are decided by the exposure mode as well. The Nikon D3100 has quite a few options to help you get the exposure that is right for the scene you are photographing.

Auto modes

The D3100 has two fully automatic, or Auto, modes that do all the work for you. These are simple grab-and-go settings to use when you're in a hurry or you just don't want to be bothered with changing the settings. The Auto modes control everything from shutter speed and aperture to ISO sensitivity and white balance.

The Auto ISO setting can be overridden using the Information Display menu to change the ISO setting. If the Function button is set to ISO, the Auto ISO can be overridden as well. The override remains in effect unless the camera is changed to P, S, A, or M and returned to one of the scene modes. When changing back to a scene mode from P, S, A, or M, the Auto ISO function is again activated.

Auto

The Auto mode is basically a point-and-shoot mode. The camera takes complete control over the exposure as well as all of the other settings. The camera's meter reads the light, the color, and the brightness of the scene and runs the information through a sophisticated algorithm. The camera uses this information to determine what type of scene you are photographing and chooses the settings that it deems appropriate for the scene.

If there isn't enough light to make a proper exposure, the camera's built-in flash automatically pops up when the Shutter Release button is half-pressed for focus. The flash fires when the shutter is released, resulting in a properly exposed image.

This mode is great for taking snapshots, when you simply want to concentrate on capturing the image and let the camera determine the proper settings.

Auto (flash off)

This mode functions in the same way as the Auto setting, except that it disables the flash, even in low-light situations. In instances when the lighting is poor, the camera's

AF-assist illuminator lights up to provide sufficient light to achieve focus. The camera uses the focus area of the closest subject to focus on.

This setting is preferable when you want to use natural or ambient light for your subject or in situations where you aren't allowed to use flash, such as museums, or events where the flash may cause a distraction, such as weddings.

Advanced scene modes

Sometimes the Auto mode isn't going to give you the proper settings to suit your needs, especially when shooting under difficult situations or when you have special circumstances. These scene modes take into account different lighting situations and modify the way the camera meters the light, as well as controlling the focus points, the flash settings, and the aperture, shutter speed, and ISO sensitivity settings.

The camera also determines if there is enough light to make an exposure and activates the built-in flash if there is not enough light. Some of these scene modes, such as Landscape, also make sure that the flash is not used, even in low-light situations.

The scene modes in the D3100 allow you to capture the image with the settings that are best for what you are photographing. The camera has the parameters programmed into it, and you can just rotate the Mode dial to the scene mode that you want to use and start shooting.

These scene modes account for difficult lighting situations and make it easier to get great photos. This can give you a little more flexibility than just placing the camera in Auto mode and hoping that your photos turn out as you want them to.

Portrait

This scene mode is for taking pictures of people. The camera automatically adjusts the colors to give natural-looking skin tones. The D3100 uses its face detection system to lock focus on the subject. This cool feature makes sure the face is in focus and that the camera doesn't accidentally lock focus somewhere else in the scene. It also attempts to use a wide aperture, if possible, to reduce the depth of field. This draws attention to the subject of the portrait, leaving distracting background details out of focus.

 For more information on aperture settings and depth of field, see Chapter 4.

The built-in flash and AF-assist illuminator automatically activate in low-light situations.

Landscape

This mode is best used for taking photos of far-off vistas. The camera automatically adjusts the colors to apply brighter greens and blues to skies and foliage. The camera also automatically focuses on the closest subject and uses a smaller aperture to provide a greater depth of field to ensure focus throughout the entire image.

In this mode, the camera automatically disables the AF-assist illuminator and the flash.

Child

This mode is for taking candid shots of children. The camera automatically adjusts the colors to give more saturation while still giving a natural skin tone. The camera automatically focuses on the closest subject and uses subject tracking in the event the child is moving around in the frame. The camera selects a fairly small aperture to capture background details. The built-in flash is automatically activated when the light is low.

This mode also does a fine job when shooting active pets.

Sports

Sports mode uses a fast shutter speed to freeze the action of moving subjects. The camera focuses continuously as long as you have the Shutter Release button half-pressed. The camera also uses predictive focus tracking that is based on information from all the focus areas to help maintain focus if your subject moves from the selected focus point.

The camera disables the built-in flash and AF-assist illuminator when this mode is selected.

Close Up

This scene mode is used for close-up or macro shots. It uses a fairly wide aperture to provide a soft background while giving the main subject a sharp focus. In this mode, the camera focuses on the subject in the center of the frame, although you can use the multi-selector to choose one of the other focus points to create an off-center composition.

When light is low, the camera automatically activates the built-in flash. Be sure to remove your lens hood when using the flash on close-up subjects because the lens hood can cast a shadow on your subject by blocking the light from the flash.

Night Portrait

Use this mode when taking portraits in low-light situations. The camera automatically activates the flash and uses a longer shutter speed to capture the ambient light from the background. This balances the ambient light and the light from the flash, giving you a more natural effect. Be sure to ask your subject to stay as still as possible. I also recommend using a tripod when you use this feature to prevent blurring from camera shake that can occur during longer exposure times.

Programmed Auto

Programmed Auto mode (P) is an automatic exposure mode suitable for use when shooting snapshots and scenes where you're not very concerned about controlling the shutter speed and aperture settings. Keep in mind that when using the P mode, you are responsible for setting the AF mode, ISO, WB, etc.

When the camera is in Programmed Auto mode, it decides the exposure settings for you, based on a set of algorithms. The camera attempts to select a shutter speed that allows you to shoot handheld without suffering from camera shake, while also adjusting your aperture so that you get enough depth of field to ensure everything is in focus.

When the camera body is coupled with a lens that has a CPU built in (all autofocus, or AF, lenses have a CPU including the kit lens), the camera automatically knows what focal length and aperture range the lens has. The camera then uses this lens information to decide what the optimal settings should be.

 For more information on lenses and lens terminology, see Chapter 5.

Programmed Auto mode chooses the widest aperture possible until the optimal shutter speed for the specific lens is reached. Then the camera chooses a smaller f-stop and increases the shutter speed as light levels increase.

For example, when using an 18-55mm kit lens, the camera keeps the aperture wide open until the shutter speed reaches about 1/40 second (approximately the minimum shutter speed needed to avoid camera shake). Upon reaching 1/40 second, the camera adjusts the aperture to increase depth of field.

The exposure settings selected by the camera are displayed in both the Info display on the monitor and the viewfinder display. Although the camera chooses what it thinks are the optimal settings, the camera does not know what your specific needs are. You

may decide that your hands are not steady enough to shoot at the shutter speed the camera has selected, or you may want a wider or smaller aperture for selective focus.

Fortunately, you aren't stuck with the camera's exposure choice. You can engage what is known as *flexible program*. Flexible program allows you to deviate from the camera's aperture and shutter speed choice when you are in P mode. This feature can be automatically engaged simply by rotating the Command dial until the desired shutter speed or aperture is achieved. This allows you to choose a wider aperture and faster shutter speed when rotated to the right, or a slower shutter speed and smaller aperture when the dial is rotated to the left.

With flexible program, you can maintain the metered exposure while still maintaining some control over the shutter speed and aperture settings.

 One thing you should be aware of when using flexible program is that when Auto ISO is enabled the camera will not choose a lower shutter speed that you have designated in the ISO sensitivity settings (this can be set in the Shooting menu) as long as there is ample light.

A quick example of making use of flexible program would be if the camera has set the shutter speed at 1/60 second with an aperture of f/8, you're shooting a portrait, and you want a wider aperture to throw the background out of focus. By rotating the Command dial to the right, you can open the aperture up to f/4, which causes the shutter speed to increase to 1/250 second. This is known as an *equivalent exposure*, meaning you get the exact same exposure but the settings are different.

When flexible program is on, an asterisk appears next to the P on the display. Rotate the main Command dial until the asterisk disappears to return to the default Programmed Auto settings.

 When using non-CPU lenses, the camera must be set to Manual exposure mode.

Aperture Priority

Aperture Priority mode (A) is a semiautomatic mode. In this mode, you decide which aperture to use, and the camera sets the shutter speed for the best exposure based on your chosen aperture. Situations where you may want to select the aperture include when you're shooting a portrait and want a large aperture (small f-number) to blur the background, and when you're shooting a landscape and you want a small aperture (large f-number) to ensure the entire scene is in focus.

 In Aperture Priority mode, if there is not enough light to make a proper exposure, the camera displays Lo in place of the shutter speed setting. In the same manner, it will also display Hi if there is too much light.

In my opinion, choosing the aperture to control depth of field is one of the most important parts of photography. This allows you to selectively control which areas of your image are in sharp focus and which areas are allowed to blur and by how much. Controlling depth of field enables you to draw the viewer's eye to a specific part of the image, which can make your images more dynamic and interesting to the viewer.

Shutter Priority

Shutter Priority mode (S) is another semiautomatic mode. In this mode, you choose the shutter speed and the camera sets the aperture. This mode is good to use when shooting moving subjects, sports, or action scenes where you need a fast shutter speed to freeze the motion of your subject and prevent blur.

 For more information on using shutter speeds in action and sports photography, see Chapter 8.

You can also select a slower shutter speed to *add* motion blur as a creative photographic technique.

 In Shutter Priority mode, if there is not enough light to make a proper exposure, the camera displays Lo in place of the aperture setting. In the same manner, it will also display Hi if there is too much light.

Manual

When in Manual mode (M), both the aperture and shutter speed settings are set by you. You can estimate the exposure, use a handheld light meter, or use the electronic analog exposure display to determine the exposure needed.

Probably the main question that people have about Manual mode is why you would use it when you have these other modes. There are a few reasons why you may want to set the exposure manually:

▶ **To gain complete control over exposure.** The camera typically decides the optimal exposure based on technical algorithms and an internal database of image information. But what the camera decides is optimal is not necessarily what is optimal in your mind.

You may want to underexpose to make your image dark and moody, or you may want to overexpose a bit to make the colors pop (making colors bright and contrasty). If your camera is set to M, you can choose the settings and place your image in whatever tonal range you want without having to adjust the exposure compensation settings.

▶ **When using studio flash.** The camera's metering system isn't used when using studio strobes or external nondedicated flash units. When using external strobes, a flash meter or manual calculation is necessary to determine the proper exposure. You can use the Manual exposure mode to quickly set the aperture and shutter speed to the proper exposure; just be sure not to set the shutter speed above the rated sync speed of 1/200 second.

▶ **When using non-CPU lenses.** The camera must be set to Manual exposure mode when you use older, non-CPU lenses or an error displays and the Shutter Release locks, rendering the camera unable to take a picture.

Release Modes

The Release modes control how the shutter is released when the Shutter Release button is pressed. This allows to you control whether the shutter is released once or multiple times; it even allows you to put a delay on it. There are four different Release mode options:

▶ **Single.** When Single release is selected the shutter cycles only once when the Shutter Release button is pressed. Even if the button is pressed and held, the shutter does not cycle again until the Shutter Release button has been released. This option is good for general shooting where the subject isn't moving or you don't need to capture a sequence of events such as for portrait or landscape shooting.

▶ **Continuous.** When Continuous mode is selected, the shutter cycles through continuously as long as the Shutter Release button is pressed and held. This mode is good for photographing moving subjects, sports, or in a situation where you want to capture a sequence of events. The D3100 fires approximately three frames per second.

▶ **Self-timer.** This option puts a time delay on the shutter after the Shutter Release button is pressed. By default the camera delays the shutter from releasing for 10 seconds. You can change the delay to 2 seconds in the Setup menu under the Self-timer delay option. This is handy when you want to get in the picture or when doing long exposures on a tripod to minimize camera shake caused when pressing the Shutter Release button. The delay allows the camera and tripod to stabilize after the button is pressed and before the shutter is released.

▶ **Quiet.** When the shutter is released, the camera makes a bit of noise. Most of this noise isn't actually the shutter, but the reflex mirror inside the camera. The reflex mirror is situated in front of the shutter and takes the image from the lens and reflects it up to a pentamirror in the viewfinder housing, which reflects it a few more times to turn the image the right way in the viewfinder. When the Shutter Release button is pressed, the mirror flips up out of the way so that the light from the lens is projected onto the sensor. When Quiet mode is selected, the mirror flips up but doesn't flip back down while the Shutter Release button is held. You can then cover your camera or move to another location before releasing the button and allowing the mirror to flip down. This mode is not actually much quieter than shooting in Single mode because the mirror-flipping-up noise is still heard.

Metering Modes

The D3100 has three metering modes that you can choose from to help you get the best exposure for your image: Matrix, Center-weighted, and Spot. You can change the modes in the Information Display menu or in the Shooting menu.

Metering modes can only be changed when using P, S, A, or M exposure modes.

Metering modes decide how the camera's light sensor collects and processes the information used to determine exposure. Each of these modes is useful for different types of lighting situations.

Matrix

The default metering system that Nikon cameras use, including the D3100, is a proprietary system called 3D Color Matrix II, or Matrix metering for short. The D3100 has a 420-pixel RGB sensor that measures the intensity of the light and the color of a scene and compares that information to information from 30,000 images stored in its database. Then the camera determines the exposure settings based on the findings from the comparison. Simplified, it works like this: You're photographing a portrait outdoors, and the sensor detects that the light in the center of the frame is much dimmer than the edges. The camera takes this information along with the focus distance and compares it to the images in the database.

The images in the database with similar light and color patterns and subject distance tell the camera that this must be a close-up portrait with flesh tones in the center and sky in the background. From this information, the camera decides to expose primarily

for the center of the frame, although the background may be over- or underexposed. The RGB sensor also takes note of the quantity of the colors and uses that information as well.

For more information on lenses and lens specifications, see Chapter 5.

The Matrix metering setting is highly intuitive, and Nikon has been refining it over a number of years, so it works very well for most subjects. I almost always have my camera set to Matrix.

It bears mentioning here that if you plan on using older lenses with your D3100 you will not necessarily take advantage of the most current metering system. Nikon lenses have been adapted over the years to supply more and more information to the camera body. Older non-D or non-G type lenses won't provide the information that is needed to make calculations. In the case that an older lens is used, the camera defaults to an older (but still very capable) metering system. The two metering systems are as follows:

2.1 The 420-pixel RGB sensor in the D3100

▶ **3D Color Matrix II.** As mentioned earlier, this is the default metering system that the camera employs when a G- or D-type lens is attached to the camera. Most lenses made since the early to mid-1990s are these types of lenses. The only difference between the G- and D-type lenses is that there is no aperture ring on a G-type lens. When using this metering method, the camera decides the exposure setting, mostly based on the brightness of the overall scene and the colors of the subject matter; the camera also takes into account the distance from the subject and which focus point is used.

In addition, the camera takes into account the focal length of the lens to further decide which areas of the image are important to getting the proper exposure. For example, when using a wide-angle lens with a faraway subject and a bright area at the top of the image, the camera sets the exposure so that the sky and clouds don't lose detail.

▶ **Color Matrix metering II.** Most AF lenses made from about 1986 to the early to mid-1990s are non-D and G-type CPU lenses. When this type of Matrix metering is being used, the camera uses only brightness, subject color, and focus information to determine the right exposure.

If a non-CPU lens is attached, the camera's meter defaults to Center-weighted metering.

For more information on lenses, see Chapter 5.

Matrix metering is generally suitable for use with most subjects unless you're in a particularly tricky lighting situation such as when the subject is lit from behind (backlit). Due to the large amount of image data in the Matrix metering database, the camera can usually make a fairly accurate assessment about what type of image you are shooting and adjust the exposure accordingly. For example, with an image that has a high amount of contrast and brightness across the top of the frame, the camera usually tries to set an exposure so that the highlights retain detail. Paired with Active D-Lighting, your exposures will have good dynamic range throughout the entire image.

When shooting a series of images where the exposure needs to be consistent, you may want to choose Center-weighted metering because even small changes in the composition can affect the exposure when using Matrix metering.

Center-weighted

When the camera's metering mode is switched to Center-weighted, the meter takes a light reading of the whole scene but bases the exposure settings mostly on the light falling on the center of the scene. The camera determines about 75 percent of the exposure from an 8mm circular pattern in the center of the frame and 25 percent from the edges.

Center-weighted metering is a very useful option. It works great when shooting photos where you know the main subject will be in the middle of the frame. This metering mode is useful when photographing a dark subject against a bright background, or a light subject against a dark background. This mode works especially well for portraits where you want to preserve the background detail while exposing correctly for the subject.

Center-weighted metering can provide you with consistent results without worrying about the fluctuations in exposure settings that can sometimes happen when using Matrix metering.

Spot

In Spot meter mode, the camera does just that: It meters only a spot. This spot is only 3.5mm in diameter and only accounts for 2.5 percent of the entire frame. The spot is linked to the active focus point, which is good, so that you can focus and meter your subject at the same time.

Spot metering is useful when the subject is the only thing in the frame that you want the camera to expose for. For example, when you are photographing a subject on a completely white or black background, you need not be concerned with preserving detail in the background; therefore, exposing just for the subject works out perfectly. One instance where this mode works well is when doing concert photography where the musician or singer is lit by a bright spotlight. You can capture every detail of the subject and just let the shadow areas go black.

Autofocus Modes

For shooting still photos the Nikon D3100 has three autofocus (AF) modes: Continuous (AF-C), Single (AF-S), and Auto (AF-A). Each mode is useful for different types of shooting conditions, from sports to still-life photographs. The AF modes can be changed in the Information Display menu or in the Shooting menu. Most lenses that work with the D3100, such as the kit lens, also have a switch to enable you to toggle from AF to Manual focus.

 Only Nikon AF-S lenses or third-party lenses with equivalent built-in motors will autofocus with the D3100.

Continuous

When the camera is set to Continuous AF (AF-C), as long as the Shutter Release button is halfway pressed, the camera continues to focus. If the subject moves, the camera activates Predictive Focus Tracking. With Predictive Focus Tracking on, the camera tracks the subject to maintain focus and attempts to predict where the subject will be by using previous distance measurements to estimate the speed at which the subject is moving. When in Continuous AF mode, by default, the camera fires when the Shutter Release button is pressed, whether or not the subject is in focus (this is known as *release priority*), so be aware that you may find yourself with more out-of-focus images. Some situations where AF-C is called for include the following:

▶ **Sports.** When photographing any type of sport you want to be sure that the camera is continuously focusing as you track the subject's movement.

▶ **Wildlife.** Animals can often be unpredictable and if you're photographing an animal or bird on the move, AF-C is essential to capturing a sharp shot.

Single

In Single AF (AF-S) mode, the camera focuses when the Shutter Release button is pressed halfway. When the camera achieves focus, the focus locks. The focus remains locked until you release the shutter or the Shutter Release button is no longer pressed. By default, the camera does not fire unless focus has been achieved (this is known as *focus priority*). This is the AF mode to use when the subject is relatively static and focus is critical. Some situations where you want to use AF-S include

▶ **Portraits.** When shooting portraits sharp focus is a necessity. Use single AF and focus on the subject's eye.

▶ **Landscapes.** When shooting landscapes use AF-S and focus on the horizon.

▶ **Still life and plants.** When shooting stationary objects select AF-S and focus on the most important detail in the composition.

Auto

When the camera is set to Auto mode (AF-A), it automatically chooses between AF-C and AF-S, depending on the subject. If the camera determines that your subject is not moving, it sets the focus mode to AF-S. If the camera detects a moving subject, it sets the focus mode to AF-C and focus tracking is activated. I find myself using this setting more often with this camera when I'm shooting casually. This mode is most useful when taking snapshots or candid photos of children or pets.

Manual

When set to Manual mode, the D3100 AF system is off. Focus is achieved by rotating the focus ring of the lens until the subject appears sharp when looking through the viewfinder. The Manual focus setting can be used when shooting still-life photographs or other nonmoving subjects, when you want total control of the focus, or simply when you are using a non-AF-S lens. Note that the camera shutter releases regardless of whether the scene is in focus.

When using the Manual focus setting, the D3100 offers a bit of assistance in the way of an electronic rangefinder. The electronic rangefinder can be viewed in the viewfinder display where the light meter is normally displayed.

 For more information on the electronic rangefinder, see Chapter 3.

I don't find myself using Manual focus a lot but there are times when it comes in handy, especially when focus is critical and you need to focus on a definite, well-defined area. Most of the time if I'm using Manual focus, my camera is on a tripod. A few instances where Manual focus may be beneficial include

- ▶ **Macro.** When shooting close up, your depth of field is very short. With macro photography, focusing on the most important part of the subject is very critical. Using Manual focus allows you and not the camera to determine *exactly* where the focus should be.

- ▶ **Portraits.** When shooting portraits, specifically headshots, focusing on the eye can be done manually. I suggest using Live View to zoom in and double check that the focus is right on.

AF Area Modes

The D3100 has inherited the Multi-CAM 1000 AF module from the professional-level D200 camera. The Multi-CAM 1000 is a very highly regarded and accurate focusing system. It features 11 focus points: one cross-type sensor, eight vertical sensors, and two horizontal sensors.

The D3100 has four AF area modes to choose from: Single-point AF, Dynamic-area AF, Auto-area AF, and 3D-tracking. AF area modes can be changed in the Information Display or the Shooting menu.

The D3100 employs 11 separate AF points. The 11 AF points can be used individually in Single-point AF mode, or you can choose one point and have it work in conjunction with the nonactive points when in Dynamic-area AF mode.

When set to 3D-tracking, the camera maintains sharp focus on a moving subject as it crosses the frame. With 3D-tracking, the camera recognizes distance, color, and light information and then uses it to track the subject across the frame.

Single-point AF mode

Single-point AF mode is the easiest mode to use when you're shooting slow-moving or completely still subjects. You can press the Multi-selector up, down, left, or right to choose one of the AF points. The camera only focuses on the subject if it's in the selected AF area. The selected AF point is displayed in the viewfinder. Use Single-point AF when focusing on a particular area is critical. Some instances where using a single AF point is beneficial include

> ► **Portraits.** Use the multi-selector to position the AF point over the subject's eye.

> ► **Macro, still life, and flowers.** Position the single AF point on the center of interest in the image.

> ► **Landscapes.** Generally you should position the AF point at the horizon line. If there is another feature such as a tree that you want to highlight, place the AF point there.

Dynamic-area AF mode

Dynamic-area AF mode also allows you to select the AF point manually, but unlike Single-point AF, the remaining unselected points remain active; this way, if the subject happens to move out of the selected focus area, the camera's highly sophisticated autofocus system can shift focus without selecting a new focus point.

 When you set the focus mode to AF-S (discussed earlier in this chapter), the mode operates exactly the same as if you were using Single-point AF. To take advantage of Dynamic-area AF, the camera must be set to AF-C mode.

This is a good general-purpose mode that works well for most everyday subjects such as children, pets, snapshots, and nearly anything that isn't moving around too much.

 If something else enters the frame when using Dynamic-area AF, the camera may shift focus to whatever has entered. Therefore be careful when using this mode in busy environments such as playgrounds.

3D-tracking mode

This mode has all 11 AF points active. You select the primary AF point, but if the subject moves, the camera uses 3D-tracking to automatically select a new primary AF point. The camera performs 3D-tracking by using distance and color information from the area immediately surrounding the focus point. The camera uses this information

to determine what the subject is, and if the subject moves, the camera selects a new focus point. This mode works very well for subjects moving unpredictably; however, you need to be sure that the subject and the background aren't similar in color.

I have problems with this mode, particularly when shooting team sports, particularly football and soccer, where all the players on a team generally wear the same-color uniforms. The AF points tend to jump from player to player. This is because the AF system can't accurately track the subjects due to the similar colors.

This mode works well only when the subject stands out significantly from the background and has good contrast. A few of the circumstances where I've found these modes to work well are

▶ **Sports.** This mode often works well with baseball because the players are close together for the most part. It also is a good choice when shooting motorsports, such as auto racing and motocross; single action sports, such as skateboarding; BMX, and snowboarding — basically any sport where the subject can be isolated.

▶ **Birds.** I've found that this mode works excellently when shooting flying birds, especially tracking them across a blue sky. If you've ever shot a bird in flight you'll appreciate this feature.

Auto-area AF

Auto-area AF mode is exactly what it sounds like: The camera automatically determines the subject and then chooses one or more AF points to lock focus.

Normally, I tend not to use a fully automatic setting such as this, but I've found that it works reasonably well and I can recommend using it when you shoot candid photos. When the camera is set to Single AF mode, the active AF points light up in the viewfinder for about 1 second when the camera attains focus; when in Continuous AF mode, no AF points appear in the viewfinder.

ISO Sensitivity

ISO, which stands for International Organization for Standardization, is the rating for the speed of film, or in digital terms, the sensitivity of the sensor. The ISO numbers are standardized, which allows you to be sure that when you shoot at ISO 100 you get the same exposure no matter what camera you use.

The ISO for your camera determines how sensitive the image sensor is to the light that is reaching it through the lens opening. Increasing or reducing the ISO affects the exposure by allowing you to use faster shutter speeds or smaller apertures (raising the ISO), or using a slower shutter speed or wider aperture (lowering the ISO).

The D3100 has a native ISO range from 100 to 3200. In addition to these native ISO settings, the D3100 also allows you to extend the range of the ISO setting by offering a setting called Hi 1, which is equivalent to an ISO of 6400, or Hi 2, which is equivalent to ISO 12,800. You can set the ISO on the D3100 by using the Information Display, or by going into the Shooting menu and choosing the ISO sensitivity settings option. The ISO can only be set in 1-stop increments.

 Using the Hi setting does not produce optimal results. Using the Hi 1 or 2 settings can cause your images to have an extremely high amount of noise and I recommend using them only as a last resort.

Auto ISO

The D3100 also offers a feature where the camera adjusts the ISO automatically for you when there isn't enough light to make a proper exposure. Auto ISO is meant to free you up from making decisions about when to raise the ISO. The Auto ISO can be set in the Shooting menu under the ISO sensitivity settings option.

You can limit how high the ISO can be set so that you can keep control of the noise created when a higher ISO is used.

If you manually set the ISO to 400, the Auto ISO function does not allow the ISO to go lower than ISO 400, no matter how bright the scene is. So when using the Auto ISO feature, be sure to set your ISO to 100 to ensure that you can get the full range of ISO settings.

Using Auto ISO can sometimes yield questionable results because you can't be sure what ISO adjustments the camera will make. So if you're going to use it, be sure to set it to conditions that you deem acceptable to ensure that your images will be neither blurry nor noisy.

In the past, I always eschewed using Auto ISO, but because the high ISO performance on Nikon's newest cameras is great, I have started using it frequently (actually, it's almost always on). It especially comes in handy when shooting concerts. This allows me to have a high ISO setting when the lighting is dim, but also reduces the ISO when the lights are turned up on the performer. This setting has actually been

quite helpful, allowing me to get many more usable concert photos than I did in the past when I cranked up the ISO and left it set high.

Be sure to set the following options in the Shooting menu/ISO sensitivity settings:

▶ **Maximum sensitivity.** Choose an ISO setting that allows you to get an acceptable amount of noise in your image. If you're not concerned about noisy images, then you can set it all the way up to Hi 2. If you need your images to have less noise, you can choose a lower ISO; the choices are 200, 400, 800, 1600, Hi 1, and Hi 2.

▶ **Minimum shutter speed.** This setting determines when the camera adjusts the ISO to a higher level. At the default, the camera bumps up the ISO when the shutter speed falls to 1/30 second. If you're using a longer lens or you're photographing moving subjects, you may need a faster shutter speed. In that case, you can set the minimum shutter speed up to 1/250 second. On the other hand, if you're not concerned about camera shake, or if you're using a tripod, you can set a shutter speed as slow as 1 second.

 The minimum shutter speed is only taken into account when using Programmed Auto or Aperture Priority modes.

 When the camera caps out on the maximum sensitivity and the light levels are low the camera *will* set the shutter speed lower than the minimum to avoid underexposures.

Noise reduction

Since the inception of digital cameras, they've been plagued with what is known as noise. *Noise,* simply put, is randomly colored dots that appear in your image. This is caused by extraneous electrons that are produced when your image is being recorded. When light strikes the image sensor in your D3100, electrons are produced. These electrons create an analog signal that is converted into a digital image by the analog-to-digital (A/D) converter in your camera.

There are two specific causes of noise. The first is heat-generated, or *thermal,* noise. While the shutter is open and your camera is recording an image, the sensor starts to generate a small amount of heat. This heat can free electrons from the sensor, which in turn contaminates the electrons that have been created as a result of the light striking the photocells on your sensor. This contamination shows up as noise.

The second cause of digital noise is known as *high ISO noise.* In any type of electronic device, there is background electrical noise. For the most part, it's very miniscule and you never notice it. Cranking up the ISO amplifies the signals your sensor is receiving. Unfortunately, as these signals are amplified, so is the background electrical noise. The higher your ISO, the more the background noise is amplified until it shows up as randomly colored specks.

Digital noise is composed of two elements: *chrominance* and *luminance.* Chrominance refers to the colored specks, and luminance refers mainly to the size and shape of the noise.

Fortunately, with every new camera released, the technology gets better and better, and the D3100 is no exception. Thanks to the brand new Expeed 2 image processor, D3100 has one of the lowest signal-to-noise ratios of any

2.2 An example of noise

camera on the market; thus, you can shoot at ISO 1600 and not worry about excessive noise. In some of the older dSLR cameras, shooting at ISO 1600 produced a very noisy image that was not suitable for large prints.

Although the D3100 is very low in noise, there is noise there, especially when shooting above ISO 1600 or when using long exposure times. For this reason, most camera manufacturers have built-in noise reduction (NR) features. The D3100 has two types of NR: Long exposure NR and High ISO NR. Each one approaches the noise differently to help reduce it.

Although the D3100 employs two different types of NR, they are both controlled by one setting simply designated Noise Reduction. Noise Reduction can be turned on or off in the Shooting menu.

Long exposure NR

For any exposure from 8 seconds or longer the camera runs a noise-reduction algorithm. Basically, how this works is that the camera takes a second exposure, this time with the shutter closed, and compares the noise from this dark frame image to the original one. The camera then applies the NR. The noise reduction takes about the same amount of time to process as the length of the shutter speed; therefore, expect

to double the time it takes to make one exposure. While the camera is applying NR, the viewfinder displays a message that says "Job nr." No additional images can be taken until this process is finished. If the camera is switched off before the NR is finished, no noise reduction is applied. While the camera is processing, the memory card access lamp is lit and no other functions can be performed.

High ISO NR

Any image shot at ISO 800 or higher is run through the noise-reduction algorithm. This feature works by reducing the coloring in the chrominance of the noise and combining that with a bit of softening of the image to reduce the luminance noise.

 When shooting in RAW format, no actual noise reduction is applied to the image.

For the most part, I choose not to use in-camera NR features. In my opinion, the camera is very aggressive in the NR, and for that reason, there is a loss of detail. For most people, this is a minor quibble and not very noticeable, but for me, I'd rather keep all the available detail in my images and apply noise reduction in post-processing. This way, I can decide for myself how much to reduce the chrominance and luminance rather than letting the camera do it. The camera doesn't know whether you're going to print the image at a large size or just display it on-screen. I say it's better to be safe than sorry.

 Noise reduction can be applied in Capture NX2 or by using Adobe Photoshop Camera Raw or some other image-editing software.

White Balance

Light, whether it is sunlight, from an incandescent light bulb, fluorescent, or from a flash, has its own specific color. This color is measured using the Kelvin scale. This measurement is also known as *color temperature*. The white balance allows you to adjust the camera so that your images look natural no matter what the light source. Because white is the color that is most dramatically affected by the color temperature of the light source, this is what you base your settings on; hence the term *white balance*. The white balance can be changed in the Shooting menu or by pressing the WB button on the top of the camera and rotating the Main Command dial.

The term *color temperature* may sound strange to you. "How can a color have a temperature?" you might ask. Once you understand the Kelvin scale, things make a little more sense.

What is Kelvin?

Kelvin is a temperature scale, normally used in the fields of physics and astronomy, where absolute zero (0 K) denotes the absence of all heat energy. The concept is based on a mythical object called a *black body radiator*. Theoretically, as this black body radiator is heated, it starts to glow. As it is heated to a certain temperature, it glows a specific color. It is akin to heating a bar of iron with a torch. As the iron gets hotter, it turns red, then yellow, and then eventually white before it reaches its melting point (although the theoretical black body does not have a melting point).

The concept of Kelvin and color temperature is tricky because it is the opposite of what you likely think of as "warm" and "cool" colors. For example, on the Kelvin scale, red is the lowest temperature, increasing through orange, yellow, white, and to shades of blue, which are the highest temperatures. Humans tend to perceive reds, oranges, and yellows as warmer and white and bluish colors to be cold. However, physically speaking, the opposite is true as defined by the Kelvin scale.

White balance settings

Now that you know a little about the Kelvin scale, you can begin to explore the white balance settings. White balance is so important because it ensures that your images have a natural look. When dealing with different lighting sources, the color temperature of the source can have a drastic effect on the coloring of the subject.

For example, a standard light bulb casts a very yellow light; if the color temperature of the light bulb is not compensated for by introducing a bluish cast, the subject can look overly yellow and not quite right.

In order to adjust for the colorcast of the light source, the camera introduces a colorcast of the complete opposite color. For example, to combat the green color of a fluorescent lamp, the camera introduces a slight magenta cast to neutralize the green.

The D3100 has eight white balance settings:

AUTO **Auto.** This setting is best for most circumstances. The camera takes a reading of the ambient light and makes an automatic adjustment. This setting also works well when using a Nikon CLS-compatible Speedlight because the

color temperature is calculated to match the flash output. I actually recommend using this setting as opposed to the Flash WB setting.

PRE PRE. This setting allows you to choose a neutral object to measure for the white balance. It's best to choose an object that is either white or light gray. The PRE setting is best used under difficult lighting situations such as when there are two different light sources lighting the scene (mixed lighting). You can also use this setting to choose a WB setting from another photo on the memory card.

 Incandescent. Use this setting when the lighting is from a standard household light bulb.

 Fluorescent. Use this setting when the lighting is from a fluorescent-type lamp. You can also adjust for different types of fluorescent lamps, including high-pressure sodium and mercury vapor lamps. To make this adjustment, go to the Shooting menu and choose White Balance, and then Fluorescent. From there, use the Multi-selector to choose one of the seven types of lamps.

 Direct sunlight. Use this setting outdoors in the daylight.

 Flash. Use this setting when using the built-in Speedlight, a hot-shoe Speedlight, or external strobes.

 Cloudy. Use this setting under overcast skies.

 Shade. Use this setting when you are in the shade of a tree or a building, or even under an overhang or a bridge — any place where the sun is out but is being blocked.

 One accessory you can use to set your white balance is a gray card, which is included with this book. Simply put the gray card in the scene and adjust your white balance off of it. See Appendix C for more details.

Figures 2.3 to 2.9 show the different results of using the white balance settings.

2.3 Auto, 5800 K

2.4 Incandescent, 2850 K

2.5 Fluorescent, 3800 K

2.6 Flash, 5500 K

2.7 Daylight, 5500 K

2.8 Cloudy, 6500 K

2.9 Shade, 7500 K

Picture Controls

With the release of the D3 and the D300, Nikon introduced its Picture Control System. All subsequent cameras, including the D3100, have also been equipped with this handy option. This feature allows you to quickly adjust your image settings, including sharpening, contrast, brightness, saturation, and hue, based on your shooting needs. This is great for photographers who shoot more than one camera and do batch processing to their images. It allows both cameras to record the images the same, so global image correction can be applied without worrying about differences in color, tone, saturation, and sharpening.

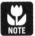 If you use Adobe Camera Raw or some other non-Nikon software to open your .NEF (RAW) files the Picture Control settings are *not* applied. You *must* use Nikon software to recognize Picture Controls in RAW files.

Picture Controls can also be saved to the memory card and imported into Nikon's image-editing software, Capture NX2 or View NX2. You can then apply the settings to RAW images or even to images taken with other camera models. These Picture Control files can also be saved to a memory card and shared with other Nikon users, either by importing them into Nikon software or loading them directly to another camera.

Original Picture Controls

Right out of the box, the D3100 comes with six Picture Controls installed.

▶ **SD.** This is the Standard setting. This applies slight sharpening and a small boost of contrast and saturation. This is the recommended setting for most shooting situations.

▶ **NL.** This is the Neutral setting. This setting applies a small amount of sharpening and no other modifications to the image. This setting is preferable if you do extensive post-processing to your images.

▶ **VI.** This is also referred to as the Vivid setting. This setting gives your images a fair amount of sharpening, and the contrast and saturation are greatly boosted, resulting in brightly colored images. This setting is recommended for printing directly from the camera or flash card. Personally, I feel that this mode is a little too saturated and often results in unnatural color tones. This mode is not recommended for portrait situations, as skin tones are not reproduced well.

▶ **MC.** This is the Monochrome setting. As the name implies, this option makes the images monochrome. This doesn't simply mean black and white; you can also simulate photo filters and toned images such as sepia, cyanotype, and more.

 When shooting MC in RAW a color file is saved. If the image is opened using non-Nikon software the images will revert to color.

▶ **PT.** This is the setting for Portraits. This gives you just a small amount of sharpening, which gives the skin a smoother appearance. The colors are muted just a bit to help achieve realistic skin tones.

▶ **LS.** This is the Landscape setting. Obviously, this setting is for shooting landscapes and natural vistas. The saturation of the blues and greens is boosted.

Custom Picture Controls

All the original Picture Controls can be customized to fit your personal preferences. You can adjust the settings to your liking, giving the images more sharpening and less contrast or choosing from a myriad of other options.

 Although you can adjust the original Picture Controls, you cannot save over them, and so there is no need to worry about losing them.

There are a few different customizations to choose from:

▶ **Quick adjust.** This option is not available with the NL setting. This option exaggerates or deemphasizes the effect of the Picture Control in use. Quick adjust can be set from ±2.

▶ **Sharpening.** This setting controls the apparent sharpness of your images. You can adjust this setting from 0–9, with 9 being the highest level of sharpness. You can also set this to Auto (A) to allow the camera's imaging processor to decide how much sharpening to apply. Setting this too high can cause things in your image to appear to have halos around them so be careful how high you set this.

▶ **Contrast.** This setting controls the amount of contrast your images are given. In photos of scenes with high contrast (sunny days), you may want to adjust the contrast down; in low-contrast scenes, you may want to add some contrast by adjusting the settings up. You can set this from ±3 or to A.

▶ **Saturation.** This setting controls how vivid or bright the colors in your images are. You can set this between ±3 or to A. This option is not available in the MC setting.

▶ **Hue.** This setting controls how your colors look. You can choose ±3. Positive numbers make the reds look more orange, the blues look more purple, and the greens look more blue. Choosing a negative number causes the reds to look more purple, the blues to look more green, and the greens to look more yellow. This setting is not available in the MC Picture Control setting. I highly recommend leaving this in the default setting of 0.

▶ **Filter Effects.** This setting is only available when set to MC. The monochrome filters approximate the types of filters traditionally used with black-and-white film. These filters increase contrast and create special effects. The options are

 • **Yellow.** This adds a low level of contrast. It causes the sky to appear slightly darker than normal and anything yellow to appear lighter.

 • **Orange.** This adds a medium amount of contrast. The sky appears darker, giving greater separation between the clouds. Orange objects appear light gray.

 • **Red.** This adds a great amount of contrast, drastically darkening the sky while allowing the clouds to remain white. Red objects appear lighter than normal.

 • **Green.** This darkens the sky and lightens any green plant life. This color filter can be used for portraits as it softens skin tones.

▶ **Toning.** This setting adds a color tint to your monochrome (black-and-white) images.

 • **B&W.** The Black-and-White option simulates the traditional black-and-white film prints done in a darkroom. The camera records the image in black, white, and shades of gray. This mode is suitable for use when the color of

the subject is not important. It can be used for artistic purposes or, as with the Sepia mode, to give your image an antique or vintage look.

- **Sepia.** The Sepia color option duplicates a photographic toning process that is done in a traditional darkroom using silver-based black-and-white prints. You may want to use this option when trying to convey a feeling of antiquity or nostalgia to your photograph. This option works well with portraits as well as still life and architecture. You can also adjust the saturation of the toning from 1 to 7, with 4 being the default and the middle ground.

NOTE Sepia-toning a photographic image requires replacing the silver in the emulsion of the photo paper with a different silver compound, thus changing the color or tone of the photograph. In the past photographs were sometimes treated to this type of toning; therefore, the sepia color option gives the image an antique look. The images have a reddish-brown look to them.

- **Cyanotype.** The Cyanotype is another old photographic printing process. The images taken when in this setting are in shades of cyan. Because cyan is considered to be a cool color, this mode is also referred to as cool. This mode can be used to make very interesting and artistic images. You can also adjust the saturation of the toning from 1 to 7, with 4 being the default setting.

2.10 Black and white **2.11 Sepia**

2.12 Cyanotype

2.13 Color toning green

> **NOTE** Cyanotype is one of the oldest printing processes. When exposed to the light, the chemicals that make up the cyanotype turn a deep blue color. This method was used to create the first blueprints and was later adapted to photography.

▶ **Color toning.** You can also choose to add colors to your monochrome images. Although this is similar to sepia and cyanotype, this type of toning isn't based on traditional photographic processes. This is simply adding a colorcast to a black-and-white image. There are seven color options you can choose from: red, yellow, green, blue-green, blue, purple-blue, and red-purple. As with Sepia and Cyanotype, you can adjust the saturation of these toning colors.

To customize an original Picture Control, follow these steps:

1. **Go to the Set Picture Control option in the Shooting menu.** Press the multi-selector right.

2. **Choose the Picture Control you want to adjust.** For small adjustments, choose the NL or SD option. To make larger changes to color and sharpness, choose the VI mode. To make adjustments to monochrome images, choose MC. Press the multi-selector right.

3. **Press the multi-selector up or down to highlight the setting you want to adjust (sharpening, contrast, and so on).** When the setting is highlighted, press the multi-selector left or right to adjust the settings. Repeat this step until you've adjusted the settings to your preferences.

4. **Press the OK button to save the settings.**

 When the original Picture Control settings have been altered, an asterisk is displayed with the Picture Control setting (SD*, VI*, and so on).

To restore a Picture Control to default settings, follow these steps:

1. **Go to the Set Picture Control option in the Shooting menu.** Press the multi-selector right.

2. **Choose the Picture Control you want to reset.** Press the multi-selector right.

3. **Press the Delete (trashcan) button.** A dialog box asking for confirmation is displayed.

4. **Select Yes, and press the OK button to reset the Picture Control.** This brings you back to the adjustment menu. Press the Menu button or tap the Shutter Release button to exit.

Understanding JPEG Compression

JPEG, which stands for Joint Photographic Experts Group, is a method of compressing photographic files and also the name of the file format that supports this type of compression. The JPEG is the most common type of file used to save images on digital cameras. Due to the small size of the file that is created and the relatively good image quality it produces, JPEG has become the default file format for most digital cameras. The JPEG compression format came into being because of the immense file sizes that digital images produce. Photographic files contain millions upon millions of separate colors, and each individual color is assigned a number; this causes the files to contain vast amounts of data, therefore making the file size quite large.

In the early days of digital imaging, these huge file sizes made it almost impossible for most people to store any number of images on their computers, which usually had relatively small storage capacities. Less than ten years ago, a standard laptop hard drive was only about 5GB. To efficiently store images, there needed to be some sort of file that could be compressed without losing too much of the image data during reconstruction of the file. Enter the Joint Photographic Experts Group. This group of experts designed what is now affectionately known as the JPEG.

The one problem with JPEG compression is that it is *lossy* compression, meaning that it loses information. For the most part, this loss of information is imperceptible to the human eye. The real problem with JPEGs comes from what is known as *generation loss*. Every time a JPEG is opened and resaved, a small amount of detail is lost. After multiple openings and savings, the quality of the image starts to deteriorate as less and less information is available. Eventually, the image may start to look pixelated or jagged (this is known as a JPEG artifact). Obviously, this can be a problem, but the JPEG would have to be opened and resaved many hundreds of times before you would notice a drop in image quality as long you save at high-quality settings.

One very convenient aspect to JPEG files is that they need no post-processing and can be immediately uploaded to the Internet or e-mailed. You can also print JPEG files straight from your camera or memory card using a pict-bridge compatible printer.

Image size

When saving a file as a JPEG, the D3100 allows you to choose an image size. Reducing the image size is like reducing the resolution on your camera: It allows you to fit more images on your card. The size you choose depends on what your output is going to be.

If you know you'll be printing your images at a large size, then you definitely want to record large JPEGs. If you're going to print at a smaller size (8 × 10 or 5 × 7), you can get away with recording at the Medium or Small setting. Image size is expressed in pixel dimensions. The Large setting records your images at 4608 × 3702 pixels; this gives you a file that's equivalent to a 14-megapixel image. The Medium setting gives you an image of 3456 × 2304 pixels, which is in effect the same as an 8-megapixel camera. The Small size setting gives you a dimension of 2304 × 1536 pixels, which gives you about a 3.5-megapixel image.

 Image size can only be changed when using the JPEG file format. RAW files are recorded only at the largest size.

Image quality

For JPEGs, in addition to the size setting that changes the pixel dimension, you have the Quality setting, which lets you decide how much of a compression ratio to apply to your JPEG image. Your choices are Fine, Normal, and Basic. JPEG Fine files are compressed to approximately 1:4, Normal to about 1:8, and Basic to about 1:16.

The more compression is applied to the JPEG, the smaller the file size. This reduced file size comes at a cost, though; highly compressed images can suffer from JPEG artifacts.

NEF or RAW Flexibility

Nikon's RAW files are referred to as NEF in Nikon literature. NEF stands for *Nikon Electronic File.* RAW files contain all the image data acquired by the camera's sensor. When a JPEG is created, the camera applies different settings to the image such as white balance, sharpness, noise reduction, and so on.

When the JPEG is saved, the rest of the unused image data is discarded to help ensure a smaller file size. With a RAW file, this image data is saved so that it can be used more extensively in post-processing. In some ways, the RAW file is like a digital negative, in which the RAW files are used in the same way as a traditional photographic negative; that is, you take the RAW information and process it in order to create your final image.

Although some of the same settings are tagged to the RAW file (WB, sharpening, saturation, and so on), these settings aren't fixed and applied as in the JPEG file; as a result, later on, when you import the RAW file into your favorite RAW converter, you can make changes to these settings with no detrimental effects.

Recording your images in RAW format allows you to be more flexible when post-processing your images and generally gives you more control over the quality of the images.

The D3100 saves its RAW files as compressed NEFs. Similar to JPEG compression, some of the image data is lost when these types of files are compressed. The complex algorithms they use to create these files actually run two compression schemes to the same file.

Because our eyes perceive changes in the darker areas of images more than in the lighter areas, the image data for the shadow areas is compressed using a lossless compression, while the midtones and lighter areas are compressed using a lossy method. This compression scheme has very little impact on the image data and allows you to be sure that you retain all of your shadow detail. Compressed RAW files allow the file size to be about 30 to 60 percent less than an uncompressed file.

RAW versus JPEG

This issue has caused quite a controversy in the digital-imaging world, with some people saying that RAW is the only way to go to have more flexibility in processing images, and others saying that if you get it right in-camera, then you don't need to use RAW images. For what it's worth, both factions are right in their own way.

continued

continued

Choosing between RAW and JPEG basically comes down to the final output, or what you're using the images for. Remember that you don't have to choose one file format and stick with it. You can change the settings to suit your needs as you see fit, or you can even choose to record both RAW and JPEG simultaneously.

Here are some reasons to shoot JPEG files:

▶ **Small file size.** JPEGs are much smaller in size than RAW files; therefore, you can fit many more of them on your SD card and later on your hard drive. If space limitations are a problem, shooting JPEG allows you to get more images in less space.

▶ **Printing straight from the camera.** Some people like to print their images straight from the camera or SD card. RAW files can't be printed without first being converted to JPEGs.

▶ **Continuous shooting.** JPEG files, being smaller than RAW files, don't fill up the camera's buffer as quickly, allowing you longer bursts without the frame rate slowing down.

▶ **Less post-processing.** If you're confident in your ability to get the image exactly as you want it at capture, then you can save yourself time by not having to process the image in a RAW converter and save straight to JPEG.

▶ **Snapshots.** JPEG is a good choice if you're just shooting snapshots of family events or if you only plan to post your images on the Internet.

Here are some reasons to shoot RAW files:

▶ **16-bit images.** When converting the file using a RAW converter such as Adobe Camera Raw (ACR) or Capture NX2, you can save your images with 16-bit color information. (When the information is written to JPEG in-camera, the JPEG is saved as an 8-bit file.) This gives you the option of working with more colors in post-processing. This can be extremely helpful when trying to save an under- or overexposed image.

▶ **White balance.** Although the WB that the camera was set to is tagged in the RAW file, it isn't fixed in the image data. Often, the camera can record a WB that isn't quite correct. This isn't always noticeable by looking at the image on the preview. Changing the WB on a JPEG image can cause posterization and usually doesn't yield the best results. Because you have the RAW image data on hand, changing the WB settings doesn't degrade the image at all.

▶ **Sharpening and saturation.** As with WB, these settings are tagged in the RAW file but not applied to the actual image data. You can add sharpening and saturation (or other options, depending on your software).

Exploring the Nikon D3100 Menus

This chapter delves in depth into the menu options. Here you can tailor the D3100 options to fit your shooting style or to make adjustments to refine the camera settings to fit different shooting scenarios.

The D3100 has quite a few customizable features to make taking pictures much easier for you. You can assign buttons to different functions that you find yourself using frequently. Using the Recent Settings menu you can access settings that you have changed recently.

The menus are accessed by pressing the Menu button on the back of the camera. Use the multi-selector to scroll through the toolbar on the left side of the LCD. When the desired menu is highlighted in yellow, press the OK button or multi-selector right to enter the menu. Pressing the Menu button again or tapping the Shutter Release button exits the Menu mode screen and readies the camera for shooting.

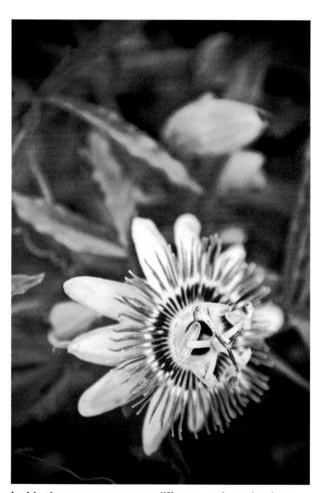

Inside the menus are many different options that let you create dynamic images.

Playback Menu

The Playback menu is where you manage the images stored on the SD card. The Playback menu is also where you control how the images are displayed and what image information is displayed during review. There are seven options available from the Playback menu, which are explained in the following sections. The Playback menu is represented by a Play button icon, similar to the one you would find on a DVD player.

Delete

This option allows you to delete selected images from your memory card or to delete all the images at once. To delete selected images, choose delete from the Playback menu and follow these steps:

1. **Press the multi-selector right, highlight Selected (default), and press the multi-selector to the right again.** The camera displays an image selection screen. You can now select the image you want to delete.

2. **Use the multi-selector left or right to choose the image.** You can also use the Zoom in button to review the image close up before deleting.

3. **Press the Thumbnail/Zoom out button to set the image for deletion.** More than one image can be selected. When the image is selected for deletion it shows a small trashcan icon in the right-hand corner.

4. **Press the OK button to erase the selected images.** The camera asks you for confirmation before deleting the images.

5. **Select Yes, and then press the OK button to delete.** To cancel the deletion, highlight No (default), and then press the OK button.

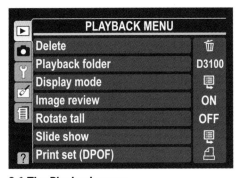

3.1 The Playback menu

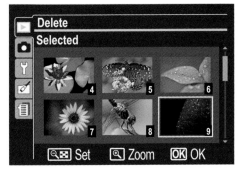

3.2 Selecting images to delete

You can also choose to delete all images that were taken on a certain date by following these steps:

1. **Choose Select date from the Delete options in the Playback menu and then press the multi-selector right.**

2. **A list of dates is shown along with a thumbnail of one of the images that was taken on that day.** To view all the images taken on that date, press the Thumbnail/Zoom out button. Use the multi-selector to browse the images. The Zoom in button can be used to take a closer look at any of the images.

3. **Press OK to select the set for deletion.**

4. **Press the multi-selector right to set or unset the date.** A small box is shown next to the date when a check mark is shown in the box for the images taken on that date that are selected for deletion.

5. **Press the OK button to delete.** A confirmation screen is displayed. Select Yes to delete the images or No to cancel the action.

To delete all images, select Delete from the Playback menu and follow these steps.

1. **Use the multi-selector to highlight All, and then press the OK button.** The camera asks you for confirmation before deleting the images.

2. **Select Yes, and then press the OK button to delete.** To cancel deletion, highlight No (this is the default setting), and then press the OK button.

 Protected and hidden images aren't deleted when using the Delete All option.

Playback folder

The Nikon D3100 automatically creates folders to store your images in. The main folder that the camera creates is called DCIM; within this folder the camera creates subfolders in which to store the images. The first subfolder the camera creates is titled 100D3100. After shooting 999 images the camera automatically creates another folder, 101D3100, and so on. Use this menu to choose which folder or folders to display images from. Keep in mind that if you have used the memory card in another camera and have not formatted it, there will be additional folders on the card (ND200, ND50, and so on).

There are two choices:

▶ **Current.** This option displays images only from the folder that the camera is currently saving to. This feature is useful when you have multiple folders from different sessions. Using this setting allows you to preview only the most current images. The current folder can be changed using the Active folder option in the Setup menu.

▶ **All.** This option plays back images from all folders that are on the SD card regardless of whether they were created by the D3100.

Display mode

There is quite a bit of image information that is available for you to see when you review images. The Display mode settings allow you to customize the information that is shown when reviewing the images that are stored on your SD card. Enter the Display mode menu by pressing the multi-selector right. Then use the multi-selector to highlight the option you want to set. When the option is highlighted, press the multi-selector right or the OK button to set the display feature. The feature is set when a check mark appears in the box to the left of the setting. Be sure to scroll up to Done and press OK to set. If this step is not done the information will not appear in the display.

The Display mode options are

▶ **Highlights.** When this option is activated any highlights that are blown out will blink. If this happens you may want to apply some exposure compensation or reduce your exposure to be sure to capture highlight detail.

▶ **RGB Histogram.** When this option is turned on you can view the separate histograms for the Red, Green, and Blue channels along with a standard luminance histogram.

▶ **Data.** This option allows you to review the shooting data (metering, exposure, lens focal length, and so on).

Generally, the only setting that I use is the RGB Histogram. I can usually tell from the histograms whether the highlights are blown out.

 For more information on using histograms, see Chapter 4.

Also inside the Display mode menu is an option called Transition effects. This allows you to add slide show–like effects to your images when scrolling through them. While

these effects might be good if you are playing back images to your friends with the camera hooked up to an HDTV, when simply reviewing your images I find that these effects slow down the playback function. For these reasons I recommend keeping this option off for the most part. The transition effects available are

▶ **Slide in.** When this is selected the images appear to slide into the frame from either side (depending on which way you're scrolling).

▶ **Zoom/fade.** This option causes the images to appear to float toward you and fade in when pressing the multi-selector right and float away from you when pressing the multi-selector left.

▶ **None.** This option simply displays the next image instantly. It's the quickest way to scroll through your images when viewing them.

Image review

Typically, when you take a picture, you want the image to display automatically. This allows you to review the image to check the exposure, framing, and sharpness. There are times, however, when you may not want the images to be displayed. You can turn this option off to conserve battery power (the LCD is actually the biggest drain on your battery).

Rotate tall

The D3100 has a built-in sensor that can tell whether the camera was rotated while the image was taken. When set to On, this setting rotates images that are shot in portrait orientation to be displayed upright on the LCD screen. I usually turn this option off, which is the default, because the portrait orientation image appears substantially smaller when displayed upright on the LCD.

Slide show

This allows you to display a slide show of images from the current active folder. You can use this to review the images that you have shot without having to use the multi-selector. This is also a good way to show friends or clients your images. You can even connect the camera to a TV to view the slide show on a big screen. You can choose an interval of 2, 3, 5, or 10 seconds.

There's also an option where you can select how each frame is transitioned to the next. Selecting the Transitions effects option allows you to choose three different transitions.

▶ **Zoom / fade.** When this option is selected the current image fades into the next image in line with a cool zoom effect.

▶ **Cube.** This option presents a spinning cube with the current picture on one side and the upcoming image on another.

▶ **None.** This option simply allows the images to appear without any sort of transition at all.

While the slide show is in progress, you can use the multi-selector to skip forward or backward (left or right), and view shooting info or histograms (up or down). You can also press the Menu button to return to the Playback menu, press the Playback button to end the slide show, or press the Shutter Release button lightly to return to the Shooting mode.

Pressing OK while the slide show is in progress pauses the slide show and offers you the options of restarting the slide show, changing the frame rate, or exiting the slide show. Use the multi-selector up and down to make your selection, and then press OK to make your selection.

Print set (DPOF)

DPOF stands for *Digital Print Order Format*. This option allows you to select images to be printed directly from the camera. This can be used with Pict-bridge-compatible printers or DPOF-compatible devices such as a photo kiosk at your local photo printing shop. This is a pretty handy feature if you don't have a printer at home and want to get some prints made quickly, or if you do have a printer and want to print your photos without downloading them to your computer.

To create a print set

1. **Use the multi-selector to choose the Print set (DPOF) option, and then press the multi-selector right to enter the menu.**

2. **Use the multi-selector to highlight Select/set, and then press the multi-selector right to view thumbnails.** Press the Zoom in button to view a larger preview of the selected image.

3. **Use the multi-selector right/left to highlight an image to print.** When the desired image is highlighted, hold the Thumbnail/Zoom out button and press the multi-selector up or down to set the image and choose the number of prints you want of that specific image. You can choose from 1 to 99. The number of prints and a small printer icon appear on the thumbnail. Continue this procedure until

you have selected all the images that you want to print. Press the multi-selector down to reduce the number of prints and to remove it from the print set.

4. **Press the OK button.** A menu appears with three options:

 - **Done (default).** Press the OK button to save and print the images as they are.

 - **Data imprint.** Press the multi-selector right to set. A small check mark appears in the box next to the menu option. When this option is set, the shutter speed and aperture setting appear on the print.

 - **Imprint date.** Press the multi-selector right to set. A small check mark appears in the box next to the menu option. When this option is set, the date the image was taken appears on the print.

5. **If you choose to set the imprint options, be sure to return to the Done option and press the OK button to complete the print set.**

RAW files can't be added to a DPOF print set. If you shoot in RAW you can use the NEF (RAW) processing option in the Retouch menu to create a JPEG copy of the image that can be added to the DPOF print set.

Shooting Menu

The Shooting menu contains most of the controls that deal with your image settings. This is where you find the most important settings such as ISO, white balance, Active D-Lighting, noise reduction, and others. You also find the settings that deal with auto-focus (AF) and your release modes. A lot of the most commonly changed settings from this menu can also be accessed in the Information Display menu, which is covered later in the chapter. The Shooting menu is represented in the Menu tab by a camera icon.

Reset shooting options

Quite simply, this menu option resets all the Shooting menu options back to default. Throughout the rest of this section I note which setting is the default for each option.

Set Picture Control

This is a menu you might find yourself using quite often. Picture Controls allow you to choose how the images are processed in-camera and they can also be used in Nikon's

image-editing software, Nikon ViewNX and Nikon Capture NX2. These Picture Controls allow you to get the same results when using different cameras that are compatible with the Nikon Picture Control System.

This option is not available when the camera is set to any of the scene modes or the fully automatic modes.

There are six standard Nikon Picture Controls available in the D3100:

▶ **Standard (SD).** This applies slight sharpening and a small boost of contrast and saturation. This is the recommended setting for most shooting situations.

▶ **Neutral (NL).** This setting applies a small amount of sharpening and no other modifications to the image. This setting is preferable if you often do extensive post-processing to your images.

▶ **Vivid (VI).** This setting gives your images a fair amount of sharpening. The contrast and saturation are boosted dramatically, resulting in brightly colored images. This setting is recommended for printing directly from the camera or SD card as well as for shooting landscapes. Personally, I feel that this mode is a little too saturated and often results in unnatural color tones. This mode is not recommended for portrait situations, as skin tones are not reproduced well.

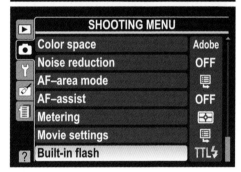

3.3 The Shooting menu

▶ **Monochrome (MC).** As the name implies, this option makes the images monochrome. This doesn't simply mean black and white, but you can also simulate photo filters and toned images such as sepia, cyanotype, and more.

▶ **Portrait (PT).** This setting gives your subject natural color and smooth skin tones.

▶ **Landscape (LS).** This Picture Control boosts the saturation of the greens and the blues for vibrant foliage and skies.

All these standard Nikon Picture Controls can be adjusted to suit your specific needs or tastes. In the color modes — SD, PT, NL, VI, and LS — you can adjust the sharpening, contrast, hue, and saturation. In MC mode you can adjust the sharpening, con-

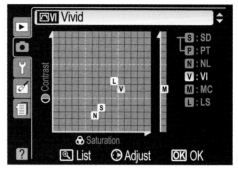

3.4 Picture Control grid

trast, filter effects, and toning. To adjust the Picture Control simply press the multi-selector right to see a sub-menu.

The D3100 also allows you to view a grid graph that shows you how each of the Picture Controls relates to each other in terms of contrast and saturation. Each Picture Control is displayed on the graph represented by a square icon with the letter of the Picture Control it corresponds to. Standard Picture Controls that have been modified are displayed with an asterisk next to the letter. Picture Controls that have been set with one or more auto settings are displayed in green with lines extending from the icon to show you that the settings will change depending on the images.

To view the Picture Control grid, follow these steps:

1. **Select the Set Picture Control option from the Shooting menu.** Press OK and the Picture Control list is displayed.

2. **Press the Thumbnail/Zoom out button to view the grid.** Once the Picture Control grid is displayed you can use the multi-selector to scroll though the different Picture Control settings.

3. **Once you have highlighted a setting, you can press the multi-selector right to adjust the settings or press OK to set the Picture Control.**

4. **Press the Menu button to exit back to the Shooting menu or tap the Shutter Release button to ready the camera for shooting.**

NOTE When saving to NEF the Picture Controls are embedded into the metadata. Only Nikon's software can use these settings. When opening RAW files using a third-party program such as Adobe Camera RAW in Photoshop the Picture Controls are not used.

Image quality

This menu option allows you to change the image quality of the file. You can choose from these options:

- ▶ **NEF (RAW) + JPEG basic.** This option saves two copies of the same image, one in RAW and one in JPEG with high compression.

- ▶ **NEF (RAW).** This option saves the images in RAW format.

- ▶ **JPEG fine.** This option saves the images in JPEG with minimal compression.

- ▶ **JPEG normal.** This option saves the images in JPEG with standard compression.

- ▶ **JPEG basic.** This option saves the images in JPEG with high compression.

These settings can also be changed in the Info display.

 For more detailed information on image quality, compression, and file formats, see Chapter 2.

Image size

This allows you to choose the size of the JPEG files. Change the image size depending on the intended output of the file or to save space on your memory card.

 Changing the image size to Medium or Small effectively reduces the resolution of the image.

The choices are

- ▶ **Large.** This setting gives you a full resolution image of 4608 × 3072 pixels or 14 megapixels.

- ▶ **Medium.** This setting gives you a resolution of 3456 × 2304 pixels or 8 megapixels.

- ▶ **Small.** This setting gives your images a resolution of 2304 × 1536 pixels or 3.5 megapixels.

 For more detailed information on image size, see Chapter 2.

The image size can also be changed in the Info display.

White balance

You can change the white balance (WB) options using this menu option. You can select a WB setting from the standard settings (auto, incandescent, fluorescent, direct sunlight, flash, cloudy, shade) or you can manually set the WB using the PRE setting.

 For detailed information on white balance settings and color temperature, see Chapter 2.

Using standard WB settings

To select one of the standard settings, choose the white balance option from the shooting menu, and then use the multi-selector button to highlight the preferred setting, and press the multi-selector right or the multi-selector center button. This brings up a new screen that gives you the option to fine-tune the standard setting. Displayed on this screen is a grid that allows you to adjust the color tint of the WB setting selected.

The horizontal axis of the grid allows you to adjust the color from amber to blue making the image warmer or cooler while the vertical axis of the grid allows you to change the tint by adding a magenta or green cast to the image. You can use the multi-selector to choose a setting from 1 to 6 in either direction; additionally, you can add points along the horizontal and vertical axes simultaneously. For example, you can add 4 points of amber to give it a

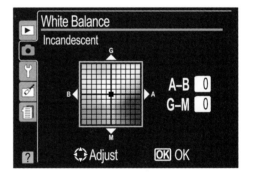

3.5 The WB fine-tuning grid

warmer tone and also add 2 points of green, shifting the amber tone more toward yellow.

Choosing the fluorescent setting brings up some additional menu options; you can choose among seven nonincandescent lighting types. This is handy if you know what specific type of fixture is being used. For example, I was shooting a night football game recently. I had the camera set to Auto WB, but I was getting very different colors from shot to shot and none of them looked right. Because I wasn't shooting RAW I needed to get more consistent shots. I knew that most outdoor sporting arenas used mercury-vapor lights to light the field at night. I selected the fluorescent WB setting from the Shooting menu and chose the #7 option: High temp. Mercury vapor. I took a few shots and noticed I was still getting a sickly greenish cast so I went back to the fine-tuning option and added 2 points of magenta to cancel out the green colorcast. This gave me an accurate and consistent color.

The seven settings are

▶ **Sodium-vapor lamps.** These are the types of lights often found in streetlights and parking lots. They emit a distinct deep yellow color.

▶ **Warm-white fluorescent.** These types of lamps give a white light with a bit of an amber cast to add some warmth to the scene. These lights burn at around 3000K, similar to an incandescent bulb.

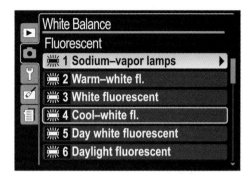

3.6 Fluorescent lamp options menu

▶ **White fluorescent.** These lights cast a very neutral white light at around 5200K.

▶ **Cool-white fluorescent.** As the name suggests, this type of lamp is a bit cooler than a white fluorescent lamp and has a color temperature of 4200K. This is the default setting.

▶ **Day white fluorescent.** This lamp approximates sunlight at about 5500K.

▶ **Daylight fluorescent.** This type of lamp gives you about the same color as daylight. This lamp burns at about 6300K.

▶ **Mercury-vapor.** These lights vary in temperature depending on the manufacturer and usually run between 4200 and 5200K.

Preset white balance

Preset white balance allows you to make and store up to five custom white balance settings. You can use this option when shooting in mixed lighting; for example, in a room with an incandescent light bulb and sunlight coming in through the window, or when the camera's auto white balance isn't quite getting the correct color.

You can set a custom white balance in two ways: direct measurement, which is when you take a reading from a neutral-colored object (the gray card included with the book works great for this) under the light source; or, copy from existing photograph, which allows you to choose a WB setting directly from an image that is stored on your memory card.

Direct measurement

To take a direct measurement for white balance, follow these steps:

1. **Place a neutral object (prefera-bly a gray card) under the light source you want to balance for.**

2. **Select white balance from the Shooting menu.** Use the multi-selector to scroll down to Preset manual and press OK. This brings up the white balance pre-set manual screen.

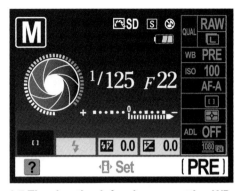

3. **Select Measure from the menu and press OK.** A dialog box is displayed asking you to confirm that you want to overwrite the existing preset. Select yes and press OK.

3.7 The shooting info when presetting WB

4. **Looking through the viewfinder, frame the reference object.** Press the Shutter Release button as if you were taking a photo.

5. **If the camera is successful in recording the white balance, "GD" flashes in the viewfinder control panel and a "data acquired" message is displayed in the info settings on the LCD panel.** If the scene is too dark or too bright, the camera may not be able to set the WB; in this case No Gd flashes in the view-finder control panel and a message is displayed on the LCD, "Unable to measure preset white balance. Please try again." Tap the Shutter Release button to clear the message, and take another reading. Adjust the exposure and reshoot.

TIP When presetting a custom WB, it's usually best to switch the camera to Manual focus because the AF system will have a hard time focusing on an object with little contrast, such as a gray card. You don't need to be in focus to set the WB.

Copy white balance from an existing photograph

You can copy the white balance setting from any photo that is saved on the memory card that's inserted into your camera. You can do this if you're shooting in a similar lighting situation or if you simply like the effect.

TIP If you have particular settings that you like, you may consider saving the images on a small memory card. This way you can always have your favorite WB pre-sets saved so you don't accidentally erase them from the camera.

1. **Press the menu button.** Use the multi-selector to choose white balance from the Shooting menu.

2. **Select Preset manual from the white balance menu.** Press the multi-selector button right or press OK to view the preset choices.

3. **Use the multi-selector to highlight Use photo.** You have two options; This image, which is the current image being used for WB reference (either selected from the camera or custom shot), or Select image.

4. **Use the multi-selector to highlight Select image.** Press OK and the folders on the SD card are displayed. Highlight the appropriate folder and press OK.

5. **The LCD displays thumbnails of the images saved to your SD card.** This is similar to the Delete and DPOF thumbnail display. Use the multi-selector directional buttons to scroll through the images. You can zoom in on the highlighted image by pressing the Zoom in button.

6. **Once the desired image is highlighted, press OK.** Select this image and press OK to save the setting or choose Select image to choose a different photo.

ISO sensitivity settings

This menu option allows you to set the ISO sensitivity. This is also where you set the parameters for the Auto ISO feature.

For more information on ISO settings and Auto ISO, see Chapter 2.

Active D-Lighting

Active D-Lighting is a setting that is designed to help ensure that you retain highlight detail when shooting in a high-contrast situation, such as shooting a picture in direct bright sunlight, which can cause dark shadows and bright highlight areas. Active D-Lighting basically tells your camera to underexpose the image a bit; this underexposure helps keep the highlights from becoming blown out and losing detail. The D3100 also uses a subtle adjustment to avoid losing any detail in the shadow area that the underexposure may cause.

Active D-Lighting is a separate and different setting than the D-Lighting option found in the Retouch menu. For more information on standard D-Lighting, see Chapter 9.

Using Active D-Lighting changes all the Picture Control brightness and contrast set-tings to Auto; adjusting the brightness and contrast is how Active D-Lighting keeps detail in the shadow areas.

When using Active D-Lighting, some extra time is required to process the images. Because your buffer fills up more quickly when shooting continuously, expect shorter burst rates.

Auto distortion control

All lenses have some sort of distortion. It is just part of the nature of creating optics. More-expensive lenses control this distortion pretty well, but even those lenses have a little bit of distortion. There are two types of lens distortions:

▶ **Barrel distortion.** This type of distortion shows up in wide-angle lenses (or wide-angle settings in zoom lenses). Barrel distortion causes the sides of the images to bulge outward (like a barrel).

▶ **Pincushion distortion.** This type of distortion is typical of longer focal lengths. This distortion is characterized by the image edges bowing inward.

For the most part, distortion is only noticeable in images with a lot of straight lines, especially when the lines are near the edges of the frame. The Auto distortion control uses in-camera software to compensate for the lens distortion. Please note that only Nikon lenses are supported for this feature and that not all Nikon lenses are sup-ported. All of the newest Nikon DX lenses are covered by this feature, including the kit lens and the very popular 35mm f/1.8G.

Color space

Color space simply describes the range of colors — also known as the gamut — that a device can reproduce. You have two choices of color spaces with the D3100: sRGB and Adobe RGB. The color space you choose depends on what the final output of your images will be.

▶ **sRGB.** This is a narrow color space, meaning that it deals with fewer colors than the larger Adobe RGB color space. The sRGB color space is designed to mimic the colors that can be reproduced on most low-end monitors and is more satu-rated than the Adobe RGB color space.

▶ **Adobe RGB.** This color space has a much broader color spectrum than is avail-able with sRGB. The Adobe gamut was designed for dealing with the color spec-trum that can be reproduced with most high-end printing equipment.

This leads to the question of which color space you should use. As I mentioned earlier, the color space you use depends on what the final output of your images is going to be. If you take pictures, download them straight to your computer, and typically only view them on your monitor or upload them for viewing on the Web, then sRGB will be fine. The sRGB color space is also useful when printing directly from the camera or memory card with no post-processing.

If you are going to have your photos printed professionally or you intend to do a bit of post-processing to your images, using the Adobe RGB color space is recommended. This allows you to have subtler control over the colors than is possible using a narrower color space like sRGB.

For the most part, I capture my images using the Adobe RGB color space. I then do my post-processing and make a decision on the output. Anything that I know I will be posting to the Web I convert to sRGB; anything destined for my printer is saved as Adobe RGB. I usually end up with two identical images saved with two different color spaces. Because most Web browsers don't recognize the Adobe RGB color space, any images saved as Adobe RGB and posted on the Internet usually appear dull.

Noise reduction

Quite simply this is where you turn on the Noise Reduction function. Noise reduction is covered in depth in Chapter 2.

AF area mode

This option is used to select the AF area mode, which controls how the focus point is selected. The AF area modes are also covered in more detail in Chapter 2.

 If the lens is switched to Manual focus the Focus mode and AF-area mode **NOTE** options are "grayed out" and unavailable in the menu.

Selecting the AF area mode from the menu gives you two options: Viewfinder and Live View. Viewfinder allows you to select the options for shooting stills when using the viewfinder and the other option is for Live View focusing. The choices for Viewfinder are

▶ **Single-point AF.** Select one focus point out of 11 using the multi-selector.

▶ **Dynamic-area AF.** Select a single focus point while keeping the surrounding points active in case the subject moves from the selected focus point.

▶ **Auto-area AF.** The camera automatically selects one or more focus points depending on the scene.

▶ **3D-tracking (11 points).** The camera uses all 11 points to track a moving subject across the frame by using color and distance information.

Choices for Live View/movie are

▶ **Face-Priority AF.** The camera uses face recognition to focus on any faces in the frame.

▶ **Wide-area AF.** The focus area is about 4X the size of the normal AF area setting.

▶ **Normal-area AF.** Use the multi-selector to choose a specific spot to focus on.

▶ **Subject-tracking AF.** The camera automatically uses color information to track the subject and move the focus point as the subject moves within the frame.

AF-assist

The AF-assist illuminator lights up when there isn't enough light for the camera to focus properly. The camera needs a certain amount of light for the AF to detect contrast in the subject.

In certain instances, even in low light, you may want to turn this option off, such as when shooting faraway subjects in dim settings (concerts or plays). When set to On, the AF-assist illuminator lights up in a low-light situation only when in AF-S mode and Auto-area AF is chosen. When in Single-point mode or Dynamic-area AF is chosen, the center AF point must be active.

When set to Off, the AF-assist illuminator does not light at all, even in dim lighting.

Metering

This option is used to select the type of exposure metering the camera uses to determine exposure. The choices are Matrix, Center-weighted, and Spot. Metering modes are covered in depth in Chapter 2.

Movie settings

This is where you choose the resolution of your movies, as well as adjust the sound settings. By default the camera records video at full resolution 1080p HD video. There are quite a few choices, and resolution sizes are discussed in more depth in Chapter 7.

Quality

This is the resolution of the images for watching on an HDTV, so recording at full 1080p resolution is advisable. For the Web, 720p is great, and for videos that will be e-mailed, 424p is sufficient.

Sound

The D3100 allows you to record sound with your video using the built-in microphone. Unfortunately the D3100 doesn't have the option of using an external microphone. There are two settings, On and Off.

Built-in flash

This option is used to set how the built-in flash determines the exposure. You can set it to TTL (default), which is the recommended setting, or you can choose to set the exposure manually (M). When Manual is selected a submenu is displayed that allows you to choose from six settings: Full, 1/2, 1/4, 1/8, 1/16, or 1/32.

 When the SB400 is attached to the camera and turned on, the Built-in flash menu changes to Optional flash, allowing the flash control on the SB400 to be changed from TTL to Manual.

 For more information on using flash and determining flash settings manually, see Chapter 6.

Setup Menu

The Setup menu contains options that don't get changed very much but a lot of them are pretty important. The settings control different things from the brightness of the LCD to controlling what function different buttons are assigned to.

Reset setup options

This option, as with the similar option in the Shooting menu, allows you to reset all the Setup menu options back to the default settings.

Format memory card

Formatting your card is a much more thorough way of erasing the images on your SD card. Formatting the card redefines the file directory of the card. Deleting images one by one or deleting all images at once leaves blank spaces on the card where image data is filled in as it is being captured. This can cause your image data to become fragmented; although this fragmentation doesn't necessarily cause problems, as the data becomes more and more fragmented the likelihood of your data being corrupted gets greater. Formatting the SD card allows the data to be written in a more organized way. The bottom line is that formatting the SD card should be done every time you are finished downloading your images.

LCD brightness

This menu sets the brightness of your LCD screen. You may want to make it brighter when viewing images in bright sunlight or make it dimmer when viewing images indoors or to save battery power. You can adjust the LCD ±3 levels. The menu shows a graph with ten bars from black to gray and on to white. The optimal setting is where you can see a distinct change in color tone in each of the bars. If the last two bars on the right blend together your LCD is too bright; if the last two bars on the left side blend together your LCD is too dark.

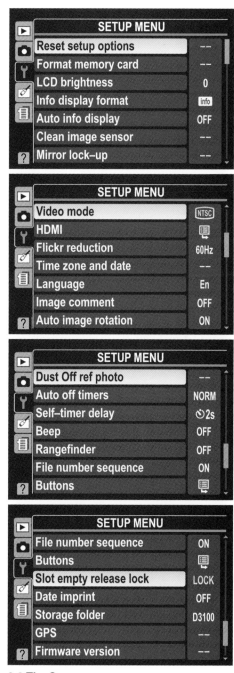

3.8 The Setup menu

Info display format

This menu option is how you set the different display options for the LCD shooting information. You can choose between displaying the shooting information in the Classic format or the Graphic format in three colors. The Graphic format allows you to see a visual representation of the shutter speed and aperture to give you a better idea of what the settings are. Additionally you can also choose for the camera to display the shooting information differently depending on whether you're using the Auto and scene modes or the P, S, A, or M modes. The default setting is the Graphic format.

Auto info display

Setting this to On (default) brings up the Info display when the Shutter Release button is half-pressed and released. When the camera is auto-focusing the display is turned off. The settings are set individually for P, S, A, and M modes and the Auto and scene modes. I prefer to keep mine turned off and press the Info button to display the screen if I need to see it.

Clean image sensor

This is a great feature that was released with the D300 and filtered down to the D3100. The camera uses ultrasonic vibration to knock any dust off the filter in front of the sensor. This helps keep some of the dust off of your sensor but is not going to keep it absolutely dust free forever. You may have to have the sensor professionally cleaned periodically.

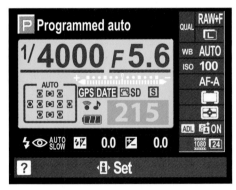

3.9 The Classic shooting information

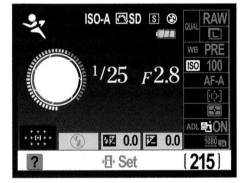

3.10 The Graphic shooting information

You can choose Clean now, which cleans the image sensor immediately, or you have four separate options for cleaning, which you access in the Clean at startup/shutdown option. These include

▶ **Startup.** The camera goes through the cleaning process immediately upon turning the camera on. This may delay your startup time a little bit.

▶ **Shutdown.** The camera goes through the cleaning process immediately upon turning the camera off.

▶ **Startup and shutdown.** The camera cleans the image sensor when the camera is turned on and also when it is powered down. This is the default setting.

▶ **Cleaning off.** This disables the sensor-cleaning feature unless activated manually.

Mirror lock-up

This locks up the mirror to allow access to the image sensor for inspection or for additional cleaning. The sensor is also powered down to reduce any static charge that may attract dust. Because it's a fairly simple process, some people prefer to clean their own sensor; however, especially for beginners, I recommend taking your camera to an authorized Nikon service center for any sensor cleaning. Any damage caused to the sensor by improper cleaning is NOT covered by warranty and can lead to a very expensive repair bill.

 This option is not available with the battery at less than 50 percent power.

Video mode

There are two options in this menu: NTSC and PAL. Without getting into too many specifics, these are types of standards for the resolution of televisions. All of North America, including Canada and Mexico, uses the NTSC standard, while most of Europe and Asia use the PAL standard. Check your television owner's manual for the specific setting if you plan to view your images on a TV directly from the camera.

HDMI

There are a couple of different sub-menu options in this section that allow you to control how your camera interacts when connected to an HDTV or monitor.

Output resolution

This allows you to adjust the output of your camera when playing back movies directly from your camera. There are five different options, Auto, 480p, 576p, 720p, or 1080i. If you know exactly what output resolution your HDTV or monitor accepts you can set it here, but I recommend leaving this setting to the default Auto. This lets the camera determine the output resolution.

Device Control

Some HD appliances allow you to control devices using the remote control. These devices are known as HDMI-CEC (High-Def Multimedia Interface – Consumer Electronics Control). The D3100 is compatible with these devices. When turned On, this allows you to browse your images using the TV remote control rather the camera's multi-selector.

Flicker reduction

When shooting under certain types of light, most notably fluorescent and mercury vapor, the video tends to flicker due to the normal fluctuation of the electrical cycle. There are two options here: 50 Hz and 60 Hz. In the U.S. and North America the proper setting is 60 Hz and in Europe the cycle is 50 Hz.

Time zone and date

This is where you set the camera's internal clock. You also select a time zone, choose the date display options, and turn the daylight-saving time options on or off.

Start by setting the time zone. The display shows a map and a list of cities in the time zone in case you are traveling and unsure of which time zone you're in. Next, set the date and time using the multi-selector left or right to scroll between the options (year, month, date, hour, minute, and seconds). Use the multi-selector up or down to change the settings. Press OK when finished.

You can also change the format in which the date is displayed. The choices are Y/M/D, M/D/Y, or D/M/Y.

For places that observe daylight saving time, there is an option to turn this on or off.

Language

This is where you set the language that the menus and dialog boxes display. English is the default language. If you accidentally change it, don't worry; English is marked clearly in English no matter what language is selected.

Image comment

You can use this feature to attach a comment to the images taken by your D3100. You can enter the text using the Input Comment menu. The comments can be viewed in Nikon's Capture NX2 or ViewNX software or can be viewed in the photo info on the camera. Setting the Attach comment option applies the comment to all images taken until this setting is disabled. Some comments you may want to attach are copyright information or your name, or even the location where the photos were taken.

Auto image rotation

This tells the camera to record the orientation of the camera when the photo is shot (portrait or landscape). This allows the camera and also image-editing software to show the photo in the proper orientation so you don't have to take the time in post-processing to rotate images shot in portrait orientation.

Dust Off ref photo

This option allows you to take a dust reference photo that shows any dust or debris that may be stuck to your sensor. Nikon Capture NX2 then uses the image to automatically retouch any subsequent photos where the specks appear. If you have a dusty sensor, this can save you a lot of time by having the retouching automatically applied for you.

To use this feature, either select Start or Clean sensor and then start. Next, you are instructed by a dialog box to take a photo of a bright featureless white object that is about 10 cm from the lens. The camera automatically sets the focus to infinity. A Dust Off reference photo can only be taken when using a CPU lens. It's recommended to use at least a 50mm lens, and when using a zoom lens you should zoom all the way in to the longest focal length.

Auto off timers

These four menu options are used to determine how long the camera's exposure meter and LCD monitor are active before turning off when no other actions are being performed. They include

▶ **Short.** When this option is selected, the menus and playback turn off after 8 seconds, the image review after 4 seconds, and the meter shuts off after 4 seconds. Live View shuts off after 30 seconds.

▸ **Normal.** When this option is selected, the menus and playback turn off after 12 seconds, the image review after 4 seconds, and the meter shuts off after 8 seconds. Live View shuts off after 30 seconds.

▸ **Long.** When this option is selected, the menus and playback turn off after 20 seconds, the image review after 20 seconds, and the meter shuts off after 60 seconds. Live View shuts off after 3 minutes.

▸ **Custom.** You can use this option to customize the auto off timer for each operation, Playback/menus, Image review, and Auto meter-off. The options for each are as follows:

- **Playback/menus.** 8 sec, 12 sec, 20 sec, 1 min, or 10 min

- **Image review.** 4 sec, 8 sec, 20 sec, 1 min, or 10 min

- **Live view.** 30 sec, 1min, 3 min, 5 min

- **Auto meter-off.** 4 sec, 8 sec, 20 sec, 1 min, or 30 min

Self-timer delay

This is where you set the delay time for the self-timer. As discussed earlier, the self-timer is handy for when you want to do a self-portrait and you need some time to get yourself into the frame. The self-timer can also be employed to reduce camera shake caused by pressing the Shutter Release button on long exposures. You can set this at 2 or 10 seconds.

Beep

When this option is on, the camera emits a beep when the self-timer is counting down or when the AF locks in Single focus mode. You can choose On or Off. For most photographers, this option is absolutely the first thing that gets turned off when the camera is taken out of the box. Although the beep can be kind of useful when in Self-timer mode, it's a pretty annoying option especially if you are photographing in a relatively quiet area.

Rangefinder

This option allows you to turn on the electronic rangefinder option, which helps you to determine if the camera is out of focus and, if it is, by approximately how far when you are manually focusing. When the Rangefinder option is turned on and the lens is set to Manual focus, this shows you a bar graph that indicates distance. When the subject is in focus, the bars are even on both sides of a 0. When the bars are displayed to the

left, this indicates that you are focused in front of the subject; bars to the right indicate that the focus is falling behind the subject. Use the focus ring to adjust the focus. The Rangefinder display is not available when shooting in Manual exposure mode. This is a handy feature when using a Manual focus lens or an older non-AF-S lens that doesn't autofocus with the D3100.

Lenses need to be f/5.6 or faster for the rangefinder to work.

You still need to select a focus point so that the camera can determine where the subject is.

File number sequence

The D3100 names files by sequentially numbering them. This option controls how the sequence is handled. When set to Off, the file numbers reset to 0001 when a new folder is created, a new memory card is inserted, or the existing memory card is formatted. When set to On, the camera continues to count up from the last number until the file number reaches 9999. The camera then returns to 0001 and counts up from there. When this is set to Reset, the camera starts at 0001 when the current folder is empty. If the current folder contains images, the camera starts at one number higher than the last image in the folder.

Buttons

This option allows you to customize a few different buttons so that you can quickly change settings depending on your preferences. There are three options.

▶ **Fn. button.** This button can be assigned a number of functions.

- **ISO sensitivity.** Pressing the button and rotating the Command dial changes the ISO sensitivity. This is the default setting.

- **Image quality/size.** Pressing the button and rotating the Command dial changes the image quality and size.

- **White balance.** Pressing the button and rotating the Command dial adjusts the white balance settings.

- **Active D-Lighting.** Pressing the button and rotating the Command dial turns Active D-Lighting on or off.

▶ **AE/AF Lock.** You can set this button to different types of settings that all relate to autoexposure or autofocus. The choices are: AE/AF Lock, AE Lock only, AF Lock only, AE Lock (hold), or AF-ON. AE Lock (hold) locks the exposure; one press of the button locks the exposure until the button is pressed again or the shutter is released. AF-ON engages the AF in the same way that half-pressing the Shutter Release button does.

▶ **AE Lock.** This setting allows you the option of locking the exposure when the Shutter Release button is half-pressed. This allows you to focus and take a meter reading of the subject and then recompose the shot without losing the proper exposure for the subject.

Slot empty release lock

By default, when no memory card is inserted into the camera, the shutter release is disabled. You can use this option to allow the shutter to release. The options are

▶ **LOCK.** This locks the shutter, not allowing the camera to fire.

▶ **OK.** This enables the shutter to be released when no SD card is in the camera.

It's very important to note here that if you set this to OK, the camera functions as if you were actually taking photos. There is even an image playback and the camera stores a number of images temporarily (I've shot up to 20, the number may be higher) until the camera is turned off. You *cannot* download these images, however, and a demo icon appears in the top left corner. I suggest that you keep this feature locked.

Date imprint

Turning on this option imprints your images with the date and/or time that they were shot. You can choose to imprint only the date, the time and date, or the date counter, which displays the number of days that have elapsed between the date that the picture was taken and a selected date.

 Once the date is imprinted, it cannot be removed except by cropping.

Storage folder

As discussed earlier, the D3100 automatically creates folders in which to store your images. The camera creates a folder named DCIM, and then stores the images in subfolders starting with folder 100D3100. When the folder gets 999 images in it, the

camera automatically starts a new folder. You can choose to rename this folder or change the folder that the camera is saving to. You can name this folder whatever you like. You can use this option to separate subjects into different folders. When I shoot SCCA sports car races, there are different groups of cars. I use a different folder for each group to make it easier to sort through the images later. If there are five groups, I start out naming my folder GRP1, then GRP2 for the second group, and so on. If you are on a road trip, you can save your images from each destination to separate folders. These are just a couple of different examples of how this feature can be used.

When selecting the active folder, you can choose a new folder or you can select a folder that has already been created. When you format your SD card, all preexisting folders are deleted and the camera creates a folder with whatever number the active folder is set to. So if you set it to a folder named ABC01, when the card is formatted the camera will create folder 100ABC01.

GPS

This option allows you to make a few changes to the settings that are only in effect when an optional GP-1 GPS unit is connected to the camera. There are two options:

Auto meter-off

This determines whether the camera's exposure meter turns off, or more succinctly, whether the camera "goes to sleep." If the camera goes to sleep the GPS unit loses the position and will need to reconnect with the GPS satellites when the camera "wakes up." Enable allows the camera to go to sleep after the time allotted in the Auto-off timer's menu with an additional minute added to allow GPS connection.

When the Disable option is selected, the camera does not go to sleep so that the GPS can stay in constant connection. This can cause your batteries to deplete faster than normal.

Position

This option is only available if the GP-1 is connected to the D3100. This displays the latitude and longitude as well as the altitude and heading. The current UTC date and time is also displayed.

 The UTC time and date is set by the GPS satellite and is independent of the camera clock.

Eye-fi upload

This option is only available when using an Eye-fi wireless SD card, which allows you to upload your images straight from your camera to your computer using your wireless router.

Firmware version

This menu option displays which firmware version your camera is currently operating under. Firmware is a computer program that is embedded in the camera that tells it how to function. Camera manufacturers routinely update the firmware to correct for any bugs or to make improvements on the camera's functions. Nikon posts firmware updates on its Web site at www.nikonusa.com.

Retouch Menu

The Retouch menu allows you to make changes and corrections to your images with the use of image-editing software. As a matter of fact, you don't even need to download your images. You can make all the changes in camera using the LCD preview (or hooked up to a TV if you prefer).

The options include D-Lighting, Red-eye correction, Trim, Monochrome, Color effects, Color balance, and Image overlay and movie edit.

 The Retouch Menu is discussed at length in Chapter 9.

Recent settings

This menu option saves your 20 most recently used settings for quick access. You can also remove the settings by using the multi-selector to highlight the setting and pressing the Delete (trashcan) button.

Essential Photography Concepts

In order to be a better photographer, it's important get down to the basics. Anyone can point a camera and take a good picture, but when you begin to understand the concepts you start *making* a photograph as opposed to just *taking* a picture. This chapter goes over many of the basic photography concepts that you need. If you're new to photography or dSLR cameras this provides you with the basic building blocks such as aperture and shutter speed; if you've got some experience with photography think of this chapter as a refresher with some advanced information on topics such as using histograms to evaluate your exposure and bracketing.

Understanding photographic concepts such as how aperture and distance relate to depth of field allows you to add creative elements to your images.

Understanding Exposure

Exposure is a very important aspect of photography. Understanding how exposure is calculated allows you to understand how your camera chooses the settings when using one of the semiautomatic modes such as Shutter Priority or Aperture Priority. Without this knowledge you will have trouble achieving a specific effect in your images.

By definition, *exposure* — as it relates to digital photography — is the total amount of light collected by the camera's sensor during a single shutter cycle. A *shutter cycle* occurs when the Shutter Release button is pressed, the shutter opens, closes, and resets. One shutter cycle occurs for each image (with the exception of multiple exposures, of course). An exposure is made of three elements that are all interrelated. Each depends on the others to create a proper exposure. If one of the elements changes, the others must increase or decrease proportionally or you no longer have an equivalent exposure. The following are the elements you need to consider.

▶ **Shutter speed.** The shutter speed determines the length of time the sensor is exposed to light.

▶ **ISO sensitivity.** The ISO setting you choose influences how sensitive your camera is to light.

▶ **Aperture/f-stop.** How much light enters your camera is controlled by the aperture, or f-stop. Each camera has an adjustable opening on the lens. As you change the aperture (the opening), you allow more or less light to enter the camera. The aperture can be compared to the iris of your eye.

Shutter speed

Shutter speed is the amount of time that light entering from the lens is allowed to expose the image sensor. Obviously, if the shutter is open longer, more light can reach the sensor. The shutter speed can also affect the sharpness of your images. When hand-holding the camera and using a longer focal-length lens such as 200mm, a faster shutter speed is required to counteract against camera shake from hand movement, which can cause blur (this is the effect that VR lenses were made to combat). When taking photographs in low light, a slow shutter speed is often required, which also causes blur from camera shake and/or fast-moving subjects.

 The guideline for hand-holding when shooting is that the shutter speed should be the reciprocal of the focal length. For example, a 200mm lens requires at least 1/200 shutter speed (without VR) to be sharp.

The shutter speed can also be used to effectively show motion in photography. Panning, or moving the camera horizontally along with a moving subject, while using a slower shutter speed can cause the background to blur while keeping the subject in focus. This is an effective way to portray motion. On the opposite end, using a fast shutter speed can freeze action such as the splash of the wave of a surfer, which can also give the illusion of motion in a still photograph.

Shutter speeds are indicated in fractions of a second. Common shutter speeds (from slow to fast) are: 1 second, 1/2, 1/4, 1/8, 1/15, 1/30, 1/60, 1/125, 1/250, 1/500, 1/1000, and so on. Increasing or decreasing shutter speed by one setting doubles or halves the exposure, respectively. The D3100 also allows you to adjust the shutter speed in 1/3-stops. It may seem like math (okay, technically it does involve math), but it is relatively easy to figure out. For example, if you take a picture with a 1/2-second shutter speed and it turns out too dark, logically you want to keep the shutter open longer to let in more light. To do this, you need to adjust the shutter speed to 1 second, which is the next full stop, letting in twice as much light.

4.1 For this image I used a relatively slow shutter speed of 1/100 second and panning to blur the background to provide an element of speed and movement to the photo.

ISO

The ISO is what used to commonly be referred to as film speed. The ISO sensitivity number tells how sensitive to light the medium is; in this case, the medium being the CMOS sensor. The higher the ISO number, the more sensitive it is and the less light

you need to take a photograph. For example, you might choose an ISO setting of 100 on a bright, sunny day when you are photographing outside because you have plenty of light. However, on a cloudy day you may want to consider an ISO of 400 to make sure your camera captures all the available light. This allows you to use a faster shutter speed should it be appropriate to the subject you are photographing.

It is helpful to know that each ISO setting is twice as sensitive to light as the previous setting. For example, at ISO 400 your camera is twice as sensitive to light as it is at ISO 200. This means it needs only half the light at ISO 400 that it needs at ISO 200 to achieve the same exposure.

 The term *ISO* is derived from the International Organization for Standardization, which is a sort of a governing body in the international manufacturing markets, helping to ensure similar products from different manufacturers perform in the same manner. This allowed photographers to purchase different brands of film knowing that the settings used on 100-speed Kodak film were the same settings used in equivalent light with 100-speed Fuji film.

Aperture

Aperture is the size of the opening in the lens that determines the amount of light that reaches the image sensor. The aperture is controlled by a diaphragm that operates in a similar fashion to the iris of your eye. Aperture is expressed as f-stop numbers, such as f/2.8, f/4, f/5.6, and f/8. Here are a couple of important things to know about aperture:

▶ **Smaller f-numbers equal wider apertures.** A small f-stop such as f/2.8, for example, opens the lens so more light reaches the sensor. If you have a wide aperture (opening), the amount of time the shutter needs to stay open to let light into the camera decreases.

▶ **Larger f-numbers equal narrower apertures.** A large f-stop, such as f/11 for example, closes the lens so less light reaches the sensor. If you have a narrow aperture (opening), the amount of time the shutter needs to stay open to let light into the camera increases.

I often get asked why the numbers of the aperture seem to be counterintuitive. The answer is relatively simple: The numbers are actually derived from ratios, which translate into fractions. The f-number is defined by the focal length of the lens divided by the actual diameter of the aperture opening. The simplest way to look at it is to put a 1 on top of the f-number as the numerator. For the simplest example, take a 50mm f/2 lens (Nikon doesn't actually make a 50mm f/2, but let's pretend for a minute). Take the

aperture number, f/2, and add 1 as the numerator. You get 1/2. This indicates that the aperture opening is half the diameter of the focal length, 25mm. So at f/4 the effective diameter of the aperture is 12.5mm. It's a pretty simple concept once you break it down.

 NOTE The terms *aperture* and *f-stop* are interchangeable.

As with ISO and shutter speed there are standard settings for aperture, each of which is a 1 stop difference from the other. The standard f-numbers are f/1.4, f/2, f/2.8, f/4, f/5.6, f/8, f/11, f/16, and f/22. At first glance these may appear to be a random assortment of numbers, but they aren't. Upon closer inspection you notice that every other number is a multiple of 2. When you break it down even further you find that each stop is a multiple of 1.4. This is where the standard f-stop numbers are derived from. Starting out with f/1, multiply by 1.4. You get f/1.4. Again multiply by 1.4; you get 2. Multiply by 1.4; you get 2.8, and so on.

 NOTE Although each stop is a multiple of 1.4, every full stop halves the amount of light entering the lens.

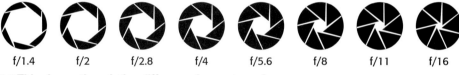

| f/1.4 | f/2 | f/2.8 | f/4 | f/5.6 | f/8 | f/11 | f/16 |

4.2 This shows the relative difference in aperture sizes.

Similar to the shutter speed settings, the Nikon D3100 also allows you to set the aperture in 1/3-stop increments.

NOTE In photographic vernacular, *opening up* refers to going from a smaller to a larger aperture and *stopping down* refers to going from a larger to smaller aperture.

Now that you know a little more about apertures, you can begin to look at why different aperture settings are used and the effect that they have on your images. The most common reason why a certain aperture is selected is to control the *depth of field* or how much of the image is in focus. Quite simply, using a wider aperture (f/1.4 to f/4) gives you a shallow depth of field allowing you to exercise *selective focus,* which means you can focus on a certain subject in the image while allowing the rest to fall out of focus.

4.3 This photo of my Boston terrier, Henrietta, was shot with a wide aperture of f/1.4 to achieve a shallow depth of field.

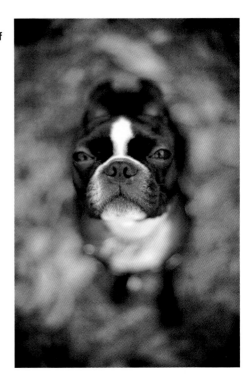

Conversely, using a small aperture (f/11 to f/32) maximizes your depth of field, allowing you to get everything in focus. Using a wider aperture is generally preferable to blur the background and draw attention to the subject when shooting portraits, and a smaller aperture is generally used when photographing landscapes to ensure that the whole scene is in focus. Depth of field is discussed in more detail later in this chapter.

Another way that the aperture setting is used, oddly enough, is to control the shutter speed. When selecting an aperture, you can use a wide aperture to allow a lot of light in so that you can user a faster shutter speed to freeze action. On the opposite end of the spectrum, you can use a smaller aperture if you want to be sure that your shutter speed is slower.

Fine-Tuning Your Exposure

Your camera's meter may not always be completely accurate. There are a lot of variables in most scenes, and large bright or dark areas can trick the meter into thinking a scene is brighter or darker than it really is, causing the image to be over- or underexposed. One example of this is in a really bright situation such as the beach on a sunny day or a similar, albeit opposite weatherwise, snowy scene. The camera's meter generally sees all of the brightness in the scene and underexposes the image to try to preserve detail in the highlights, causing the main subject and most of the image to be dark and lacking in contrast. In snowy scenes, this is a special problem because it causes the snow to appear gray and dingy. The general rule of thumb in this situation is to add 1 to 2 stops of exposure compensation.

CAUTION Exposure compensation is not available when using scene modes.

Exposure compensation

Exposure compensation is a feature of the D3100 that allows you to fine-tune the amount of exposure to vary from what is set by the camera's exposure meter. Although you can usually adjust the exposure of the image in your image-editing software (especially if you shoot RAW), it's best to get the exposure right in the camera to be sure that you have the highest image quality. If after taking the photograph you review it and it's too dark or too light, you can adjust the exposure compensation and retake the picture to get a better exposure. Exposure compensation is adjusted in EV (Exposure Value); 1 EV is equal to 1 stop of light. You adjust exposure compensation by pressing the Exposure Compensation button next to the Shutter Release button (the button with the +/-), and rotating the Command dial to the left for more exposure (+EV) or to the right for less exposure (–EV). The exposure compensation is adjusted in 1/3 stops of light.

You can adjust the exposure compensation up to +5 EV and down to –5 EV, which is a large range of 10 stops. To remind you that exposure compensation has been set, the exposure compensation indicator is displayed in the viewfinder and on the rear LCD screen when the shooting info is being displayed.

 Be sure to reset the exposure compensation to 0 after you finish to avoid unwanted over- or underexposure.

There are a few ways to get the exact exposure that you want. You can use the histogram to determine whether you need to add or subtract from your exposure. You can also use bracketing to take a number of exposures and choose from the one that you think is best, or you can combine the bracketed images with different exposures to create one image using post-processing software.

Histograms

The easiest way to determine if you need to adjust the exposure compensation is to simply preview your image. If it looks too dark, add some exposure compensation; if it's too bright, adjust the exposure compensation down. This, however, is not the most accurate method of determining how much exposure compensation to use. To accurately determine how much exposure compensation to add or subtract, look at the *histogram.* A histogram is a visual representation of the tonal values in your image. Think of it as a bar graph that charts the lights, darks, and midtones in your picture.

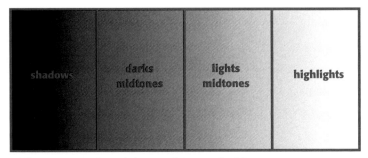

4.4 A representation of the tonal range of a histogram

The histogram charts a tonal range of about 5 stops, which is about the limit of what the D3100's sensor can record. This range is broken down into 256 brightness levels from 0 (absolute black) to 255 (absolute white), with 128 coming in at middle, or 18 percent, gray. The more pixels there are at any given brightness value, the higher the bar. If there are no bars, then the image has no pixels in that brightness range.

The D3100 offers four histogram views: the luminance histogram, which shows the brightness levels of the entire image, and histograms for each color channel — red, green, and blue.

The most useful histogram for determining if your exposure needs adjusting is the luminance histogram. To display the luminance histogram, simply press the multi-selector up while viewing the image on the LCD. This displays a thumbnail of the current image, the shooting info, and a small luminance histogram.

For most general subjects you want to expose your subject so that it falls right about in the middle of the tonal range, which is why your camera's meter exposes for 18 percent gray. If your histogram graph has most of the information bunched up on the left side, then your image is probably underexposed; if it's bunched up on the right side, then your image is probably overexposed.

Ideally, with most average subjects that aren't bright white or extremely dark, you want to try to get your histogram to look sort of like a bell curve, with most of the tones in the middle range, tapering off as they get to the dark and light ends of the graph. But this is only for most average types of images.

As with almost everything in photography, there are exceptions to the rule. If you take a photo of a dark subject on a dark background (a low-key image), then naturally your histogram will have most of the tones on the left side of the graph. Conversely, when you take a photograph of a light subject on a light background (a high-key image), the histogram will have most of the tones on the right.

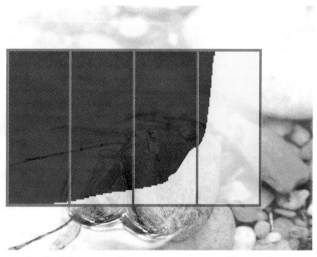

4.5 An example of a histogram from an overexposed image (no highlight detail). Notice the graph is completely touching the far right of the graph.

The most important thing to remember is that there is no such thing as a perfect histogram. A histogram is just a factual representation of the tones in the image. The other important thing to remember is that although it's okay for the graph to be near one side or the other, you usually don't want your histogram to have spikes bumping up against the edge of the graph; this indicates your image has blown-out highlights (completely white, with no detail) or blocked-up shadow areas (completely black, with no detail).

4.6 An example of a histogram from an underexposed image (no shadow detail). Notice the spikes at the far left of the graph.

Now that you know a little bit about histograms, you can use them to adjust exposure compensation. Here is a good set of steps to follow when using the histogram as a tool to evaluate your photos:

1. **After taking your picture, review its histogram on the LCD.** To view the histogram in the image preview, press the Playback button to view the image. Press the Multi-selector up, and the histogram appears directly to the right of the image preview.

2. **Look at the histogram.** An example of an ideal histogram is shown in figure 4.7.

3. **Adjust the exposure compensation.** To move the tones to the right and make the image brighter, add a little exposure compensation by pressing the Exposure Compensation button and rotating the Command dial to the left. To move the tones to the left and darken the image, press the Exposure Compensation button and rotate the Command dial to the right.

4. **Retake the photograph if necessary.** After taking another picture, review the histogram again. If needed, adjust the exposure compensation more until you achieve the desired exposure.

4.7 An example of a histogram from a properly exposed image. Notice that the graph does not spike against the edge on the left or the right, but tapers off.

4.8 An example of a histogram from a low-key image

4.9 An example of a histogram from a high-key image

Bracketing

Another way to ensure that you get the proper exposure is to *bracket* your exposures. Bracketing is a photographic technique in which you vary the exposure of your subject over three or more frames. By doing this, you are able to get the proper exposure in

difficult lighting situations where your camera's meter can be fooled. Bracketing is usually done with at least one exposure under and one exposure over the metered exposure.

Although some Nikon dSLRs offer an auto-bracketing feature, the D3100 doesn't. However, it's almost as easy to bracket images manually so it isn't a problem. It's a very simple procedure to do.

1. **Set the exposure mode to Manual.**

2. **Using the exposure meter, set the aperture and shutter speed so that you are getting the proper exposure.** A typical exposure on a sunny day is f/16 at 1/125 second at ISO 100.

3. **Take a shot at the proper exposure.**

4. **Adjust your settings.** You can now change the exposure setting. A good start is to adjust your exposure settings by at least one stop.

5. **Take multiple shots.** You'll want to take both overexposed and underexposed images.

When bracketing, whether you adjust the shutter speed or aperture depends on what kind of picture you are taking. If there's a lot of movement in the scene, you probably want to change the aperture. If depth of field is a concern, you want to change the shutter speed.

In addition to helping ensure that you get the correct exposure, you can also use different elements from the bracketed exposures and combine them using image-editing software to get a final image that has a wider tonal range than is possible for your image sensor to capture. This technique is known as High Dynamic Range (HDR). You can use a few different programs to create an HDR image. All recent versions of Photoshop (starting with CS2) have a tool called Merge to HDR that enables you to select two or more images (using three to five images is recommended) and automatically merges the separate images for you. Using Photoshop you can also layer the bracketed images and use layer masks to reveal or hide different areas of the images. Although HDR is a very good tool for getting more tonal range in your images, be careful not to overuse it. In recent years, quite a few photographers have had the tendency to take this technology too far, creating unrealistic, overly processed-looking images.

Figures 4.10, 4.11, and 4.12 are a sequence of bracketed images. I bracketed three frames by one stop to show the broad range of exposures you can get with bracketing. Figure 4.13 is a composite of all three images used to create an HDR image.

 For a more detailed look at HDR photography, check out *HDR Photography Photo Workshop,* also published by Wiley.

4.10 Bracketed image underexposed by 1 stop

4.11 Bracketed image shot as metered

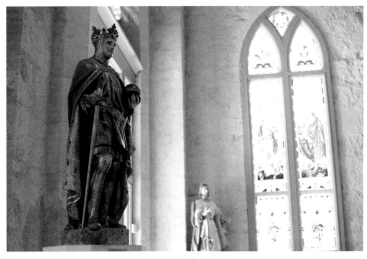

4.12 Bracketed image overexposed by 1 stop

4.13 Three bracketed images merged to HDR

Understanding Depth of Field

Depth of field is the distance range in a photograph in which all included portions of an image are at least acceptably sharp. It is heavily affected by aperture, but how far your camera is from the subject also has an effect, as does the focal length of the lens.

Remember that wide-angle lenses give a greater depth of field at a given aperture and distance than lenses with longer focal lengths at the same settings.

If you focus your lens on a specific point, everything that lies on the horizontal plane of that same distance is also in focus. This means everything in front of the point and everything behind it is technically not in focus. Because our eyes aren't acute enough to discern the minor blur that occurs directly in front of and directly behind the point of focus, it still appears sharp. This is known as the zone of acceptable sharpness, which is called depth of field.

▶ **Shallow depth of field.** This results in an image where the subject is in sharp focus, but the background and/or the foreground has a soft blur. You likely have seen it used frequently in portraits. Using a large aperture, such as f/2.8, results in a subject that is sharp with a softer background. Using a shallow depth of field is a great way to get rid of distracting elements in the background of an image.

▶ **Deep depth of field.** This results in an image that is reasonably sharp from the foreground to the background. Using a small aperture such as f/11 is ideal to keep photographs of landscapes or groups in focus throughout.

4.14 An image with a shallow depth of field has only the main subject in focus.

4.15 An image with a deep depth of field has most of the image in focus.

A factor to consider when working with depth of field is your distance from the subject. The farther you are from the subject you are focusing on, the greater the depth of field in your photograph. For example, if you stand in your front yard to take a photo of a tree a block away, it has a deep depth of field with the tree, background, and foreground all in relatively sharp focus. If you stand in the same spot and take a picture of your dog that is standing just several feet away, your dog is in focus, but that tree a block away is just a blur of color.

 To get deep depth of field, use a larger aperture number; to get a shallow depth of field, use a smaller aperture number.

Rules of Composition

Although some of you are likely well versed in the concepts of composition, some of you may be coming in cold, so to speak. So this section is intended as a refresher course and a general outline of some of the most commonly used rules of composition.

Photography, like any artistic discipline, has general rules. Although they are called rules, they are really nothing more than guidelines. Some photographers — notably Ansel Adams, who was quoted as saying, "The so-called rules of photographic composition are, in my opinion, invalid, irrelevant, and immaterial" — claim to have eschewed the rules of composition. However, when you look at Adams's photographs, they follow the rules perfectly in most cases.

Another famous photographer, Edward Weston, said, "Consulting the rules of composition before taking a photograph is like consulting the laws of gravity before going for a walk." Again, as with Adams, when you look at his photographs, they tend to follow these very rules.

This isn't to say you need to follow all the rules every time you take a photograph. As I said, these are really just general guidelines that, when followed, can make your images more powerful and interesting.

However, when you're starting out in photography, you should pay attention to the rules of composition. Eventually, you become accustomed to following the guidelines and it becomes second nature. At that point you no longer need to consult the rules of composition; you just inherently follow them.

Keep it simple

Simplicity is arguably the most important rule in creating a good image. In most cases, you want to be sure the viewer can identify what the intended subject of your photograph is. When you have too many competing elements in your image, it can be hard for the viewer to decide what to focus on.

One of the most commonly used techniques for achieving simplicity in images is to frame a single subject against a plain backdrop. Another much-used technique is using a shallow depth of field to isolate the subject from a background that may be busy. By causing the background to go out of focus the subject stands out better.

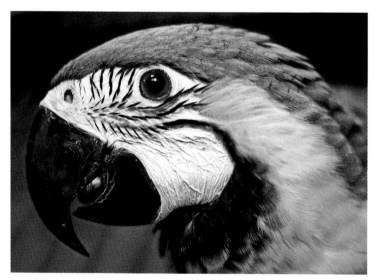

4.16 There's no question as to what the subject is in this photograph.

Sometimes changing your perspective is all you need to do to remove a distracting element from your image. A good tip is to try walking around and shooting the same subject from different angles.

Simplicity in an image can speak volumes. Try to concentrate on removing any unnecessary elements to achieve simplicity.

Rule of Thirds

Beginning photographers are often likely to take the main subject of the photograph and stick it right in the middle of the frame. This seems to makes sense, and it often works pretty well for snapshots. However, your goal is to create more interesting and dynamic images, so it often works better to put the main subject of the image a little off-center. Placing the subject off-center in a random position

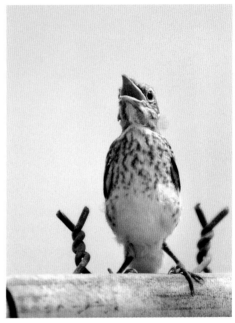

4.17 Getting down and shooting this bird from a lower angle allowed me to place the sky behind him. Shooting the bird from up high would have placed the distracting elements of the city behind the main subject of the photo.

also rarely works to make a good composition. Fortunately there is what is known as the *Rule of Thirds*.

The Rule of Thirds is a compositional guideline that has been in use for hundreds of years, and famous artists throughout the centuries have followed it. With the Rule of Thirds, you divide the image into nine equal parts using two equally spaced horizontal and vertical lines, kind of like a tic-tac-toe pattern. You want to center the main subject of the image at an intersection of the lines, as illustrated in figure 4.18. The subject doesn't necessarily have to be right on the intersection of the line, but merely close enough to it to take advantage of the Rule of Thirds.

Another way to use the Rule of Thirds is to place the subject in the center of the frame, but at the bottom or top third of the frame. This part of the rule is especially useful when photographing landscapes. You can place the horizon on or near the top or bottom line, but you almost never want to place it in the middle. Of course, there are always exceptions so if you think that the subject might look better in the middle by all means give it a shot. It never hurts to experiment, and it's better to have tried a shot and failed than not tried it at all.

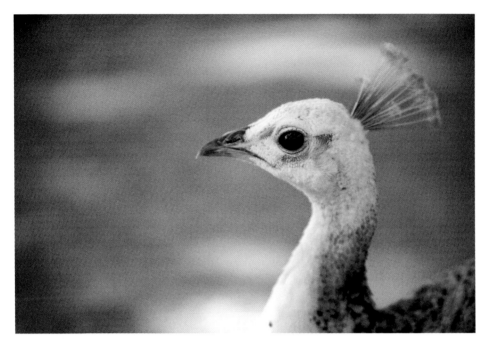

4.18 The peahen, which is the main subject of this photo, is placed in the right side of the frame in accordance with the Rule of Thirds.

When using the Rule of Thirds with a moving subject, you want to be sure to keep most of the frame in front of the subject to present the illusion that the subject has someplace to go within the frame.

Leading lines and S-curves

Another good way to add drama to an image is to use a *leading line* to draw the viewer's eye through the picture. A leading line is an element in a composition that leads the eye toward the subject. A leading line can be a lot of different things: a road, sidewalk, railroad tracks, buildings, or columns, to name a few.

In general, you want your leading line to go in a specific direction. Most commonly, a leading line leads the eye from one corner of the picture to another. A good rule of thumb to follow is to have your line go from the bottom-left corner leading toward the top right.

You can also use leading lines that go from the bottom of the image to the top, and vice versa. Often, leading lines heading in this direction lead to a *vanishing point*. A vanishing point is the point at which parallel lines appear to converge and disappear. Depending on the subject matter, a variety of directions for leading lines can work equally well.

4.19 A leading line draws the viewer's eye through the image. In this photo, the road forms an S-curve.

Another nice way to use a leading line is with an *S-curve*. An S-curve is exactly what it sounds like: It resembles the letter S. The S-curve draws the viewer's eye up from the bottom of the image, through the middle, over to the corner, and back to the other side again.

Helpful hints

Along with the major rules of composition, there are all sorts of other helpful guide-lines. Here are just a few that I've found most helpful:

▶ **Frame the subject.** Use elements of the foreground to make a frame around the subject to keep the viewer's eye from wandering.

▶ **Avoid having the subject looking directly out of the side of the frame he is closest to.** Having the subject looking out of the photograph can be distracting to the viewer. For example, if your subject is on the left side of the composition having him face the right is better, and vice versa.

▶ **Avoid *mergers*.** A merger is when an element from the background appears to be a part of the subject, like the snapshot of Granny at the park that looks like she has a tree growing out of the top of her head.

▶ **Try not to cut through the joint of a limb.** When composing or cropping your picture, it's best not to end the frame on a joint, such as an elbow or a knee. This can be unsettling to the viewer.

▶ **Avoid having bright spots or unnecessary details near the edge.** Having anything bright or detailed near the edge of the frame draws the viewer's eye away from the subject and out of the image.

▶ **Avoid placing the horizon or strong horizontal or vertical lines in the center of the composition.** This cuts the image in half and makes it hard for the viewer to decide which half of the image is important.

▶ **Separate the subject from the background.** Make sure the background doesn't have colors or textures similar to the subject. If necessary, try shooting from different angles, or use a shallow depth of field to achieve separation.

▶ **Fill the frame.** Try to make the subject the most dominant part of the image. Avoid having lots of empty space around the subject unless it's essential to making the photograph work.

▶ **Use odd numbers.** When photographing multiple subjects, odd numbers seem to work best.

These are just a few of the hundreds of guidelines out there. Remember, these are not hard-and-fast rules, just simple pointers that can help you create interesting and amazing images.

Selecting and Using Lenses

The choice of lenses today is much more vast than it was just as few as five years ago. With the advent of dSLR cameras and the DX sensor format being so popular, most camera and lens manufacturers quickly realized that the standard focal lengths being used for traditional film cameras were not quite adequate. The demand for true wide-angle lenses was so great that lens manufacturers were forced to come up with brand-new lens designs that were optimized for the digital era. This has been a great benefit for today's digital

The ability to use a variety of lenses is one of the main advantages of using a dSLR camera.

photographer as the lenses that are being made today are truly the world's best, many of which can be purchased at reasonable prices. However, because there are now so many lenses to choose from, selecting one can be a daunting task. This chapter is designed to provide insight into all of the different types of lenses available.

Introduction to Lenses

A lens is one of the most important parts of a photographer's kit, arguably more impor-
tant than the camera body itself because a good lens usually outlives the camera
body. A lot of my lenses have been with me for over a decade while I've been through
about a dozen camera bodies!

One of the great things about photography is that your lens choice allows you to show
your subjects and surroundings in a way that's just not possible with the human eye.
Some people will argue that photography allows you to render a scene realistically so
it can be remembered as it was, but I think photography has endured because you can
realistically render the scene, but you can also distort that reality with your lens choice.

Nikon lens compatibility

One thing you need to remember before purchasing a lens for your D3100 is that
only Nikon AF-S and AF-I (or the third-party equivalent) lenses autofocus with the
D3100. Until recently, all Nikon AF lenses were focused by a screw-type motor in
the camera body. Most high-level cameras have this focus motor, but some models
leave it out to make the cameras more compact and lower the overall price; the
D3100 is one such model.

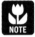 Sigma's AF-S equivalent is termed HSM for Hyper-Sonic Motor. Tamron's
NOTE version is USD or Ultra-Sonic Drive.

AF-S lenses are focused by an internal mechanism in the lens that uses ultrasonic
vibrations to drive the focus motor. This eliminates the need for an external motor to
move the lens elements and also makes for very quiet and fast autofocus. Previous to
the AF-S lens, Nikon offered AF-I lenses that worked on the same principle. These
lenses also autofocus with the D3100, but are mostly in the super-telephoto range
and are quite expensive.

Although AF-S lenses, such as the kit lens, are the only lenses that offer full AF func-
tionality, almost any Nikon lens made since 1977 can mount to the camera and offers
some, but not all, available features.

Any AF-D or AF-G lens allows all functions (except AF, of course). Any lens that
doesn't have a CPU (non-CPU) does not autofocus, nor does the exposure meter
work. Metering has to be done by using an external light meter or estimation and you
have to shoot in Manual exposure mode. All non-CPU lenses are manual focus lenses,

but some manual focus lenses have a CPU; these lenses are known as AI-P. With AI-P lenses, all features are available, except AF and 3D Color Matrix metering.

Deciphering Nikon's lens codes

When shopping for lenses, you may notice all sorts of letter designations in the lens name. For example, the kit lens is the AF-S DX Nikkor 18-55mm f/3.5-5.6G ED VR. So, what do all those letters mean? Here's a simple list to help you decipher them:

▶ **AI/AIS.** These are auto-indexing lenses that automatically adjust the aperture diaphragm down when the Shutter Release button is pressed. All lenses made after 1977 are auto-indexing, but when referring to AI lenses, most people generally mean the older Manual Focus (MF) lenses.

▶ **E.** These lenses were Nikon's budget series lenses, made to go with the lower-end film cameras, such as the EM, FG, and FG-20. Although these lenses are compact and are often constructed with plastic parts, some of them, especially the 50mm f/1.8, are of quite good quality. These lenses are also manual focus only.

▶ **D.** Lenses with this designation convey distance information to the camera body to aid in metering for exposure and flash.

▶ **G.** These are newer lenses that lack a manually adjustable aperture ring. You must set the aperture on the camera body. These lenses also convey distance information to the camera body.

▶ **AF, AF-D, AF-I, and AF-S.** All these lens codes denote that the lens is an auto-focus (AF) lens. The AF-D represents a distance encoder for distance information, the AF-I indicates an internal focusing motor type, and the AF-S indicates an internal Silent Wave Motor.

▶ **AI-P.** This designates a manual focus lens that has a CPU chip.

▶ **DX.** This lets you know the lens was optimized for use with Nikon's DX-format sensor. The DX designation is explained in depth in the next section.

▶ **VR.** This code denotes that the lens is equipped with Nikon's Vibration Reduction image stabilization system.

▶ **ED.** This indicates that some of the glass in the lens is Nikon's Extra-Low Dispersion glass, which means the lens is less prone to lens flare and chromatic aberrations. Chromatic aberrations can be seen as color fringing around the edges of a high-contrast subject. These are usually more pronounced at the edges of the images.

▶ **Micro-Nikkor.** This is Nikon's designation for macro lenses that allow close-up focusing.

▶ **IF.** IF stands for internal focus. The focusing mechanism is inside the lens, so the front of the lens doesn't rotate or move in and out when focusing. This feature is useful when you don't want the front of the lens ele-

5.1 Nikon lenses have a veritable alphabet soup of designations on them, but all of these letters add up to tell you all about the lens.

ment to move — for example, when you use a polarizing filter. The internal focus mechanism also allows for faster focusing.

▶ **DC.** DC stands for Defocus Control. Nikon only offers a couple of lenses with this designation. These lenses make the out-of-focus areas in the image appear softer by using special lens elements to add spherical aberration. The parts of the image that are in focus aren't affected. Currently, the only Nikon lenses with this feature are the 135mm f/2 and the 105mm f/2. Both of these are considered portrait lenses.

▶ **N.** On some of Nikon's newest professional lenses, you may see a large, golden N. This means that the lens has Nikon's Nano Crystal Coating, which is designed to reduce flare and ghosting.

DX crop factor

Crop factor is a ratio that describes the size of a camera's imaging area as compared to another format; in the case of SLR cameras, the reference format is 35mm film.

SLR camera lenses were designed around the 35mm film format. Photographers use lenses of a certain focal length to provide a specific field of view. The *field of view,* also called the angle of view, is the amount of the scene that's captured in an image. This is usually described in degrees. For example, when you use a 16mm lens on a 35mm camera, it captures almost 180 degrees of the scene horizontally, which is quite a bit. Conversely, when you use a 300mm focal length, the field of view is reduced to a mere 6.5 degrees horizontally, which is a very small part of the scene. The field of view is consistent from camera to camera because all SLRs use 35mm film, which has an image area of 24mm × 36mm.

With the advent of digital SLRs, the sensor was made smaller than a frame of 35mm film to keep costs down because the sensors are more expensive to manufacture. This sensor size was called APS-C or, in Nikon terms, the DX-format. The lenses that are used with DX-format dSLRs have the same focal length they've always had, but because the sensor doesn't have the same amount of area as the film, the field of view is effectively decreased. This causes the lens to provide the field of view of a longer focal lens when compared to 35mm film images.

Fortunately, the DX sensors are a uniform size, thereby supplying consumers with a standard to determine how much the field of view is reduced on a DX-format dSLR with any lens. The digital sensors in Nikon DX cameras have a 1.5X crop factor, which means that to determine the equivalent focal length of a 35mm or FX camera, you simply have to multiply the focal length of the lens by 1.5. Therefore, a 28mm lens provides an angle of coverage similar to a 42mm lens, a 50mm is equivalent to a 75mm, and so on.

5.2 This image was shot with a 28mm lens on a D700 FX camera. Inside the red square is the amount of the scene that would be captured with the same lens on a DX camera like the D3100.

Early on, when dSLRs were first introduced, all lenses were based on 35mm film. The crop factor effectively reduced the coverage of these lenses, causing ultrawide-angle lenses to act like wide-angle lenses, wide-angle lenses to perform like normal lenses, normal lenses to provide the same coverage as short telephotos, and so on. Nikon has created specific lenses for dSLRs with digital sensors. These lenses are known as DX-format lenses. These lenses are designed to have shorter focal lengths to allow DX cameras to have true wide-angle lenses. These DX-format lenses were also redesigned to cast a smaller image inside the camera so that the lenses could actually be made smaller and use less glass than conventional lenses. The byproduct of designing a lens to project an image circle to a smaller sensor is that these same lenses can't effectively be used with FX-format and can't be used at all with 35mm film cameras (without severe vignetting) because the image won't completely fill an area the size of the film or FX sensor.

There is an upside to this crop factor. Lenses with longer focal lengths now provide a bit of extra reach. A lens set at 200mm now provides the same amount of coverage as a 300mm lens, which can offer a great advantage for sports and wildlife photography or when you simply can't get close enough to your subject.

Kit Lenses

The Nikon D3100 comes paired with Nikon's 18-55mm f/3.5-5.6G VR AF-S DX lens. This lens covers the most commonly used focal lengths for everyday photography. The 18mm setting covers the wide-angle range, and zooming all the way out to 55mm gives you a moderate telephoto setting, allowing you to get close-up photos of subjects that may not be very close. Nikon also offers a D3100 kit with two lenses, the 18-55mm and a 55-200mm f/4-5.6 AF-S DX VR. The 55-200mm lens allows you a good medium-to-long telephoto range to really pull those far-off subjects closer, and it offers Nikon's Vibration Reduction (VR) feature. This feature allows you to hand hold the camera at slower shutter speeds without worrying about image blur that can be caused by camera shake.

The 18-55mm VR lens has received many good reviews. The optics give you sharp images with good contrast when stopped down a bit. However, when shooting wide open, the images can appear a little soft around the corners. It should be said here that all lenses have a "sweet spot" or a range of apertures at which they appear sharpest. With most lenses this sweet spot is usually one or two stops from the maximum aperture. For the kit lens, the sweet spot is around f/5.6 to f/8. Another thing to be aware of is that as the aperture gets smaller than f/16, you also may lose some sharpness due to the diffraction of the light by the aperture blades.

Detachable Lenses

Although your D3100 comes with a kit lens or two, one advantage to owning a digital SLR camera is the ability to use detachable lenses. This allows you to change your lens to fit the specific photographic style or scene that you want to capture. After a while, you may find that the kit lens doesn't meet your needs and you want to upgrade. Nikon dSLR owners have quite a few lenses from which to choose, all of which benefit from Nikon's expertise in the field of lens manufacturing.

The human eye is basically a fixed-focal-length lens. It can only see a certain set angular distance. This is called the *field of view* (or angle of view). Your eyes have about the same field of view as a 35mm lens on your D3100. Changing the focal length of your lens, whether by switching lenses or zooming, changes the field of view, allowing the camera to "see" more or less of the scene that you're photographing. Changing the focal length of the lens allows you to change the perspective of your images.

 NOTE *Stopping down* refers to making the aperture smaller, and *opening up* refers to making the aperture larger.

Although Nikon offers many very high-quality professional lenses, the D3100 kit lenses are very good performers for their price range, and they offer some advantages when paired with the D3100 that even some of Nikon's more-expensive lenses don't. These advantages include the following:

▶ **Low cost.** The 18-55mm VR lens costs less than $200, while the 55-200mm VR lens comes in at around $250. The 18-200mm VR lens retails for around $750. Buying both the 18-55mm and 55-200mm VR lenses can save you around $300.

▶ **Excellent image quality.** These lenses offer very high quality for the price. They offer aspherical lens elements, which help to eliminate distortion, and Nikon's Super Integrated Coating on the lens helps to ensure accurate color and reduce lens flare. These lenses have been praised by professional and amateur reviewers alike. They are uncommonly sharp for a lens in this price range.

▶ **Compact size.** Being designed specifically for dSLR cameras, these lenses are small in size and super-light. They are great lenses for everyday use or long trips where you don't want a lot of gear weighing you down.

▶ **VR.** Vibration Reduction is a very handy feature, especially when working in low-light situations or when using a long focal length. It can allow you to hand hold your camera at slower shutter speeds than you can with standard lenses.

Image courtesy of Nikon, Inc.

5.3 The D3100 with the 18-55mm kit lens

Zoom Lenses versus Prime Lenses

There are two different types of lenses: zoom lenses, which allow you to change the focal length setting of the lens, and prime lenses, which have a fixed focal length. There is no doubt that zoom lenses are more versatile, but prime lenses are also rather convenient in that they are usually smaller than their zoom counterparts. Both lenses have their strong points and most pros have both types of lenses in their arsenal.

Understanding zoom lenses

A zoom lens, such as the AF-S Nikkor 14-24mm, is a lens that has multiple optical elements that move within the lens body; this allows the lens to change focal length, and therefore the field of view, which is how much of the scene you can see at any given focal length.

One of the main advantages of the zoom lens is its versatility. You can attach one lens to your camera and use it in a wide variety of situations.

There are a few things to consider when buying zoom lenses (or upgrading from one you already have), including variable aperture, depth of field, and quality.

Variable aperture

One of the major issues when buying a consumer-level lens such as the 18-55mm VR lens is that it has a variable aperture, which means that as you zoom in on something when shooting wide open or closed down to the minimum aperture, the aperture opening gets smaller, allowing less light to reach the sensor and causing the need for a slower shutter speed or higher ISO setting. Higher-end lenses have a constant aperture all the way through the zoom range. In daylight or brightly lit situations, this may not be a factor, but when shooting in low light, this can be a drawback. Although the VR feature helps when shooting relatively still subjects, moving subjects in low light are blurred.

If you do a lot of low-light shooting of moving subjects, such as concert or performance photography, you may want to look into getting a zoom lens with a wider aperture such as f/2.8. These are fast aperture pro lenses and usually cost quite a bit more than your standard consumer zoom lens. The lens I use most when photographing action in low light is the Nikkor 17-55mm f/2.8; this lens allows me to use an ISO of about 800-1600 (keeping the noise levels low) and relatively fast shutter speeds to freeze the motion of the subject.

☐ Nano Crystal Coat ☐ Aspherical lens elements

☐ ED glass elements

5.4 Lenses are made up of many different glass elements. This is a diagram of the inside of a Nikon 24-70mm f/2.8 lens.

Depth of field

Another consideration when buying a consumer-level zoom lens is depth of field. For example, the 18-55mm lens has a smaller aperture, giving you more depth of field at all focal lengths than a lens with a wider aperture. If you are shooting landscapes, this may not be a problem, but if you are getting into portrait photography, you may want a shallower depth of field; therefore, a lens with a wider aperture is probably what you want.

For detailed information about depth of field, see Chapter 4.

Quality

In order to make consumer lenses like the 18-55mm VR and the 55-200mm VR afford-able, Nikon makes them mostly out of a composite plastic. Although the build quality is pretty good, the higher-end lenses have metal lens mounts and some have metal

alloy lens bodies. This makes them more durable in the long run, especially if you are rough on your gear like I sometimes am. Conversely, the plastic bodies of the consumer lenses are much smaller and lighter than their pro-level counterparts. This is a great feature when traveling or if you want to pack light. If I'm going on a quick day trip, more often than not I'll just grab my D3100 kit and go. It's more compact and much lighter than my other cameras and lenses and I appreciate the small size.

Understanding prime lenses

Before zoom lenses were available, the only option a photographer had was using a *prime lens,* which is also called a fixed-focal-length lens. Because each lens is fixed at a certain focal length, when you want to change how much of the scene is in the image, you have to either physically move farther away from or closer to the subject, or swap out the lens with one that has a focal length more suited to the range.

The most important features of the prime lens are that they can offer a faster maximum aperture, they are generally far lighter, and they usually cost much less (fast wide-angle primes are the exception). The normal focal length prime lenses aren't very long, so the maximum aperture can be faster than with zoom lenses. Prime lenses in normal focal lengths also require fewer lens elements and moving parts, so the weight can be kept down considerably. There are fewer elements in a prime lens, so the overall cost of production is less, meaning you pay less.

You might ask if you can buy one zoom lens that encompasses the same range as four or five prime lenses, then why bother with prime lenses? While this may sound like a logical conclusion, there are a lot of reasons why you might choose a prime lens over a zoom lens.

Prime lenses don't require as many lens elements (pieces of glass) as zoom lenses do, and this means that prime lenses are almost always sharper than consumer-level zoom lenses. Although it has to be said, with the advances that have taken place in machining and lens manufacturing, high-end zoom lenses are on par with primes for sharpness.

Image courtesy of Nikon, Inc.

5.5 The Nikkor 35mm f/1.8G AF-S fixed-focal-length prime lens is one of the best bargains in fast prime lenses.

As discussed earlier in the chapter, the Nikon D3100 can only autofocus when an AF-S lens is attached to the camera. Nikon now offers a nice selection of AF-S prime lenses. Currently, the AF-S prime lens lineup consists of the 24mm f/1.4, 35mm f/1.8, 50mm f/1.4, 85mm f/1.4, 60mm f/2.8 macro, 85mm f/3.5 macro and 105mm f/2.8 VR macro. For telephoto primes, you have the 200mm, 300mm, 400mm, 500mm, and 600mm telephoto lenses. Unfortunately most of these lenses are quite expensive with the exception of the 35mm f/1.8, which can be purchased for about $200.

Wide-angle and Ultrawide-angle Lenses

Wide-angle lenses, as the name implies, provide a very wide angle of view of the scene you're photographing. Wide-angle lenses are great for photographing a variety of subjects, but they're really excellent for subjects such as landscapes and group portraits.

The focal-length range of wide-angle lenses starts out at about 10mm (ultrawide) and extends to about 24mm (wide angle). Most wide-angle lenses on the market today are zoom lenses, although there are quite a few prime lenses available. Wide-angle lenses are generally *rectilinear*, meaning that there are lens elements built in to the lens to correct the distortion that's common with wide-angle lenses; this way, the lines near the edges of the frame appear straight. Fisheye lenses, which are also a type of wide-angle lens, are *curvilinear*; the lens elements aren't corrected, resulting in severe optical distortion.

In the past, ultrawide-angle lenses were rare, prohibitively expensive, and out of reach for most amateur photographers. These days, it's very easy to find an ultrawide-angle lens at a relatively affordable price. Most wide-angle zoom lenses run the gamut from ultrawide to wide angle. Some of the ones that work with the D3100 include the following:

▶ **Nikkor 10-24mm f/3.5-4.5.** This is one of Nikon's newer ultrawide DX zooms. The 10-24mm was specifically designed for DX cameras. This lens gives you a very wide field of view, and it's small and well built with little distortion. The AF-S motor allows it to focus perfectly with the D3100. This lens is available for about $800.

▶ **Sigma 10-20mm f/3.5.** When it comes to third-party lenses, I prefer Sigma lenses. They have superior build quality and their Hyper-Sonic Motor (HSM), which is similar to Nikon's Silent Wave AF-S motor, allows this lens to autofocus with the D3100. This lens is a little less sharp than the Nikon and it has a reduced

range on the long end, but it's much cheaper. You may not even miss the longer range at all, as it's most likely covered by one of your other lenses such as the 18-55mm kit lens. This lens also has a constant aperture, which gives it a leg up on the competition, but you can save about $200 by buying the variable aperture f/4-5.6 version.

Image courtesy of Nikon, Inc.

5.6 A Nikkor 10-24mm f/3.5-4.5 lens

▶ **Tokina AT-X 124 AF Pro DX II.** This is a 12-24mm f/4 wide-angle lens. This is Tokina's updated version of the original 12-24mm f/4, which is a very sharp and relatively inexpensive lens. Be sure if you get this lens that you get the II version. The original version will not autofocus with the D3100.

Sigma also offers a 12-24mm lens. It's built like a tank and has an HSM motor. The Sigma is also useable with Nikon FX cameras, which may be something to consider if you're planning to upgrade to FX sometime in the future.

NOTE So far the only wide-angle prime is the 24mm f/1.4, which is only moderately wide on a DX camera such as the D3100. Also, this lens is extremely expensive.

When to use a wide-angle lens

You can use wide-angle lenses for a variety of subjects, and they're great for creating dynamic images with interesting results. Once you get used to seeing the world through a wide-angle lens, you may find that your images start to be more creative, and you may look at your subjects differently. There are many considerations when you use a wide-angle lens. Here are a few:

▶ **Greater depth of field.** Wide-angle lenses allow you to get more of the scene in focus than you can when you use a midrange or telephoto lens at the same aperture and distance from the subject.

▶ **Wider field of view.** Wide-angle lenses allow you to fit more of your subject into your images. The shorter the focal length, the more you can fit in. This can be especially beneficial when you shoot landscape photos where you want to fit an immense scene into your photo.

▶ **Perspective distortion.** Using wide-angle lenses causes things that are closer to the lens to look disproportionately larger than things that are farther away. You can use perspective distortion to your advantage to emphasize objects in the foreground if you want the subject to stand out in the frame.

▶ **Handholding.** At shorter focal lengths, it's possible to hold the camera steadier than you can at longer focal lengths. At 14mm, it's entirely possible to hand hold your camera at 1/15 second without worrying about camera shake.

▶ **Environmental portraits.** Although using a wide-angle lens isn't the best choice for standard close-up portraits, wide-angle lenses work great for environmental portraits where you want to show a person in her surroundings.

Wide-angle lenses can also help pull you into a subject. With most wide-angle lenses, you can focus very close. This helps you get up close and personal with the subject while creating the perspective distortion that wide-angle lenses are known for. Don't be afraid to get close to your subject to make a more dynamic image. The worst wide-angle images are the ones that have a tiny subject in the middle of an empty area.

Understanding wide-angle limitations

Wide-angle lenses are very distinctive when it comes to the way they portray your images, and they also have some limitations that you may not find in lenses with longer focal lengths. There are also some pitfalls that you need to be aware of when using wide-angle lenses:

▶ **Soft corners.** The most common problem that wide-angle lenses, especially zooms, have is that they soften the images in the corners. This is most prevalent at wide apertures, such as f/2.8 and f/4, and the corners usually sharpen up by f/8 (depending on the lens). This problem is greatest in lower-priced lenses.

▶ **Vignetting.** This is the darkening of the corners in the image. This occurs because the light that's needed to capture such a wide angle of view must come from an oblique angle. When the light comes in at such an angle, the aperture is effectively smaller. The aperture opening no longer appears as a circle but is shaped like a cat's eye. Stopping down the aperture 1 to 2 stops reduces this effect, and stopping down by 3 stops usually eliminates any vignetting.

▶ **Perspective distortion.** Perspective distortion is a double-edged sword: It can make your images look very interesting or make them look terrible. One of the reasons that a wide-angle lens isn't recommended for close-up portraits is that it distorts the face, making the nose look too big and the ears too small. This can make for a very unflattering portrait.

▶ **Barrel distortion.** Wide-angle lenses, even rectilinear lenses, are often plagued with this specific type of distortion, which causes straight lines outside the image center to appear to bend outward (similar to a barrel). This can be unwanted when doing architectural photography. Fortunately, Adobe Photoshop and other image-editing software allow you to fix this problem relatively easily.

5.7 A shot taken with a wide-angle lens can add an interesting perspective to some images.

Standard or Midrange Lenses

Standard, or midrange, zoom lenses fall in the middle of the focal-length scale. Zoom lenses of this type usually start at a moderately wide angle of around 16–18mm and zoom in to a short telephoto range. These lenses work great for most general photography applications and can be used successfully for everything from architectural to portrait photography. Basically, this type of lens covers the most useful focal lengths and will probably spend the most time on your camera. The 18-55mm kit lens falls into this range.

Here are a few of the midrange lenses available:

▶ **Nikkor 17-55mm f/2.8.** This is Nikon's top-of-the-line standard DX zoom lens. It's a professional lens that has a fast aperture of f/2.8 over the whole zoom range and is extremely sharp at all focal lengths and apertures. The build quality on this lens is excellent, as most of Nikon's pro lenses are. The 17-55mm has Nikon's super-quiet and fast-focusing Silent Wave Motor as well as ED glass elements to reduce chromatic aberration. This lens is top-notch all around and is worth every penny of the price tag.

▶ **Sigma 17-70mm f/2.8-4 OS.** This lens is a low-cost alternative to the Nikon 17-55mm that has a variable aperture of f/2.8 on the wide end and f/4 on the long end. You can get this lens for about one-quarter of the cost of the Nikon 17-55mm and it's much smaller and lighter. It has Sigma's HSM so it autofocuses fast and quiet. It's a great walking-around lens for standard shots. This lens also allows you to focus closely on subjects; it's not a true macro lens, but it is close. The OS (optical stabilization) also helps to reduce blur from camera shake. This is one of my favorite lenses for DX cameras because it does almost everything I need and it is light-weight.

▶ **Tamron SP AF 17-50mm f/2.8 Di-II VC.** This is a pretty good, reasonably priced constant aperture lens that includes Vibration Compensation (Tamron's version of Nikon's VR). The only drawback to this lens is that Tamron's built-in motor (BIM) that allows it to focus with the D3100 is very slow and loud. Tamron has recently developed a silent motor that may be integrated into this lens in the near future.

Image courtesy of Nikon, Inc.
5.8 A Nikkor 16-35mm f/4 lens

There are a few prime lenses that fit into this category: the 28mm, 30mm, and 35mm. These lenses are considered normal lenses for DX cameras in that they approximate the normal field of view of the human eye. They are great all-around lenses. They come with apertures of f/2.8 or faster and can be found for less than $400. There are only a couple of normal prime lenses available that can autofocus with the D3100: the Nikon 35mm f/1.8G and the Sigma 30mm f/1.4 HSM. Both are great lenses, but at right around $200, you can't go wrong with the Nikon. This is the lens that I use most with all DX cameras, including the D3100.

Telephoto Lenses

Telephoto lenses have very long focal lengths and are used to get closer to distant subjects. They provide a very narrow field of view and are handy when you're trying to focus on the details of a subject. Telephoto lenses produce a much shallower depth of field than wide-angle and midrange lenses, and you can use them effectively to blur background details to isolate a subject.

Telephoto lenses are commonly used for sports and wildlife photography. The shallow depth of field also makes them one of the top choices for photographing portraits.

As with wide-angle lenses, telephoto lenses also have their quirks, such as perspective distortion. As you may have guessed, telephoto perspective distortion is the opposite of the wide-angle variety. Because everything in the photo is so far away with a telephoto lens, the lens tends to compress the image. Compression causes the background to look too close to the foreground. Of course, you can use this effect creatively. For example, compression can flatten out the features of a model, resulting in a pleasing effect. Compression is another reason why photographers often use a telephoto lens for portrait photography.

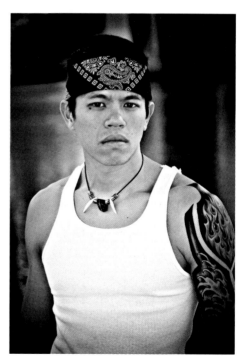

5.9 A portrait shot with a telephoto lens

Super-Zooms

Most lens manufacturers, Nikon included, offer what's commonly termed a *super-zoom*, or sometimes called a *hyper-zoom*. Super-zooms are lenses that encompass a very wide focal length range, from wide angle to telephoto. The most popular of the super-zooms is the Nikon 18-200mm f/3.5-5.6 VRII, shown here.

These lenses allow you to have a huge focal-length range that you can use in a wide variety of shooting situations without having to switch out lenses. This can come in handy if, for example, you are photographing a landscape scene by using a wide-angle setting, and lo and behold, Bigfoot appears on the horizon. You can quickly zoom in with the super-telephoto setting and get a good close-up shot without having to fumble around in your camera bag to grab a telephoto and switch out lenses, possibly causing you to miss the shot of a lifetime.

Of course, there's no free lunch, and these super-zooms come with a price (figuratively and literally). In order to achieve the great ranges in focal length, some concessions must be made with regard to image quality. These lenses are usually less sharp than lenses with a shorter zoom range and are more often plagued with optical distortions and chromatic aberration. Super-zooms often show

pronounced barrel distortion (the bowing out of straight lines in the image) at the wide end and can have moderate to severe pincushion distortion (the bowing in of the straight lines in the image) at the long end of the range.

Another caveat to using these lenses is that they generally have appreciably smaller maximum apertures than zoom lenses with shorter ranges. This can be a problem, especially because larger apertures are generally needed at the long end to keep a high-enough shutter speed to avoid blurring from camera shake when hand holding. Of course, some manufacturers include some sort of Vibration Reduction feature to help control this problem.

Some popular super-zooms include the Nikon 18-200mm f/3.5-5.6 VR (mentioned earlier), the Sigma 18-200mm f/3.5-6.3 with Optical Stabilization, and the Tamron 18-270mm VC f/3.5-5.6. There are also a few super-zoom super-telephoto lenses, including the Nikon 80-400mm and the Sigma 50-500mm.

A typical telephoto zoom lens usually has a range of about 55–200mm, although compact zoom lenses that reach out to 300mm are becoming more common. For example Nikon has just released a 55-300mm f/4.5-5.6 VR lens that's a perfect addition to the D3100 with a 18-55 kit lens if you need the extra reach provided over the 200mm version. If you want to zoom in close to a subject that's very far away, you may need an even longer lens. These super-telephoto lenses can act like telescopes, really bringing the subject in close. They range from about 300mm up to about 800mm.

 Almost all super-telephoto lenses are prime lenses, and they're very heavy, **NOTE** bulky, and expensive.

There are several telephoto prime lenses available. Most of them are pretty expensive, although you can sometimes find some older Nikon primes that are discontinued or used — and at decent prices. One of these lenses is the 300mm f/4. A couple of relatively inexpensive telephoto primes are in the shorter range of 50–85mm. The 50mm is considered a normal lens for FX format, but the DX format makes this lens a 75mm equivalent, landing it squarely in the short telephoto range for use with the D3100. Nikon has an AF-S version of the 50mm f/1.4 and has recently released an 85mm f/1.4.

Here are some of the most common telephoto lenses:

▶ **Nikkor 70-200mm f/2.8 VRII.** This is Nikon's top-of-the-line telephoto lens. The VR makes this lens useful when photographing far-off subjects handheld. This is a great lens for sports, portraits, and wildlife photography.

Image courtesy of Nikon, Inc.

5.10 A Nikkor 55-300mm f/2.8 VR lens

▶ **Nikkor 55-300mm f/4-5.6 VR.** This is one of Nikon's newest lenses and is actually a pretty strong performer for its price range. The 55-300mm VR is quite sharp and only has mild barrel distortion issues. It's a great lens with a long reach. Great for wildlife photography or general spying purposes for you private investigators out there.

▶ **Nikkor 80-200mm f/2.8D AF-S.** This is a great, affordable alternative to the 70-200mm VR lens. This lens is sharp and has a fast, constant f/2.8 aperture.

▶ **Sigma 70-200mm f/2.8 HSM.** This is a good alternative to the Nikon lenses. The HSM motor allows for autofocus with the D3100 and the lens costs less than half the price of the Nikon 70-200, although you do lose VR.

Macro Lenses

A macro lens is a special-purpose lens used in macro and close-up photography. It allows you to have a closer focusing distance than regular lenses, which in turn allows you to get more magnification of your subject, revealing small details that would otherwise be lost. True macro lenses offer a magnification ratio of 1:1; that is, the image projected onto the sensor through the lens is the exact same size as the actual object being photographed. Some lower-priced macro lenses offer a 1:2 or even a 1:4 magnification ratio, which is one-half to one-quarter of the size of the original object. Although lens manufacturers refer to these lenses as macro, strictly speaking, they are not.

One major concern with a macro lens is the depth of field. When focusing at such a close distance, the depth of field becomes very shallow; it's often advisable to use a

small aperture to maximize your depth of field and ensure everything is in focus. Of course, as with any downside, there's an upside: You can also use the shallow depth of field creatively. For example, you can use it to isolate a detail in a subject.

Macro lenses come in a variety of focal lengths, and the most common is 60mm. Some macro lenses have substantially longer focal lengths, which allow more distance between the lens and the subject. This comes in handy when the subject needs to be lit with an additional light source. A lens that's very close to the subject while focusing can get in the way of the light source, casting a shadow.

When buying a macro lens, you should consider a few things: How often are you going to use the lens? Can you use it for other purposes? Do you need AF? Because newer dedicated macro lenses can be pricey, you may want to consider some cheaper alternatives.

The first thing you should know is that it's not absolutely necessary to have an AF lens. When shooting very close up, the depth of focus is very small, so all you need to do is move slightly closer or farther away to achieve focus. This makes an AF lens a bit unnecessary. You can find plenty of older Nikon manual focus (MF) macro lenses that are very inexpensive, and the lens quality and sharpness are still superb.

Some other manufacturers also make good-quality MF macro lenses. I have a 50mm f/4 Macro-Takumar made for early Pentax screw-mount camera bodies. I bought this lens for next to nothing, and I found an inexpensive adapter that allows it to fit the Nikon F-mount. The great thing about this lens is that it's super-sharp and allows me to focus close enough to get a 4:1 magnification ratio, which is 4X life size.

Nikon currently offers three focal-length macro lenses under the Micro-Nikkor designation that autofocus with the D3100:

- ▶ **Nikkor 60mm f/2.8.** Nikon offers two versions of this lens — one with a standard AF drive and one with an AF-S version with the Silent Wave Motor. The AF-S version also has the new Nano Crystal Coat lens coating to help eliminate ghosting and flare.

- ▶ **Nikkor 85mm f/3.5 VR.** This is Nikon's latest macro lens offering. This lens is comparable with the 105mm f/2.8 VR, but because it's designed solely for DX cameras, it's smaller, lighter, and less expensive. This is a great choice for serious macro photographers.

- ▶ **Nikkor 105mm f/2.8 VR.** This is a great lens that not only allows you to focus extremely close but also enables you to back off and still get a good close-up

shot. This lens is equipped with VR. This can be invaluable with macro photography because it allows you to hand hold at slower shutter speeds — a necessity when stopping down to maintain a good depth of field. This lens can also double as a very impressive portrait lens. This is currently the favored lens in my arsenal for shooting portraits.

Image courtesy of Nikon, Inc.

5.11 A Nikkor 85mm f/3.5G VR macro lens

A couple of third-party lenses that work well with the D3100 are

▶ **Tamron 90mm f/2.8.** This lens is highly regarded for its sharpness. It's also got a built-in motor so it will autofocus with the D3100. However, be aware that the front element of the lens moves in and out during focusing, which can cause the lens element to hit your subject if you're too close. Also, unlike the offerings from Sigma and Nikon, Tamron's built-in focus motor is very loud and very slow.

▶ **Sigma 150mm f/2.8 HSM.** This is another highly regarded lens for its sharpness. Fast, quiet focusing with the HSM.

Using Vibration Reduction Lenses

Nikon has an impressive list of lenses that offer Vibration Reduction (VR). This technology is used to combat image blur caused by camera shake, especially when you hand hold the camera at long focal lengths. The VR function works by detecting the motion of the lens and shifting the internal lens elements. This allows you to shoot up to 3 stops slower than you would normally.

Third-party Lenses

Several companies make lenses that work flawlessly with Nikon cameras. In the past, third-party lenses had a bad reputation of being, at best, cheap knock-offs of the original manufacturers. This is not the case anymore, as a lot of third-party lens manufacturers have stepped up to the plate and started releasing lenses that rival some of the originals (usually at half the price).

Although you can't beat Nikon's professional lenses, there are many excellent third-party lens choices available to you. The three most prominent third-party lens manufacturers are Sigma, Tokina, and Tamron. Each of these companies makes lenses that cover the entire zoom range.

I have included a number of examples of third-party lenses in each of the sections in this chapter. Although I currently have a full line of Nikon pro lenses, I still have a few third-party lenses simply because they are smaller and lighter than Nikon's pro lenses, especially the constant aperture f/2.8 lenses. I highly recommend checking into some third-party lenses if you're looking for a fast, constant aperture zoom lens for not a lot of money.

If you're an experienced photographer, you probably know this rule of thumb: To get a reasonably sharp photo when handholding the camera, you should use a shutter speed that corresponds to the reciprocal of the lens's focal length. In simpler terms, when shooting at a 200mm zoom setting, your shutter speed should be at least 1/200 second. When shooting with a wider setting, such as 28mm, you can safely hand hold at around 1/30 second. Of course, this is just a guideline; some people are naturally steadier than others and can get sharp shots at slower speeds. With the VR enabled, you should theoretically be able to get a reasonably sharp image at a 200mm setting with a shutter speed of around 1/30 second. I find that this is only possible if you have really steady hands. At wider focal lengths you have a better chance a getting a 4-stop advantage up to a point of course (you won't be able to hand hold a 1 second exposure no matter how steady you are).

Although the VR feature is good for providing some extra latitude when you're shooting with low light, it's not made to replace a fast shutter speed. To get a good, sharp photo when shooting action, you need to have a fast shutter speed to freeze the action. No matter how good the VR is, nothing can freeze a moving subject except a fast shutter speed.

Another thing to consider with the VR feature is that the lens's motion sensor may overcompensate when you're panning, causing the image to actually be blurrier. So, in situations where you need to pan with the subject, you may need to switch off the VR. The VR function also slows down the AF a bit, so when catching the action is very important, you may want to keep this in mind. However, Nikon's newest lenses have been updated with VR II, which Nikon claims can tell the difference between panning motion and regular side-to-side camera movement.

While VR is a great advancement in lens technology, few things can replace a good exposure and a solid monopod or tripod for a sharp image.

Working with Light

Light is the essence of photography; without light there is no photograph. Not only is light necessary to make an exposure, but the impact that light has on your images is also a major factor. Light has many different qualities that come into play when making a photograph. Light can be soft and diffuse, or it can be hard and directional. Light can also have an impact on the color of your images; different light sources emit light at different temperatures, which changes the colorcast of the image.

The ability to control light is a crucial step toward being able to make images that look exactly how you want them to. In this chapter, I explain some of the different types of light and how to modify them to suit your needs.

Light, whether from a light bulb, the sun, or electronic flash, is required to make an exposure.

Lighting Essentials

There are a number of different ways that light can be manipulated using accessories to modify the light. The way the light strikes the subject has a big effect on how your images appear to the viewer. The angle of the light, the contrast it creates, and the amount of light all impact the image.

In this section I cover the two types of lighting used in photography as well as lighting direction. Keep in mind that these light types can also be used when shooting video as well as still photography.

Soft light

Soft light is very diffused and appears to come from a large light source and wraps around the subject. The shadow edges fade gradually from dark to light, resulting in a pleasing and subdued

6.1 A soft light portrait

edge transfer. Soft lighting is generally the most desirable type of lighting in photography, especially when it comes to portraits. Soft light appears almost omni-directional, and it's often difficult to pinpoint exactly where the light source is located. Soft lighting is often achieved by placing the light source very close to the subject, as the larger the light source is in relation to the subject the softer the light is.

> **NOTE** The term *shadow edge transfer* is used to describe how abruptly the shadows in the images go from light to dark. This is the determining factor of whether light is soft or hard. Soft light has a smooth transition and hard light has a well-defined shadow edge transfer.

Use soft light when you want to portray your subject in a pleasing way. This type of light softens hard edges and smoothes out details that would otherwise make your

subject look rough or even harsh. Soft light can be used effectively for almost any type of image — portraits and food especially benefit from soft lighting. Often landscapes look their best when the clouds diffuse the sun. While soft lighting is usually great for most subjects, sometimes it can lack drama and depth.

Generally, to achieve a soft light, the light source must be modified in some way. When using artificial light such as a flash or continuous lighting the light is modified by directing it through a translucent material such as an umbrella or a softbox. Bouncing the light off of a nearby wall or ceiling can also soften the light. This is called *bounce flash* and is covered later in this chapter. Continuous light can also be redirected to the subject using reflective material. In the case of the sun, diffusion can be provided by clouds or by placing a translucent fabric between the sun and the subject.

Hard light

With hard light, the shadow edge transfer is very abrupt and sometimes even harsh. Hard light is considered very directional and it's very easy to discern exactly where the light is coming from. Moving a light source farther away from the subject makes the light harder and more directional because the light source is comparatively small relative to the subject. A great example is the sun. Although the sun is huge, it is very far away so it's a small light source comparatively and creates very hard shadows.

Although photographers usually try to avoid hard lighting for most subjects there are times when hard lighting can be used effectively. Using hard lighting for a portrait often makes for a very moody portrait that evokes a dramatic feeling.

6.2 The hard light in this portrait of ***Spiderman*** **and** ***Evil Dead*** **director Sam Raimi adds an air of darkness and mystery.**

Hard light is also great for bringing out details and textures in objects and is great for macro subjects, flowers, and some still-life photos. Hard light can also be effective at bringing out details in many landscape subjects such as mountains, rocky outcroppings, and other natural formations.

Hard light is most often achieved with a bare light source, although there are some accessories that can be used to make the light more directional, such as grids or snoots. The bright midday sun is an excellent example of a hard light source.

Frontlight

As you might have guessed this type of lighting comes from the front of the subject. It's likely you've heard the old photographer's rule, "Keep the sun at your back." This is a good general rule for photography especially for quick snapshots, and will yield acceptable results for most subjects. However, lighting from the front can sometimes produce rather flat results that lack depth and dimension. And, this can work well when photographing technical items such as circuit boards or microchips.

6.3 This panel was lit from the front; notice the flat, even lighting.

Frontlighting works well enough for portraits and a lot of fashion photographers swear by it. Frontlighting flattens out the facial features and hides blemishes and wrinkles better than most other types of lighting.

6.4 The light was moved to the side for this shot. Notice the shadows are deep, giving the texture depth and form.

Sidelight

The name for this type of light can be a tad misleading. Sidelighting doesn't necessarily mean that the light comes in from the side at a 90° angle, but usually comes in at much shallower angle (although using a 90° angle can be very effective in some circumstances).

Lighting the subject from the side increases the shadow contrast and causes the details to pop out and become more pronounced. This is what gives your photograph, which is a two-dimensional image, a three-dimensional feel.

Sidelight is equally effective when using hard or soft light and works great for just about every subject there is.

6.5 The soft frontlight makes for a very flattering portrait.

6.6 Lighting from the side adds depth and dimension to almost any subject.

Backlight

Of course this type of light comes from behind the subject. This type of lighting is used the least in photography, but make no mistake, this type of lighting has its use in a few different applications.

Backlighting can introduce anomalies such as lens flare and decreased contrast to your images and, although that can be a bad thing, when used sparingly it can make your images quite interesting.

6.7 Using backlighting can make for interesting portraits that stand out.

The key to making backlighting work is to spot meter. When shooting portraits meter on the subject; for silhouettes meter on the brightest area in the scene.

Using backlighting in a portrait gives a nice, soft light on the face as well as a great rim light on the edges of the subject as you can see in figure 6.7.

Backlighting works great to make portraits more dynamic, bring silhouettes to landscape photos, and make translucent subjects such as flowers seem to glow.

Natural Light

Natural light is the easiest light to find because it exists naturally in the scene and can be some of the most beautiful lighting you can find, but natural light is also some of the hardest light to deal with because of its relative unpredictability. Light from the sun changes from minute to minute and can be different depending on the time of day and the weather. Natural light can be hard and directional on a bright summer day at high noon or it can be soft, gold, and glowing at the end of the day.

More often than not natural light benefits from some sort of modification. Often this means using an accessory,

6.8 Backlighting in a landscape allows you make dynamic silhouettes.

but natural light is also modified by other means as well, such as a window. Here are a few examples of natural lighting techniques:

▶ **Use fill flash.** You can use the flash as a secondary light source (not as your main light) to fill in the shadows and reduce contrast.

▶ **Try window lighting.** Believe it or not, one of the best ways to use natural light is to go indoors. Seating your model next to a window provides a beautiful soft light that is very flattering. A lot of professional portrait photographers use window light as well as food photographers. It can be used to light almost any subject softly and evenly. This is easily the quickest and often the nicest light source you'll find.

6.9 Window light is considered one of the best light sources for portraits.

▶ **Find some shade.** The shade of a tree or the overhang of an awning or porch can block the bright sunlight while still giving you plenty of diffuse light with which to light your subject.

▶ **Take advantage of the clouds.** A cloudy day softens the light, allowing you to take portraits outside without worrying about harsh shadows and too much contrast. Even if it's only partly cloudy, you can wait for a cloud to pass over the sun before taking your shot.

▶ **Use a modifier.** Use a reflector to reduce the shadows or a diffusion panel to block the direct sun from your subject.

Continuous Lighting

Continuous lighting is just what it sounds like: a light source that is constant. It is by far the easiest type of lighting to work with. Unlike natural lighting, continuous lighting is consistent and predictable. You can see the actual effects the lighting has on your

subjects, and can modify and change the lighting before you even press the Shutter Release button.

Continuous lights are an affordable alternative to using studio strobes. Because the light is constant and consistent, the learning curve is also less steep. With strobes, you need to experiment with the exposure or use a flash meter. With continuous lights, you can use the Matrix meter on the D3100 to yield excellent results.

As with other lighting systems, there are a lot of continuous light options. Here are a few of the more common ones:

- ▶ **Incandescent.** Incandescent, or tungsten, lights are the most common type of lights. This type of continuous lighting is the source of the name "hot lights."

- ▶ **Halogen.** Halogen lights, which are much brighter than typical tungsten lights, are actually very similar. They are considered a type of incandescent light. The color temperature of halogen lamps is higher than the color temperature of standard tungsten lamps.

- ▶ **Fluorescent.** Fluorescent lighting is in the majority of office buildings, stores, and even in your own house. In a fluorescent lamp, electrical energy changes a small amount of mercury into a gas.

Incandescent and halogen

Although incandescent and halogen lights make it easier to see what you're photographing and cost less, there are quite a few drawbacks to using these lights for serious photography work. First, they are hot. When models have to sit under lamps for any length of time, they get hot and start to sweat. This is also a problem with food photography. It can cause your food to change consistency or even to sweat; for example, cheese that has been refrigerated. On the other hand, it can help keep hot food looking fresh and hot.

Second, although incandescent lights appear to be very bright to you and your subject, they actually produce less light than a standard flash unit. For example, a 200-watt tungsten light and a 200-watt-second strobe use the same amount of electricity per second, so they should be equally bright, right? Wrong. Because the flash discharges all 200 watts of energy in a fraction of a second, the flash is actually much, much brighter. Why does this matter? Because when you need a fast shutter speed or a small aperture, the strobe can give you more light in a shorter time. An SB-600 gives you about 30-watt-seconds of light at full power. To get an equivalent amount of light at the maximum sync speed of 1/200 second from a tungsten light, you would need a

7500-watt lamp! Of course, if your subject is static, you don't need to use a fast shutter speed; in this case, you can use one 30-watt light bulb for a 1-second exposure or a 60-watt lamp for a 1/2-second exposure.

Other disadvantages of using incandescent lights include

▶ **Color temperature inconsistency.** The color temperature of the lamps changes as your household current varies and as the lamps get more and more use. The color temperature may be inconsistent from manufacturer to manufacturer and may even vary within the same types of bulbs.

▶ **Light modifiers are more expensive.** Because most continuous lights are hot, modifiers such as softboxes need to be made to withstand the heat; this makes them more expensive than the standard equipment intended to be used for strobes.

▶ **Short lamp life.** Incandescent lights tend to have a shorter life than flash tubes, so you'll have to replace them more often.

Although incandescent lights have quite a few disadvantages, they are by far the most affordable type of lights you can buy. Many photographers who are starting out use inexpensive work lights they can buy at any hardware store for less than $10. These lights use a standard light bulb and often have a reflector to direct the light; they also come with a clamp you can use to attach them to a stand or anything else you have handy that might be stable.

Halogen work lamps, also readily available at any hardware store, offer a higher light output than a standard light, generally speaking. The downside is they are very hot, and the larger lights can be a bit unwieldy. You also may have to come up with some creative ways to get the lights in the position you want them. Some halogen work lamps come complete with a tripod stand. If you can afford it, I'd recommend buying these; they're easier to set up and less of an aggravation in the long run. The single halogen work lamps that are usually designed to sit on a table or some other support are readily available for less than $20; the double halogen work lamps with two 500-watt lights and a 6-foot tripod stand are usually available for less than $40.

If you're really serious about lighting with hot lights, you may want to invest in a photographic hot-light kit. These kits are widely available from any photography or video store. They usually come with lights, light stands, and sometimes with light modifiers such as umbrellas or softboxes for diffusing the light for a softer look. The kits can be relatively inexpensive, with two lights, two stands, and two umbrellas for around $100. Or you can buy much more elaborate setups ranging in price up to $2,000. I've searched the Internet for these kits and have found the best deals are on eBay.

Light Modifiers

Light modifiers do exactly what their name says they do: They modify light. When you set up a photographic shot, in essence, you are building a scene using light. For some images, you may want a hard light that is very directional; for others, a soft, diffused light works better. Light modifiers allow you to control the light so you can direct it where you need it, give it the quality the image calls for, and even add color or texture to the image. There are many different kinds of diffusers. Here's a list of the most common:

▶ **Umbrella.** The photographic umbrella is used to soften the light of a flash. You can either shoot through the umbrella or bounce the light from the inside of the umbrella depending on the type of umbrella you have. Umbrellas are very portable and make a great addition to any Speedlight set-up.

▶ **Softbox.** These also soften the light and come in myriad sizes from huge 8-foot softboxes to small 6-inch versions that fit right over your Speedlight mounted on the camera.

▶ **Reflector.** This is probably the handiest modifier you can have. You can use it to reflect natural light onto your subject, or you can use it to bounce light from your Speedlight onto the subject, making it softer. Some reflectors can act as diffusion material to soften direct sunlight. They come in a variety of sizes from 2 to 6 feet and fold up into a small, portable size. I recommend that every photographer have at least a small reflector in their camera bag.

▶ **Other types.** There are lots of types of modifiers; snoots and grids make the light more directional. Barn doors are also use to direct the light or deflect it from a certain area.

Fluorescent

Fluorescent lights have a lot of advantages over incandescent lights; they run at much lower temperatures and use much less electricity than standard incandescent lights. Fluorescent lights are also a much softer light source than incandescent lights.

In the past, fluorescent lights weren't considered viable for photographic applications because they cast a sickly green light on the subject. Today, most fluorescent lamps for use in photography are color corrected to match either daylight or incandescent lights. Also, given white balance is adjustable in the camera or in Photoshop with RAW files, using fluorescents has become much easier because you don't have to worry about color-correcting filters and special films.

These days, because more people are using fluorescent lights, light modifiers are more readily available. They allow you to control the light to make it softer or harder.

Fluorescent light kits are readily available through most photography stores and online. These kits are a little more expensive than the incandescent light kits — an average kit with two light stands, reflectors, and bulbs costs about $160. Fluorescent kits aren't usually equipped with umbrellas or softboxes because the light is already fairly soft. You can buy these kinds of accessories and there are kits available that come with softboxes and umbrellas, although they cost significantly more. Unfortunately, there aren't many low-cost alternatives to buying a fluorescent light kit. The only real option is to use the clamp light mentioned earlier in the chapter and fit it with a fluorescent bulb that has a standard bulb base on it. These types of fluorescent bulbs are readily available at any store that sells light bulbs.

D3100 Flash Basics

A flash is a device that electronically creates a quick burst of brilliant light by discharging a high voltage pulse of electricity through a tube filled with Xenon gas. This technology allows you to take photos in low-light situations by illuminating the subject for the brief duration that the camera's shutter is open.

Most camera manufacturers offer flash units; Nikon's are called Speedlights. Nikon Speedlights are dedicated flash units, meaning they are built specifically for use with the Nikon camera system and offer much more functionality than a nondedicated flash. A nondedicated flash is a flash made by a third-party manufacturer; the flashes usually don't offer fully automated flash features. There are, however, some non-Nikon flashes that use Nikon's i-TTL flash metering system. The i-TTL system allows the flash to operate automatically, usually resulting in a perfect exposure without you having to do any calculations. The i-TTL mode is covered later in the chapter.

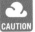 Not all Nikon Speedlights are fully compatible with dSLRs such as the D3100. CAUTION Speedlights such as the SB-900, SB-800, SB-700, SB-600, and SB-400 can be used with full functionality, whereas older Speedlights such as the SB-80DX, the SB-50DX, the SB-28, the SB-26, and SB-24 can only be used by manually setting the output or using non-TTL Auto, in which a sensor on the Speedlight determines the right amount of output.

Understanding Flash Exposure

If you are using your Speedlight in the i-TTL mode, the flash calculations are automatically applied for you, but it's always good to know how to achieve the same results if you don't have the technology to rely on as well as to understand how to work with the numbers. When you know these calculations, you can use any flash and get excellent results. Once you understand the formulas, the numbers, and where to plug them in, it's quite simple. Once you learn how to adjust the flash manually you may prefer to do it that way as opposed to using full Auto.

There are three main components that go into making a properly exposed flash photograph: Guide Number (GN), aperture, and distance. If one of these elements is changed, another one must be changed proportionally to keep the exposure consistent. The following sections cover each element and how to put them together.

Guide Number

The first component in the equation for determining proper flash exposure is the Guide Number, which is a numeric value that represents the amount of light emitted by the flash. You can find the GN for your specific Speedlight in the owner's manual. The GN changes with the ISO sensitivity to which your camera is set; for example, the GN for a Speedlight at ISO 400 is greater than the GN for the same Speedlight when it's set to ISO 100 (because of the increased sensitivity of the sensor). The GN also differs depending on the zoom setting of the Speedlight. The owner's manual has a table that breaks down the GNs according to the flash output setting and the zoom range selected on the Speedlight.

 If you plan to do a lot of manual flash exposures, I suggest making a copy of the GN table from the owner's manual and keep it in your camera bag.

Aperture

The second component in the flash exposure equation is the aperture setting. As you already know, the wider the aperture, the more light that falls on the sensor. Using a wider aperture allows you to use a lower power setting on your flash, or if you're using the automatic i-TTL mode, the camera fires the flash using less power. This allows your flash to recycle (think recharge) faster as well as putting less of a drain on your batteries.

Distance

The third component in the flash exposure equation is the distance from the light source to the subject. The closer the light is to your subject, the more light falls on it. Conversely, the farther away the light source is, the less illumination your subject receives. This is important because if you set your Speedlight to a certain output, you can still achieve a proper exposure by moving the Speedlight closer or farther away as needed.

GN / Distance = Aperture

Here's where the GN, aperture, and distance all come together. The basic formula allows you to take the GN and divide it by the distance to determine the aperture at which you need to shoot. You can change this equation to find out what you want to know specifically:

▶ **GN / D = A.** If you know the GN of the flash and the distance of the flash from the subject, you can determine the aperture to use to achieve the proper exposure.

▶ **GN / A = D.** If you know the aperture you want to use and the GN of the flash, you can determine the distance to place your flash from the subject.

▶ **A × D = GN.** If you already have the right exposure, you can take your aperture setting and multiply it by the distance of the flash from the subject to determine the approximate GN of the flash.

Built-in Flash exposure modes

Flashes have different modes that determine how they receive the information on how to set the exposure. The built-in flash has two different exposure modes to choose from: Manual, which you set yourself, and i-TTL, which allows the camera to determine the Speedlight settings. Some external Speedights such as the SB-400 and SB-600 have the same exposure modes as the built-in flash, while the more-expensive units have even more modes. This section covers the two modes that are immediately available with the built-in flash.

i-TTL

The D3100 determines the proper flash exposure automatically by using Nikon's proprietary i-TTL system. The camera gets most of the metering information from monitor preflashes emitted from the Speedlight. These preflashes are emitted almost

simultaneously with the main flash so it looks as if the flash has only fired once. The camera also uses data from the lens, such as distance information and f-stop values, to help determine the proper flash exposure.

 In the camera and Speedlight menu system i-TTL is referred to simply as TTL.

Additionally, two separate types of i-TTL flash metering are available for the D3100: i-TTL BL (Balanced Fill-Flash) and standard i-TTL flash. With i-TTL BL mode, the camera attempts to balance the light from the flash with the ambient light to produce a more natural-looking image. With Standard i-TTL flash, the camera determines the exposure for the subject only, and does not take the background lighting into account.

When using the built-in flash on the D3100, the default mode when using Matrix or Center-weighted metering is the i-TTL BL mode. To switch the flash to standard i-TTL, the camera simply selects Spot metering.

The Standard i-TTL and i-TTL BL flash modes are available with Nikon's current Speedlight lineup, including the SB-900, SB-800, SB-600, SB-400, and the R1C1 Macro flash kit.

Manual

When you set your flash to full Manual mode, you must adjust the settings yourself. The best way to figure out the settings is by using a handheld flash meter or by using the GN/D = A formula discussed previously.

The built-in flash is set by fractions in Manual mode, 1/1 is full power. The output is halved for each setting (which is equal to one stop of light). The settings are Full, 1/2, 1/4, 1/8, 1/16, 1/32.

The Guide Number for the built-in flash is 39 when measuring distance in feet, or 12 when using meters, at full power (1/1) set to ISO 100. To determine the GN at higher ISO settings multiply the Guide Number by 1.4 for each stop the ISO increases. For example doubling the ISO setting to 200 increases the GN by a factor of 1.4, so GN $39 \times 1.4 = $ GN 54.6.

Similarly, when reducing the flash power by one stop you divide the GN by a factor of 1.4, so at half power (1/2) the GN is about 28; GN 39 / 1.4 = GN 27.8.

Flash sync modes

Flash sync modes control how the flash operates in conjunction with your D3100 shutter. These modes work with both the built-in Speedlight and accessory Speedlights, such as the SB-900, SB-800, SB-700, SB-600, and so on. These modes allow you to choose when the flash fires, either at the beginning of the exposure or at the end, and they also allow you to keep the shutter open for longer periods, enabling you to capture more ambient light in low-light situations.

Flash sync can be changed on the camera by pressing the Flash mode button and rotating the Command dial.

Sync speed

Before getting into the different sync modes, you need to understand sync speed. The sync speed is the fastest shutter speed that can be used while achieving a full flash exposure. This means if you set your shutter speed at a speed faster than the rated sync speed of the camera, you don't get a full exposure and end up with a partially underexposed image. With the D3100, you can't actually set the shutter speed above the rated sync speed of 1/200 second when using a dedicated flash because the camera won't let you. This means you don't need to worry about having partially black images when using a Speedlight. But if you're considering using a studio strobe or a third-party flash, you should be aware of this.

Limited sync speeds exist because of the way shutters in modern cameras work. As you already know, the shutter controls the amount of time the light is allowed to reach the imaging sensor. All dSLR cameras have what is called a *focal plane shutter*. This term stems from the fact that the shutter is located directly in front of the focal plane, which is essentially the sensor. The focal plane shutter has two shutter curtains that travel vertically in front of the sensor to control the time the light can enter through the lens. At slower shutter speeds, the front curtain covering the sensor moves away, exposing the sensor to light for a set amount of time. When the exposure has been made, the second curtain then moves in to block the light, thus ending the exposure.

To achieve a faster shutter speed, the second curtain of the shutter starts closing before the first curtain has exposed the sensor completely. This means the sensor is actually exposed by a slit that travels the length of the sensor. This allows your

camera to have extremely fast shutter speeds, but limits the flash sync speed because the entire sensor must be exposed to the flash at once to achieve a full exposure.

Front-curtain sync

Front-curtain sync is the default sync mode for your camera whether you are using the built-in flash, one of Nikon's dedicated Speedlights, or a third-party accessory flash. With Front-curtain sync, the flash is fired as soon as the shutter's front curtain fully opens. This mode works well with most general flash applications.

One thing worth mentioning about Front-curtain sync is that although it works well when you're using relatively fast shutter speeds, when the shutter is slowed down (also known as dragging the shutter when doing flash photography), especially when you photograph moving subjects, your images have an unnatural-looking blur in front of them. Ambient light recording the moving subject creates this.

6.10 A shot using Front-curtain sync with a shutter speed of 1 second. Notice that the flash freezes the hand during the beginning of the exposure and the trail caused by the ambient exposure appears in the front, causing the hand to look like it's moving backward.

Red-eye reduction

You've no doubt seen red-eye in a picture at one time or another — that unholy red glare emanating from the subject's eyes that is caused by light reflecting off the retina. Fortunately, the D3100 offers a Red-Eye Reduction flash mode. When this mode is activated, the camera turns on the AF-assist illuminator (when using the built-in flash) or fires some preflashes (when using an accessory Speedlight), which cause the pupils of the subject's eyes to contract. This stops the light from the flash from reflecting off of the retina and reduces or eliminates the red-eye effect. This mode is useful when taking portraits or snapshots of people or pets when there is little light available.

Slow sync

Sometimes when using a flash at night, especially when the background is very dark, the subject is lit but the background is extremely dark and the subject appears to be in a black hole. Slow Sync mode helps take care of this problem. In Slow Sync mode, the camera allows you to set a longer shutter speed (up to 30 seconds) to capture the ambient light of the background. Your subject and the background are lit, so you can achieve a more natural-looking photograph.

When doing flash photography at slow speeds, your camera is actually recording two exposures: the flash exposure and the ambient light. When you use a fast shutter speed, the ambient light usually isn't bright enough to have an effect on the image. When you slow down the shutter speed it allows the ambient light to be recorded to the sensor balancing the light from the flash with the ambient light. If the shutter speed is too slow you get an effect that is known as *ghosting*. Ghosting is a partial exposure that is usually fairly transparent-looking on the image. Ghosting is especially noticeable on moving subjects. Figure 6.11 shows a pretty extreme example of ghosting and how it can be used creatively. However, most often you do not want this effect in your photos.

When using Front-curtain sync, ghosting causes a trail to appear in front of the subject because the flash freezes the initial movement of the subject. Because the subject is still moving, the ambient light records it as a blur that appears in front of the subject, creating the illusion that it's moving backward. To counteract this problem, you can use a Rear-curtain sync setting, which I explain in the next section.

6.11 An example of ghosting in a slow-sync image

 Slow sync can be used in conjunction with Red-Eye Reduction for night portraits.

 When using Slow sync, be sure the subject stays still for the whole exposure to avoid ghosting. Or you can use ghosting creatively by purposely having the subject move to create a motion blur.

Rear-curtain sync

Earlier I discussed how when using a long shutter speed with Front-curtain sync the image can have an unnatural-looking trail in front of a moving subject. When using Rear-curtain sync, the camera fires the flash just before the rear curtain of the shutter starts moving. This allows the motion to be more accurately portrayed by causing a motion blur trail behind the subject rather in front of it, as is the case with Front-curtain sync. Rear-curtain sync is often used in conjunction with Slow sync.

6.12 An image taken using the default flash sync mode at night. Notice how the subject appears to be in a "black hole."

6.13 An image taken using straight flash at night with Slow sync. Notice how the ambient light is balanced with the flash resulting in a more natural look. Slight ghosting results in reduction of sharpness.

151

6.14 A picture taken using Rear-curtain sync. The flash freezes the motion at the end of the exposure, which causes the ghosting to appear behind the subject. This allows you to portray forward motion more accurately.

Flash Exposure Compensation

When you photograph subjects using flash, whether you use an external Speedlight or the built-in flash on your D3100, there may be times when the flash causes your principal subject to appear too light or too dark. This usually occurs in difficult lighting situations, especially when you use i-TTL metering. Your camera's meter can get fooled into thinking the subject needs more or less light than it actually does. This can happen when the background is very bright or very dark, or when the subject is off in the distance or very small in the frame.

Flash Exposure Compensation (FEC) allows you to manually adjust the flash output while still retaining TTL readings so your flash exposure is at least in the ballpark. With the D3100, you can vary the output of your built-in flash's TTL setting from −3 Exposure Value (EV) to +1 EV. This means if your flash exposure is too bright, you can adjust it down to 3 full stops under the original setting. Or if the image seems underexposed or too dark, you can adjust it to be brighter by 1 full stop. Additionally, the D3100 allows you to fine-tune how much exposure compensation is applied by letting you set the FEC incrementally in 1/3 stops of light.

Fill flash

Fill flash is a handy flash technique that allows you to use your Speedlight as a secondary light source to fill in the shadows rather than as the main light source, hence the term *fill flash*. Fill flash is used mainly in outdoor photography when the sun is very bright, creating deep shadows and bright highlights that result in an image with very high contrast and a wide tonal range. Using fill flash allows you to reduce the contrast of the image by filling in the dark shadows, thus allowing you to see more detail in the image.

You also may want to use fill flash when your subject is backlit (lit from behind). When the subject is backlit, the camera's meter takes into account the bright part of the image that is behind your subject. This results in a properly exposed background while your subject is underexposed and dark. However, if you use the spot meter to obtain the proper exposure on your subject, the background will be overexposed and blown out. The ideal thing is to use fill flash to provide an amount of light on your subject that is equal to the ambient light of the background. This brings sufficient detail to both the subject and the background, resulting in a properly and evenly exposed image.

6.15 A portrait taken without fill flash **6.16 A portrait taken with fill flash**

All of Nikon's dSLR cameras offer i-TTL BL (Nikon calls this Balanced Fill-Flash) or, in laymen's terms, automatic fill flash, with both the built-in flash and detachable Speedlights SB-900, SB-800, SB-600, and SB-400. When using a Speedlight, the camera automatically sets the flash to do fill flash (as long as you're not in Spot metering mode). This is a very handy feature because it allows you to concentrate on composition and not worry about your flash settings. If you decide that you don't want to use the i-TTL BL option, you can set the camera's metering mode to Spot metering, or if you are using an SB-900, SB-800, or SB-600, simply press the Speedlight's Mode button.

Of course, if you don't own an additional i-TTL dedicated Speedlight or you'd rather control your flash manually, you can still do fill flash. It's actually a pretty simple process that can vastly improve your images when you use it in the right situations.

To execute a manual fill flash, follow these steps:

1. **Use the camera's light meter to determine the proper exposure for the background or ambient light.** A typical exposure for a sunny day is 1/125 second at f/16 with an ISO of 100. Be sure not to set the shutter speed higher than the rated sync speed of 1/200.

2. **Determine the flash exposure.** Using the GN/D = A formula, find the setting that you need to properly expose the subject with the flash.

3. **Reduce the flash output.** Reducing the flash output from your calculated exposure down 1/3 to 2/3 stops allows the flash exposure to be less noticeable while filling in the shadows or lighting your backlit subject. This makes your images look more natural, as if a flash didn't light them, which is the ultimate goal when attempting fill flash.

Bounce flash

Probably the easiest way to improve your flash pictures, especially snapshots, is to use bounce flash. Bounce flash is a technique in which you bounce the light from the flash unit off of the ceiling or a wall onto the subject to diffuse the light, resulting in a more evenly lit image. To do this, your flash must have a head that swivels and tilts. All current Nikon Speedlights have a swiveling head, although the SB-400 head doesn't swivel left or right, it only tilts up. When you attempt bounce flash, you want to get as much light from the flash onto your subject as you can. To do this, you need to first look at the placement of the subject and adjust the angle of the flash head appropriately. Consider the height of the ceiling or distance from the surface you intend to bounce the light from to the subject.

Diffusers

One of the easiest ways to improve your flash photography is to use a flash diffuser. These are simple devices that fit over or are placed in front of the flash head. As the name implies, a diffuser diffuses, or softens, the light. This helps to avoid that annoying dark black shadow that often appears next to your subject when taking photos using direct flash. There are a lot of different types of diffusers that range in price from $10 all the way up to $60. The type of diffuser I use depends on which flash I'm using. When using the built-in flash, I use a LumiQuest Soft Screen that I picked up at my local camera store for about $12. When using the SB-900 or SB-800, I use the diffusers that were included with them, and for the SB-600, I use a Sto-Fen Omni-Bounce. I've tried other diffusers, particularly the Gary Fong Lightsphere, and found it too bulky, not to mention it's no better than the smaller diffusers that are easier to store in your camera bag.

I almost never use a flash or Speedlight without a diffuser unless I am specifically aiming for a scene that has very hard and directional light. If you use the built-in flash a lot, I recommend *always* using a diffuser. I cannot stress this point enough. It makes a huge difference in image quality.

Unfortunately, not all ceilings are useful for bouncing flash. For example, the ceiling in my studio is corrugated metal with iron crossbeams. If I attempted to bounce flash from a ceiling like that, it would make little or no difference to the image because the light won't reflect evenly and will scatter in all directions. In a situation where the ceiling is not usable, you can position the subject next to a wall and swivel the flash head in the direction of the wall and bounce it from there.

 To bounce the flash at the correct angle, remember the angle of incidence equals the angle of reflection.

You want to aim the flash head at such an angle that the flash isn't going to bounce in behind the subject so it is poorly lit. You want to be sure that the light is bounced so that it falls onto your subject. When the subject is very close to you, you need to have your flash head positioned at a more obtuse angle than when the subject is

farther away. I recommend positioning the subject at least 10 feet away and setting the angle of the flash head at 45 degrees for a typical height ceiling of about 8 to 10 feet.

An important pitfall to be aware of when bouncing flash is that reflected light picks up and transmits the color of the surface from which it bounces. This means if you bounce light off a red surface, your subject will have a reddish tint to it. The best approach is to avoid bouncing light off of surfaces that are brightly colored, and stick with bouncing light from a neutral-colored surface. White surfaces tend to work the best because they reflect more light and don't add any color. Neutral gray surfaces also work well, although you can lose a little light due to lessened reflectivity and the darker color.

Unfortunately, you can't do bounce flash with the built-in flash on the D3100; you need an external Speedlight such as an SB-900, SB-800, SB-600, or SB-400.

6.17 A picture taken with straight flash **6.18 A picture taken with bounced flash**

Studio Strobes

One thing that bears mentioning is the use of studio strobes. Most professional photographers, especially those who shoot large sets and fashion, use studio strobes. These are large, high-powered flashes. They function in much the same way as a shoe-mount flash such as a Speedlight, but they run off of household AC and must be triggered by the camera using a sync cord or some sort of other trigger.

These strobes are completely manual, and the exposure setting must be figured out by using a flash meter or using the trusted GN / D = A equation.

There are two types of studio strobes: standard pack and monolights. Standard pack and head strobes have a separate power pack and flash heads that are controlled centrally from the power pack. Monolights are flash heads that have a power pack built in and you adjust them individually at each head. Monolights tend to be lower in power than standard strobes, but they are more portable and less expensive.

Nikon Creative Lighting System Basics

Nikon introduced the Creative Lighting System (CLS) in 2004. CLS is Nikon's name for its innovative flash technology that uses i-TTL metering and also allows Speedlights to communicate with each other wirelessly. This allows you to position the Speedlights wherever you want and control the direction of light to make the subject appear exactly how you want. The Nikon CLS enables you to achieve creative lighting scenarios similar to what you would achieve with expensive and much larger studio strobes. You can do it wirelessly with the benefit of full i-TTL metering. To take advantage of the Nikon CLS, you need the D3100 and at least one SB-900, SB-800, or SU-800 as a commander and another SB-900, SB-800, or SB-600 Speedlight. With the CLS, there is no more mucking about with huge power packs and heavy strobe heads on heavy-duty stands, with cables and wires running all over the place.

The Nikon CLS is not a lighting system in and of itself, but is comprised of many different pieces you can add to your system as you see fit (or your budget allows). The first and foremost piece of the equation is your camera.

Understanding the Creative Lighting System

The Nikon CLS is basically a communication system that allows the camera, the commander, and the remote units to share information regarding exposure.

A *commander*, which is also called a master, is the flash that controls external Speedlights. Remote units, which are sometimes referred to as slaves, are the external flash units the commander controls remotely. Communication between the commander and the remote units is accomplished by using pulse modulation. *Pulse modulation* is a term that means the commanding Speedlight fires rapid bursts of light in a specific order. The pulses of light are used to convey information to the remote group, which interprets the bursts of light as coded information.

Firing the commander tells the other Speedlights in the system when and at what power to fire. Using an SB-800 or SB-900 Speedlight or an SU-800 Commander as a master allows you to control three groups of remote flashes.

This is how CLS works in a nutshell:

1. **The commander unit sends out instructions to the remote groups to fire a series of monitor preflashes to determine the exposure level.** The camera's i-TTL metering sensor reads the preflashes from all the remote groups and also takes a reading of the ambient light.

2. **The camera tells the commander unit the proper exposure readings for each group of remote Speedlights.** When the shutter is released, the commander, via pulse modulation, relays the information to each group of remote Speedlights.

3. **The remote units fire at the output specified by the camera's i-TTL meter, and the shutter closes.**

All these calculations happen in a fraction of a second as soon as you press the Shutter Release button. It appears to the naked eye as if the flash just fires once. There is no waiting for the camera and the Speedlights to do the calculations.

Although you'll need to buy at least two Speedlights, one to act as a commander (SB-900, SB-800, or SU-800) and one to act as a remote (SB-900, SB-800, or SB-600), I'd highly recommend it if you're planning on doing any sort of advanced photography.

For a definitive and in-depth look into the Nikon CLS, read the *Nikon Creative Lighting System Digital Field Guide, 2nd Edition*, also from Wiley.

Speedlights

Speedlights are Nikon's line of flashes. They are amazing accessories to add to your kit, and you can control most of them wirelessly. Currently, there are four shoe-mounted flashes that work with the D3100 — the SB-900, SB-800, SB-600, and SB-400. Two macro lighting ring flash setups — the R1 or R1C1 that include two SB-R200 Speedlights — are also available. You can also purchase SB-R200s for the R1 kits and the SU-800 Wireless Commander unit.

This is not meant to be a definitive guide to the Nikon Speedlight system, but a quick overview of some of the flashes Nikon has to offer and their major features.

 The SB-400 cannot be used as a wireless remote.

SB-900

The SB-900 Speedlight is Nikon's most powerful Speedlight. This flash takes all the features of Nikon's previous flagship flash, the SB-800, and expands on them, adding more power, a greater range, and a more intuitive user interface. You can use the SB-900 as an on-camera flash, a commander flash that can control up to three groups of external Speedlights on four channels, or a remote flash that you control from another SB-900, SB-800, or an SU-800 Wireless Commander. The SB-900 automatically detects whether it's attached to an FX or DX-format camera, ensuring you get the maximum efficiency.

SB-800

The SB-800 has been recently discontinued, but if you can find a used one it will work perfectly with the D3100. The SB-800 can be used not only as a flash but also as a commander to control up to three groups of external Speedlights on four channels. You can also set the SB-800 to work as a remote flash for off-camera applications. The SB-800 has a built-in AF-assist Illuminator to assist in achieving focus in low light. The SB-800 has a powerful GN of 184 at ISO 200.

SB-700

The SB-700 is Nikon's newest Speedlight and it's much smaller than the SB-800 and 900, but a little bigger than the SB-600. The SB-700 is a powerhouse flash; it takes all of the great features of the larger Speedlights such as the capability to control external Speedlights wirelessly and packs it into a smaller package. The SB-700 has also inherited the numerous switches and dials from the SB-900, which makes it much quicker to find and change the settings.

SB-600

The SB-600 Speedlight is the SB-900 or SB-800's little brother. This flash has fewer features than its bigger siblings but has most of the features you need. You can use it on the camera as well as off camera by setting it as a remote. Like the SB-900 and SB-800, the SB-600 also has a built-in AF-assist Illuminator. The SB-600 cannot, however, be used as a commander to control off-camera flash units. The SB-600 has an impressive GN of 138 at ISO 200, which, although it gives about 1 stop less light than the SB-800, is more than enough for most subjects.

 You can use a Nikon SC-28 TTL remote cord to get your Speedlight off-camera. This is an economical way to start using off-camera flash without the need for an expensive Speedlight for a commander flash.

SB-400

The SB-400 is Nikon's entry-level Speedlight. It can only be used in the i-TTL/i-TTL BL mode. One nice feature is the horizontally tilting flash head that allows you to do bounce flash. Unfortunately, this only works when the camera is in the horizontal position, unless you bounce off a wall when holding the camera vertically. For such a small flash, the SB-400 has a decent GN of 98 at ISO 200.

 The SB-400 does not work wirelessly with the Nikon CLS. It only works when connected to the camera hot shoe or a Nikon SC-28 TTL remote cord.

SU-800 wireless Speedlight commander

The SU-800 is a wireless Speedlight commander that uses infrared technology to communicate wirelessly with off-camera Speedlights. It can control up to three groups of Speedlights on four different channels.

Working with Live View and Video

Nikon has been improving its Live View / video feature with every camera it releases and with the D3100 it made some pretty radical changes. Live View is now standard on almost every camera in Nikon's current lineup and adds convenience to the picture-taking process and also eases the transition for those stepping up from compact cameras.

The main changes were that it added full resolution 1080p HD video while the early cameras recorded at 720p, and probably the biggest feature is the addition of full-time autofocus, the first of its kind in HD dSLRs.

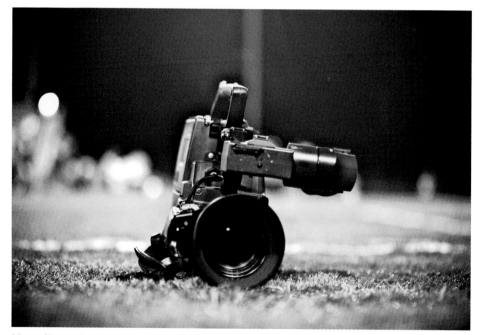

Many filmmakers are turning to dLSR cameras because of their portability and wide selection of lenses.

Live View

This feature has recently become a standard feature in dSLRs. Using Live View allows you to view a live feed of what is being projected onto the sensor from the lens. As you may already know the image from the lens is projected to the viewfinder via a mirror that is in front of the sensor. There's a semi-transparent area in the mirror that acts as a beam splitter, which is used by the camera for its normal phase detection AF. For Live View to work, the mirror must be flipped up, making phase-detection AF unusable so the camera uses contrast detection directly from the sensor to determine focus. This makes focusing with Live View a bit slower than when focusing normally. In addition, when shooting, the mirror must flip down and back up, which takes some extra time. This makes Live View not the best option to use when shooting moving subjects or things like sports where timing is the key element in capturing an image successfully.

That being said, Live View can come in handy when shooting in a studio setting, especially when using a tripod. You can move the focus area anywhere in the frame. You're not limited to the 11 AF points. Live View can also be handy when grabbing everyday snapshots.

 Keep in mind that when using Live View handheld you are holding the camera **CAUTION** at arm's length and that increases the risk of blurry images due to added camera shake.

Focus Modes

The D3100 offers a few different focus modes when using Live View or Video mode. They are similar in operation to the focus modes you use when shooting stills using the viewfinder.

AF-S Single servo

This is equivalent to single AF (AF-S) in the normal Shooting mode. Use the multi-selector to move to focus point to your subject, half-press the Shutter Release button to focus. The shutter won't release until the camera detects that the scene is in focus. Pressing the Record button starts the recording, but the focus will be locked on the initial subject.

This setting is best for stationary subjects like portraits, still life, products, and landscapes.

For video you need to be sure that your subject isn't moving at all, especially if you're using a wide aperture for shallow depth of field. Even the slightest change in distance can cause the subject to go out of focus.

AF-F Full time servo

This is a new feature that was introduced with the D3100 and D7000 cameras. This Focus mode allows the camera to focus continuously while in Live View or when shooting video (similar to AF-C continuous AF). Even though the camera is focusing continuously to shoot a still frame, the AF is engaged and refocuses before releasing the shutter. I find that this mode works best when shooting video.

Full-time AF operates in conjunction with the AF-Area modes, which are covered in the next section.

AF area modes

To make the Live View focusing quicker and easier, Nikon has given you a few different options for AF area modes. These modes noticeably speed up the process of focusing as compared to previous cameras. You can change the settings in the Shooting menu under AF-area mode �'t Live view.

 The AF area mode cannot be changed while recording video.

▶ **Face priority AF.** Use this mode for shooting portraits or snapshots of the family. You can choose the focus point but the camera uses face recognition to focus on the face rather than something in the foreground or background. This can really be an asset when shooting in a busy environment, such as when there's a lot of distracting elements in the background. When the camera detects a face in the frame, a double yellow border is displayed around the AF area. If more than one face is detected (the camera can read up to 35 faces), then the closest face is chosen as the focus point.

▶ **Wide-area AF.** This makes the area where the camera determines focus from about 4X the size of the Normal-area AF mode. This is good when you don't need to be very critical about the point of focus in your image. For example, when shooting a far-off landscape you really only need to focus on the horizon line. This is a good general mode for everyday use. You can move the AF area anywhere within the image frame.

 When using Face priority, Normal-area, or Wide-area AF press the OK button to move the AF area to the center of the frame.

▶ **Normal-area AF.** This mode has a smaller AF point and is used when you need to achieve focus on a very specific area within the frame. This is the preferred mode to use when shooting with a tripod. It's the mode I use when shooting macros, still life, and similar subjects. I also use this mode when shooting portraits instead of Face Priority so I can control the AF area.

▶ **Subject tracking AF.** This is a pretty cool feature especially when used in conjunction with video. Use the multi-selector to position the AF area over top of the main subject of the image. Press the OK button to start the tracking. The AF area follows along with the subject as it moves around within the frame. Be aware, however, that this feature works best with slow to moderately fast-paced subjects that stand out from the background. When using this mode with very fast-moving subjects, the camera tends to lose the subject and lock on something of similar color and brightness within the frame. This mode also decreases in effectiveness the lower the light gets. To disable the subject tracking simply press the OK button. This resets the AF area to the center. To reactivate press the OK button again.

 When half-pressing the Shutter Release button to focus for taking a still shot subject tracking is disabled. Releasing the button reactivates tracking.

Video

It was just about two years ago that Nikon introduced the world's first dSLR with HD video capability, the D90. Since then Nikon has been adding features to the video mode with every new camera. The D3100 is Nikon's first camera with true 1080p HD video, and it's the first dSLR to feature full-time AF while actually *recording* video.

Before going any further one thing must be made clear: The D3100 is not a video camera. It's a still camera that just happens to record video by using the feed from the Live View feature. The D3100 is one of Nikon's newest dSLR cameras, and it's an excellent example of that. It has a 14-megapixel sensor, low noise at high ISO settings, and a fast, continuous shutter speed — everything you could want from a dSLR. Why am I bringing this up? Because there are some people who aren't happy with the current video performance in dSLR cameras. These evaluations are being

based on comparisons to dedicated video cameras. This is an unfair comparison, as the D3100 was designed primarily to shoot still photographs, and it does an excellent job accomplishing that. You wouldn't compare a still grab from a video camera to a high-res still image from the D3100, would you? Of course not. It's like comparing apples to oranges.

The D3100's Video mode is, for all practical purposes, fully automatic. Once you flip the switch to activate Live View and the Video mode, the camera controls all the settings. Shutter speed and ISO can't be adjusted at all, and the aperture setting is locked in once Live View is activated. The only way to manually adjust the exposure is by applying exposure compensation. There are some ways to get around the total lack of control, which are covered as you go through this chapter.

That being said, HD dSLR videography has been taking off, not just for still photographers, but for serious filmmakers as well. Many TV shows and feature films have been made using HD dSLR cameras because dSLR cameras like the D3100 have advantages that far outweigh any perceived drawbacks when compared to a dedicated video camera. Here are a few of the major advantages that dSLR cameras have over HD video cameras.

▶ **Price.** dSLR cameras are much cheaper than a mid- to pro-level HD video camera.

▶ **Image quality.** The D3100's APS-C–sized sensor also allows the camera to record video with less noise at high sensitivities than most video cameras can.

▶ **Interchangeable lenses.** You can use almost every Nikon lens ever made on the D3100. While some HD video cameras take Nikon lenses, you need an expensive adapter, and you lose some resolution and the ability to get a very shallow depth of field.

▶ **Depth of field.** You can get a much more shallow depth of field than video when using a lens with a fast aperture, such as a 50mm f/1.4. Most video cameras have sensors that are much smaller than the sensor of the D3100, which gives them a much deeper depth of field. A shallow depth of field gives videos a much more professional cinematic look.

About Video

Before getting into the basics of the D3100's Video mode, it's best to do a little exploration into the realm of video. Video capture functions much differently from still-photo capture. Of course, all photography is capturing light by using a sensor (or film), a lens,

and a lightproof box (your camera). Video is just digitally capturing still images at a high frame rate and playing them back sequentially.

The D3100 can shoot video in three resolutions that can be set in the Shooting menu under the Movie settings option or in the Info display. You can choose a small video size of 640 × 424 pixels, which is shot using a 3:2 aspect ratio. This is the same ratio at which still images are recorded. This resolution is very small and best suited for filming small clips that are sent through e-mail or for posting on the Internet without using up too much bandwidth. Note that this setting is not HD. The best setting to use is the 1080p/24fps HD setting, which is a 16:9 or cinematic ratio. This setting gives you the most resolution and can easily be watched on large HDTVs, offering an exceptional image quality. For smaller HD videos you can record at 720p, which offers more than enough resolution for all practical purposes.

Progressive versus interlaced

If you're familiar with HD, you've probably heard the terms progressive and interlaced. Your D3100 has an HDMI output setting (found in the Setup menu) that lets you choose between progressive and interlaced resolutions. So, what's the difference? Interlaced video is displayed on your television by scanning in every other line that makes up the picture, which actually appears as if it's being displayed all at once and how television has been displayed since the beginning. Progressive scanning works by progressively displaying single lines of the image. As with interlaced technology, all of this happens too fast for the human eye to detect the separate changes, and so everything appears to happen all at once.

Both of these types of video display can be used for HD viewing. Progressive video resolution is most commonly displayed at 720p and interlaced at 1080i. Because only half of the image is being sent at a time, 1080i is actually only broadcasting at 540 lines per second. So, although 1080i technically has a higher resolution, 720p has better image quality. Neither is really better than the other, and each has it own specific strengths and weaknesses.

Frame rate

You may have noticed at the end of the resolution number (1080 or 720) there is another number (24, 25, 30). This number is the *frame rate* or the number of frames recorded every second and is expressed using the term *frames per second (fps)*.

As mentioned earlier, video capture is simply recording still images, linking them together, and then playing them back one after another in sequence. This allows the still images to appear as if they're moving. An important part of video capture is frame rate. This is the rate at which the still images are recorded and is almost always expressed in terms of frames per second (fps). Most video cameras capture video at 30 or 60 fps. A rate of 30 fps is generally considered the best for smooth-looking video that doesn't appear jerky. Shooting at 24 fps is the minimum rate to fool the human eye into seeing seamless motion. This also gives videos a quality that's similar to cinema.

The Nikon D3100 shoots full HD video at 24 fps, giving you a cinematic feel from the start. You can select different frame rates when shooting at 720p. You can choose to record at 24, 25, or 30fps. This can be set in the Shooting menu under the Movie settings option or in the Info display menu. Select 24fps for the cinematic look, or 30fps for a smoother look. The 25fps option is for videos that will be played back on PAL devices (the analog TV encoding system used in Europe).

Shutter

When shooting video with your D3100, the camera isn't using the mechanical shutter that it uses when making still exposures. The Video mode uses what's known as an electronic shutter. This electronic shutter isn't an actual physical shutter but is a feature of the sensor that tells the sensor when to activate to become sensitive to the light striking it. The D3100 has a CMOS sensor that uses what is known as a rolling shutter.

A rolling shutter operates by exposing each row of pixels progressively (similar to HDTV reception discussed earlier) from top to bottom. In effect, it rolls the exposure down the sensor row by row. Unfortunately, this rolling shutter has a few unwanted artifacts that are inherent in its operation. These artifacts are usually most noticeable when the camera is making quick panning movements or the subject is moving from one side of the frame to the other. There are three types of artifacts common to the rolling shutter:

▶ **Skew.** This is the most common artifact. Skew causes objects in the video to appear as if they're leaning (or skewed). This artifact only appears when the camera is quickly panned. This artifact is caused by the image being progressively scanned. As just discussed, the rolling shutter exposes each single frame from the top down. When the camera is moved sideways while the frame is

being exposed, the top of the subject is exposed on one side of the frame, and the bottom of the subject is on the other side of the frame. This can also be seen when a subject moves very quickly across the frame.

▶ **Jello.** This video problem is closely related to skew and occurs when the camera is panned quickly back and forth. First, the video skews to one side and then the other, causing it to look like it's made of jello; it looks as if the subject is wobbly. This is the most common problem you will encounter when shooting video with the D3100. Unfortunately, there's not much you can do about this problem. It's a symptom of the rolling shutter. Using a tripod can help to minimize it a bit.

▶ **Partial exposure.** This is caused by a brief flash of light, typically from a camera flash. As the shutter rolls down the frame, it's exposing for the ambient light. The brief flash duration causes part of the frame to be overexposed. This isn't a major problem, and you can expect to experience it at weddings or events where people are taking pictures with flash.

CAUTION Older fluorescent lights with low-frequency ballasts can cause video with a rolling shutter to flicker. Try changing the settings in the Flicker reduction option in the Setup menu if you run into this problem.

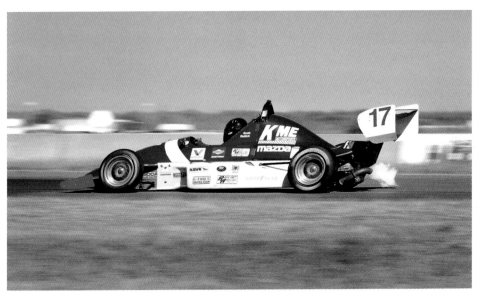

7.1 This is a still grab taken from a moving subject. Notice the distortion of the car, especially in the wheels, caused by the fast movement of the suject and the rolling shutter.

Dealing with the Jello Effect

One of the biggest complaints that I see on Internet forums about dSLR video is about the rolling shutter artifacts. While I agree that the jello effect looks very bad there's a very easy way to deal with it: *Don't do fast pans or whip pans.* It's that simple. If you know something is going to look bad, the easiest way around it is to avoid it.

Think like a filmmaker, use slow preplanned camera movements. This small tip will make your videos look more professional and is probably the best I can offer to deal with this problem.

Another easy way to minimize the effect is to use something to stabilize the camera, such as a steadi-cam. See the accessories appendix at the end of the book for ideas.

Setting up for video

Using the video feature is quite simple. Simply pull the Live View switch on the back of the camera to activate Live View, and then press the Record button to start recording. However, there are some important things to consider before you start recording:

▶ **Quality.** The Quality setting determines what size your videos are. Sizes and their uses are covered earlier in this chapter. You set the Quality by going to the Shooting menu, selecting the Movie settings option, selecting Quality, and then pressing OK. You have five choices: 1920 × 1080; 24fps (16:9), 1280 × 720; 24fps (16:9), 1280 × 720; 25fps (16:9), 1280 × 720; 30fps (16:9), or 640 × 424 (3:2).

▶ **Sound.** This option is also found under the Movie settings option. You can either record sound using the D3100's built-in microphone or you can turn the sound recording off.

▶ **Picture Control.** Just like your still images, the D3100 applies Picture Control settings to your movie. You can also create and use Custom Picture Controls that fit your specific application. For example, I created a Custom Picture Control called Raging Bull that uses the Monochrome Picture Control with added contrast and the yellow filter option. This gives me a black-and-white scene that's reminiscent of the Martin Scorsese film of the same name. Before you start recording your video, decide which Picture Control you want to use for your movie.

For more information on Picture Controls, see Chapter 2. For more on the D3100 menus, see Chapter 3.

Adding too much sharpening to a Picture Control can cause haloing in your movies.

▶ **Shooting mode.** Selecting a shooting mode is one of the most important parts of shooting video. This is how you select your lens aperture. The mode you select determines the aperture that you shoot with for the entire clip. This is important for controlling depth of field. The scene modes apply the same settings that they use for still photography, but they can be unpredictable. Because the shutter speed is controlled completely electronically, Shutter Priority mode isn't very useful either.

Using Programmed Auto is just taking a major risk with your aperture setting. Basically, that leaves you with the two most useful shooting modes: Aperture Priority and Manual. For all intents and purposes, these both operate exactly the same. Remember that the shutter is electronic and is completely controlled by the camera. The shutter speed that's displayed on the screen is for shooting stills in Live View and has no impact upon the movie. Basically, I recommend setting the camera to Aperture Priority mode when you record video. You can quickly set the aperture using the Command dial.

Recording

After you figure out all your settings and before you press the Record button, you want to get your shot in focus. You can do this by pressing the Shutter Release button halfway, as you normally would. When the AF point on the LCD is green, you're focused and ready to go. If you're using the AF-F full time autofocus be sure that the image is in focus before pressing the Record button.

Be aware that video clips are limited to 10 minutes in length to avoid overheating and damaging the sensor. You may notice that your videos may appear noisier near the end of clips due to thermally generated noise.

The only way to adjust the exposure while recording is to manually apply exposure compensation by pressing the Exposure Compensation button, and then rotating the Command dial. You can dial in ±5 stops. The camera chooses the ISO settings for you. The rest is up to your imagination. You can make short clips of your kids running around that you can later e-mail to the grandparents or you can get creative with some software and produce a full-length feature film. You're the director.

Sound

One thing to be aware of when recording video is that you're not only recording images you are also recording sound. The microphone is on the camera and noises, including those the camera makes when adjustments are made, will be picked up. It may not sound loud at the time, but it will be extremely loud in your footage. The best bet is to get your settings right before filming starts to avoid this, or to turn the sound recording off.

Although the full-time AF seems like a great feature there is one huge caveat: Nikon's Silent Wave Motor is *not* silent. The focusing mechanism of the lens is clearly picked up by the on-camera mic and is very evident during playback. Unfortunately Nikon did not include an external mic input as it does on other models so you're pretty much stuck with it. For this reason I recommend using AF-F sparingly. As I mentioned before, think like a filmmaker. Plan your shots and know where the focus will be and set it before you start recording.

If you're really computer savvy and you have the proper video-editing software, you can record sound using a separate sound recorder and sync it later using software such as Final Cut Pro or Adobe Premier.

Tricks, Tips, and Workarounds

You probably bought a dSLR because you wanted flexibility and control that you just can't get with a compact digital camera. Now you have a D3100, but the Video mode wants to operate like a point-and-shoot camera. Is there a way to completely and manually control the D3100's settings when using the HD video feature? The short answer is no, but there are some ways to work around the camera settings by tricking it into choosing the settings that you prefer:

▶ **AE-L.** You've probably noticed that as you're filming, the video goes from light to dark as the lighting changes, depending on what the scene is. If you're filming in a high-contrast area, this can make your video look bad. The constant dimming and brightening of the video can be quite distracting. To stop your camera exposure from fluctuating, simply press the AE-L button. The best way to do this is to go to the Setup menu ➞ Buttons and assign the AE-L/AF-L button to AE Lock (hold). This allows you to lock the exposure without holding the AE-L/AF-L button down.

You'll want to find a relatively neutral area in the scene and meter it by pointing the camera at it. Press the AE-L button to lock the exposure and record the video without fluctuations in your exposure. Be sure to press the AE-L button

again to unlock the exposure meter. Even if you exit Live View mode, the exposure remains locked until the camera is turned off or goes to sleep.

▶ **ISO.** Unfortunately, there are no selectable ISO settings when recording video. This makes it difficult to control the amount of noise that your videos show. Before I get started with this trick, I need to point out that this isn't exact science. This is just an estimation of the settings that the camera may or may not use. When shooting video, the camera doesn't actually use an ISO setting but adjusts the signal gain. This is very similar to adjusting the ISO sensitivity. Looking at the footage, it's apparent that in low light, the video appears noisier than video shot in bright light. This trick helps you to set the gain where you want it:

- **Select your camera settings.** Set the Quality, Sound, and Picture Control if needed. Set the camera to Aperture Priority or Manual. If you're using an MF, non-CPU lens, then set the shooting mode to Manual.

- **Set the scene.** Find the area or scene you're going to film. You need a constant light source, and the scene shouldn't have too much contrast or your exposures will be incorrect.

- **Set the aperture.** This step determines the ISO range the camera chooses. See Table 7.1 for settings.

- **Meter the scene.** This is important. Focus on an 18-percent gray card (found at the back of the book) or a neutral object to take a meter reading. Don't do this step in Live View. Focus on the card or neutral object as if you were taking a picture normally.

- **Lock the exposure.** Use the AE-L/AF-L button to lock the exposure. The button should be set to AE Lock (hold). You can set this in the Setup menu as described earlier in this section.

- **Activate Live View.** Pull the Live View switch. You're now ready to record your video by using the ISO range that you specified by the aperture setting.

NOTE Auto mode and Auto no-flash do not allow you to use the AE-L or Exposure Compensation feature for Live View or video recording.

The following table gives an approximation of the ISO sensitivity and noise levels in the video as they would relate to noise in still images.

Table 7.1: Aperture Settings

f/1.4–2.8	ISO 200–320
f/4–5.6	ISO 400–640
f/8–11	ISO 800–1200
f/16–32	ISO 1600+

▶ **Shutter speed.** The camera automatically selects the shutter speed for you, but you have a small amount of control by selecting the aperture. This tip is mostly for shooting moving subjects in bright sunlight. Fast shutter speeds can cause the video to appear slightly jerky because just as when shooting a still the action is frozen (remember videos are just stills played in succession) and as the subject moves through the frame there is no motion blur to make it look more natural to the eyes. Use a smaller aperture to slow down the shutter speed so that you get a little motion blur in the frame. Of course you can use the "jerky" fast shutter speed as an effect as well. Movies such as *Saving Private Ryan* and *Gladiator* made use of this effect in the action scenes. In this case, opening up the aperture is the key. It helps to use a fast lens such as a 35mm f/1.8.

Playback

Playing back your videos is super easy. Press the Play button on the back of the camera and scroll through the videos and stills as normal. When the video is displayed on the LCD screen simply press the OK button to start playback. Press the multi-selector up to stop, down to pause, and left or right to rewind or fast-forward. Use the Zoom in and Zoom out buttons to raise or lower the volume.

Connecting your camera to an HD or standard TV displays what is on the LCD on the TV and the options are the same.

Editing

You can make simple edits to your videos in-camera, for more serious edits you'll need to think about using third-party software such as iMovie for Mac or Premier Elements for PC users. Basically, you have three options. Choose the Start frame, choose the End frame, and grab a still image from the video. Each edit you make is saved as a new file so there's no need to worry about making any permanent changes to your original file. To edit your video do the following:

1. **Press the Menu button.** Use the multi-selector to select the Retouch menu.

2. **Select Edit Movie.** Press OK or multi-selector right to view menu options.

3. **Choose the edit you want to make.** The options are Choose start point, Choose end point, or Save selected frame. Press OK or multi-selector right. This pulls up a menu with all videos that are saved to the current card.

4. **Select the video.** Use the multi-selector to scroll through the available videos. The selected video is highlighted in yellow. Press OK when your video is selected.

5. **Play the video.** Press the OK button to begin playback. Press the multi-selector up at the moment you want to make the edit. You can use the multi-selector down button to stop playback and the left and right to go back or forward in the video clip.

6. **Make the edit.** Press the multi-selector up to make the cut. I prefer to actually pause the movie by pressing the multi-selector down so I can be absolutely sure that's where I want the edit to be. I then make the edit. The movie is automatically saved.

Real World Applications

The key to capturing great images is to know which settings to use to achieve the desired results, although having a good eye doesn't hurt either. In this chapter I delve deeper into some of the different types of photography you may decide to try.

Some of topics covered in the following sections include what shutter speeds to use, what metering modes work best for different situations, how to use the scene modes to your advantage, as well as many other tips and techniques that I have learned and developed over the years.

Of course, in this limited space these sections aren't meant to be exhaustive or definitive, but they point you in the right direction.

Knowing which settings to use and how to work with light allows you to get creative with your images.

Abstract Photography

Generally, when you photograph something, you attempt to portray the subject clearly. For example, when photographing a portrait, you try to represent the face or some revealing aspect of the person; when shooting a landscape, you try to show what's in the environment, be it trees, mountains, or a skyline. However, when shooting abstract photography, you are working with the *idea* of the subject rather than an absolute subject. The subject is less important than the actual composition. When attempting abstract photography, you want to try to bring out the essence of what you're photographing.

There are no hard-and-fast rules to photography, and this is even truer in abstract photography. With this type of photography, you may be attempting to show the texture or color of something. What the actual object is isn't necessarily important.

An abstract photograph should give the viewer a different perspective of the subject than a normal photograph would. There are a few hardliners who say that if you can recognize the subject then it's not truly abstract. To that I say: Abstract photography (or any abstract art) can be broken down into two types — *objective* and *nonobjective*. Objective abstract art presents something that can be recognized, but it presents it in an unusual way. Nonobjective abstract art takes the subject and breaks it down to a base element such as lines, forms, colors, and texture. In figure 8.1 I used shallow depth of field and focused on a mirror hanging on the wall to trick the eye into seeing depth in a two-dimensional object. Not only that, I used lines, shapes, and patterns to make this into a geometric composition (not unlike the abstract painter Piet Mondrian).

Inspiration

Almost anything can be used to create an abstract photograph. It can be a close-up of the texture of tree bark or the skin of an orange. Look for objects with bright colors or interesting textures. Looking at things from an unusual perspective can often open up new ideas for images. For example, in figure 8.2 I simply looked straight up while hiking through a park. To add to the abstraction, I put my fisheye lens, which adds to the perspective distortion and makes the trees look like they are hundreds of feet tall.

Many structures and vehicles have interesting lines and shapes. Keep an eye out for patterns, which can be anywhere — on the side of a building or the surface of a rock or even in a tree reaching up to the sky. Evening shadows often create dynamic patterns with the added benefit of the rich colors of the sunset.

8.1 Looking at something from a different perspective can turn even an everyday object like a wall mirror into an abstract image. Taken at f/2.8, 1/40 second, ISO 1000, Tamron 17-50mm f/2.8 lens at 45mm.

8.2 Look for leading lines and patterns to make interesting compositions. Taken at f/11, 1/100 second, ISO 400, Nikon 10.5mm f/2.8 fisheye lens.

Abstract photography practice

8.3 Finding beauty in the obvious is what abstract photography is all about. Taken at f/22, 1/200 second, ISO 400, Nikon 105mm f/2.8G macro lens.

Table 8.1 Taking Abstract Pictures

Setup	**Practice Picture:** Figure 8.3 is a study of smoke from a burning stick of incense. The twisting and swirling of the smoke creates interesting patterns that work perfectly for abstract images.
	On Your Own: Abstract photo opportunities can exist in even the most mundane subjects; take a closer look at things to find some interesting aspects.

Lighting	**Practice Picture:** For this shot I used an SB-600 off-camera controlled by an SU-800 Commander. The Speedlight was set up camera left and aimed away from the background perpendicular to the camera lens. The Speedlight mode was set to Manual and the output level was set to 1/4 power. The background was a piece of black poster board.
	On Your Own: Try to find ways to use the lighting to your advantage. Finding the delicate interplay between shadows and highlights can give your images the added dynamic you need. For abstract images you can take advantage of natural light or you can create elaborate lighting set-ups of your own. There are no rules in abstract photography.
Lens	**Practice Picture:** Micro-Nikkor 105mm f/2.8G VR.
	On Your Own: You can use any type of lens to make an abstract image. Using wide angles or fisheyes can add strange distortions, or use a macro lens to come in close and focus on a minute detail.
Camera Settings	**Practice Picture:** For this shot I chose the Manual exposure mode so that I had complete control over the exposure settings. For a low-key image such as this the camera's meter generally tends to want to add too much exposure in order to bring detail out in the dark areas. I wanted the shadow areas to go completely black to draw attention to the smoke. I bumped up the ISO to 400 to avoid having the Speedlight fire at full power for every shot. I also set the white balance to Tungsten to get a distinct blue smoke.
	On Your Own: There are no hard-and-fast rules for which settings to use when shooting an abstract image because the subject matter can vary widely. It helps to know exactly how the meter determines exposure so you can adjust it for your specific needs.
Exposure	**Practice Picture:** ISO 400 at f/22 for 1/200 second (sync speed). Because focusing on smoke is next to impossible, I chose a small aperture to ensure that all of the details were in focus from the front of the frame to the back.
	On Your Own: Your settings can vary widely depending on your subject matter and lighting. With a relatively still subject you can use longer shutter speeds; when your subject is moving, be sure to use a faster shutter speed to freeze any motion.
Accessories	I used a tripod to assure that I didn't get any blur from camera shake.

Abstract photography tips

▶ **Keep your eyes open.** Always be on the lookout for interesting patterns, repeating lines, or strange textures.

▶ **Don't be afraid to experiment.** Sometimes something as minor as changing the white balance setting can change the whole image. Sometimes the wrong setting may be the right one for the image.

Action and Sports Photography

Capturing action has been an aspiration of photographers since the inception of photography. Freezing a moment of time allows you to study the subject in motion. These types of photographs often bring you closer to an event or freeze the moment, allowing you to see the action in a way that's just not possible with the naked eye.

 Action photography can be done with any type of moving subject, from a pet running up the beach, to a child running around at the playground, to a professional basketball player slam-dunking the ball.

Although the relatively quick frame rate of 3 fps of the D3100 comes in handy when shooting action and sports, the most essential skill for achieving great action shots is timing. To get a great shot, you need to get the peak of the action. In order to capture the action at its peak, it helps to be familiar with the sport. For example, when photographing a track event such as the 100-meter dash, you know that as the runners come off of the starting blocks, there will be strength and energy in their form. Of course, catching the winner crossing the finish line is also a great time for a shot.

 I don't recommend pressing and holding the Shutter Release button and firing off dozens of frames hoping to get the shot. This technique is known as "spray and pray," and more often than not you will miss the peak of the action.

The best way to get a feel for the sport you're photographing is quite simply to stand back and watch before you start shooting. Taking a few minutes to act as a spectator allows you to see the rhythm of the action.

Another big part of capturing a great action shot is being in the right place at the right time. While this sounds like luck, it's not. Take basketball, for example; it's quite easy to be in the right place at the right time. With basketball, you know exactly where the action is going to be 95 percent of the time: right at the goal. When shooting baseball you know that if you have a runner on third then it's almost certain that there will be an exciting play at home plate. With other sports it's not always quite as easy, but as I mentioned previously, watching for a while can give you an idea of where most of the action will take place.

Probably the most important camera setting for photographing action is the shutter speed. The shutter speed determines how the movement is shown in your photograph. For the most part, a fast shutter speed is used when photographing action. A fast shutter speed allows you to freeze the motion of the subject. Freezing the motion lets you do things like getting a nice, sharp image of an athlete in motion.

Using a fast shutter speed isn't the only way to capture great action shots. Using a slow shutter speed can sometimes be exactly what you need to bring out the movement in an action shot. For example, when shooting any type of motorsports, it's very common for a photographer to use a slow shutter speed in conjunction with panning to introduce some blurring into the image to illustrate movement.

If you're not familiar with panning, it is a technique in which you follow your subject along the same plane that it is traveling. Generally, you would pan horizontally, but you can also pan vertically, although this can be more difficult. Panning reduces the relative speed of the subject in relation to the camera, thereby allowing you to freeze the motion of the subject more easily than if you held the camera still and snapped the shot while the subject moved through the frame.

8.4 Good timing is essential to catch the peak of the action. Taken at f/2.8, 1/500 second, ISO 1600, Nikon 80-200mm f/2.8S AF-S lens at 80mm.

Inspiration

I tend to gravitate toward the more exciting events when I'm out taking action shots. BMX, skateboarding, and motocross are some of my favorite types of sports to photograph. You may find you favor more low-key action events, but regardless of what appeals to you, just keep your eyes open. Nearly everywhere you look there is some kind of action taking place.

To find action scenes to shoot, you may want to start by scouting out the local parks and recreation areas. Nearly every city has a skatepark these days. Check your local newspapers for sporting events. Often the local skateboard shops and bike shops have contests. I try to take pictures of people having fun doing what they love to do.

Using flash when shooting sports isn't always necessary or advisable, but in some cases it can help to separate your subject from the background, especially if the background is busy, as in figure 8.5. For this shot I placed an SB-800 set to Manual power 1/1 camera right and fired it wirelessly using an SU-800. I used an ultra wide-angle lens to add an interesting perspective to the shot.

 Be extremely cautious when using a wide-angle lens for shooting sports. Wide-angle lenses make objects appear farther away than they actually are.

8.5 For this shot I used a Speedlight to separate the rider from the background, making the rider "pop." Taken at f/5.6, 1/200 second, ISO 800, Nikon 10-24mm f/3.5-4.5 lens at 10mm.

 Be sure to ask permission before shooting an athlete with any type of flash. The Speedlight can momentarily blind the athlete, causing disastrous results.

Action and sports photography practice

8.6 It takes lightning-fast reflexes to catch the action when photographing any type of fast-moving sport.

Table 8.2 Taking Action and Sports Pictures

Setup	**Practice Picture:** For figure 8.6, I was photographing a professional bull riding competition in San Antonio, Texas. I snapped this shot just as the bull attempted to gore this cowboy (don't worry, he was fine).
	On Your Own: You don't need to photograph professional events to get great images. You can catch action shots at a Little League game that are just as good as shots taken at a major-league game.
Lighting	**Practice Picture:** Oftentimes, especially when shooting indoor sports, you will find that even when shooting with a fast lens the light will be too low; the only option is to up the ISO. The overhead lights of the venue provided the light for this shot.
	On Your Own: When photographing outside, a good rule of thumb is to keep the sun at your back. When photographing action indoors try to make the best of what light you have and bring a fast lens if you can.

continued

Table 8.2 Taking Action and Sports Pictures *(continued)*

Lens	**Practice Picture:** Nikon 80-200mm f/2.8 AF-S zoomed to about 100mm.
	On Your Own: Often when photographing sports you will need a long lens to capture the action close up. For nonteam sports such as skateboarding and BMX, you can often use a wide-angle lens to add an interesting perspective to the scene. When photographing indoors or night sports a fast lens is almost a necessity.
Camera Settings	**Practice Picture:** I chose Shutter Priority so that I could be sure that the shutter speed was fast enough to freeze the motion of the bulls and cowboys. Although these animals weigh 2,000 pounds they are extremely fast moving.
	On Your Own: Controlling your shutter speed is the most important aspect in action photography, whether it's choosing a fast shutter speed to freeze motion or a slow one to add blur.
Exposure	**Practice Picture:** ISO 1600 at f/2.8 for 1/1000 second. Even at f/2.8 to get a fast-enough shutter speed to freeze the action I had to have the ISO cranked up to a high setting.
	On Your Own: First and foremost, be sure that you choose a shutter speed that is appropriate for the subject and the effect you're after. A fast shutter speed to freeze action, a slow shutter speed to show movement.
Accessories	I used a monopod to minimize camera shake.

Action and sports photography tips

▶ **Practice panning.** Panning can be a difficult technique to master, but practice makes perfect. The more time you spend practicing this, the better you (and your images) will get.

▶ **Pay attention to your surroundings.** Often when concentrating on getting *the* shot, you can forget that there are things going on around you. When photographing sporting events, be sure to remember that there may be balls flying around or athletes on the move. It's better to miss a shot than to get hurt in the process of trying to get the shot.

▶ **Know the sport.** In order to be able to effectively capture a definitive shot, you need to be familiar with the sport, its rules, and the ebb and flow of the action. Being able to predict where the action will peak will get you better shots than hoping that you will luck into a shot.

Architectural Photography

Buildings and structures surround us, and many architects pour their hearts and souls into designing buildings that are interesting to the casual observer. This may be why architectural photography is so popular.

Despite the fact that buildings are such familiar, everyday sights, photographing them can be technically challenging and difficult — especially when you take pictures of large or extremely tall buildings. A number of problems can arise, the main one being *perspective distortion*. Perspective distortion is when the closest part of the subject appears irregularly large and the farthest part of the subject appears abnormally small. Think about standing at the bottom of a skyscraper and looking straight up to the top.

 Nikon makes perspective control lenses to help with perspective distortion, but the lenses are optimized for full-frame cameras and start out at about $2,000. Basically, you have to either fix the image using software or work with the perspective distortion to make a dynamic and interesting image.

One of the easiest ways to combat perspective distortion is to get some distance between the structure and the camera. In figure 8.7, instead of getting up close to the building I stood back a bit and zoomed in on the building.

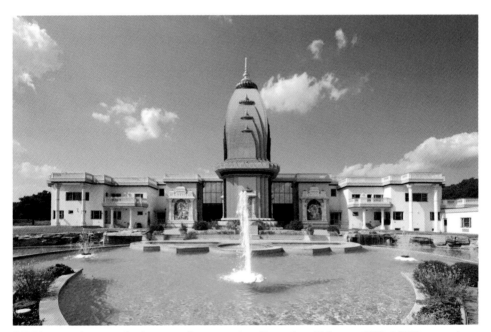

8.7 Distance lessens the impact of perspective distortion. Taken at f/10, 1/400 second, +2/3EV, ISO 100, Nikon 10-24mm f/3.5-4.5 lens at 24mm.

You can correct some amount of perspective distortion in-camera using the Retouch menu option, Perspective control.

Copyright and Permission

In most places, you don't need permission to photograph a building as long as it's a place to which the public has free access. If you are on private property, you should definitely request permission to photograph before you start. If you are inside a building, it is generally a good idea to ask permission before photographing as well.

Due to recent tightening of security policies, a lot of photographers have been approached by security and/or police, so it's a good idea to check the local laws in the city where you are photographing to know what rights you have as a photographer.

For the most part, copyright laws allow photography of any building on "permanent public display." Although the architect of the structure may own the copyright of the design, it usually does not carry over to photographs of the building. There are exceptions to this, so again, check local laws, especially if you plan on selling your images.

Inspiration

Because buildings and architecture are all around us, there are limitless possibilities to shoot. Try looking for buildings with architectural features that you may enjoy, such as art deco, gothic, or modern. The building doesn't necessarily have to be in tip-top condition. Sometimes photographing a building in a state of disrepair can give you an excellent image.

You don't necessarily have to include the whole building in the picture. Sometimes focusing on a small feature or aspect of the structure, as I did in figure 8.8, is all you need to do.

8.8 Isolating the towers of the Caldwell County Courthouse in Lockhart, Texas, (built in 1893) makes for an interesting shot with the sky for a backdrop. Taken at f/5.6, 1/800 second, ISO 200, 35mm f/1.8G lens.

Architectural photography practice

8.9 Even a humble abode can make an interesting architectural shot. Taken at f/11, 1/250 seconds, ISO 100 with a Tamron 17-50mm f/2.8 at 17mm.

Table 8.3 Taking Architectural Pictures

Setup	**Practice Picture:** For figure 8.9, I shot a little shack that I ran across in Fredericksburg, Texas.
	On Your Own: There are buildings everywhere you look. You don't necessarily need to photograph a grandiose structure. I made an interesting architectural shot out of this little house, which is nothing more than a two room shack.
Lighting	**Practice Picture:** This image was shot using only natural light.
	On Your Own: When photographing at night look for buildings that are lit up. The different lights and colors can make the shot more interesting. When photographing buildings during the day, try to keep the sun to your back. Avoid shooting into the sun, which means your building is backlit.
Lens	**Practice Picture:** Tamron 17-50mm f/2.8 set to 17mm.
	On Your Own: Generally, a wide-angle lens is needed to photograph architecture, but backing away from a building and using a longer focal length will help you overcome any problems with perspective distortion. Sometimes I use the widest setting on the lens to use perspective distortion to exaggerate the lines and angles of the building.

continued

Table 8.3 Taking Architectural Pictures *(continued)*

Camera Settings	**Practice Picture:** For this shot I chose the Manual exposure mode so that I had complete control over the exposure.
	On Your Own: Controlling your exposure allows you to get the exact effect that you're after. I recommend bracketing your exposure when doing shots like this. When shooting at night, the camera's meter generally tends to want to add too much exposure in order to bring detail out in the dark areas, which causes highlights to get blown out and the sky to be way too bright. This is why I recommend using Manual exposure at night.
Exposure	**Practice Picture:** ISO 100 at f/11. for 1/250 seconds. I chose a small aperture to ensure that all of the details were in focus from the front of the building to the back.
	On Your Own: Your shutter speeds can vary widely depending on the time of day. Generally you want to use a small aperture to ensure that you have a good, sharp image from back to front.
Accessories	A tripod helps to be sure your camera is steady.

Architectural photography tips

▶ **Shoot from a distance.** When taking pictures of tall buildings and skyscrapers try not to take your photograph too close to the base of the building. The perspective distortion can make the structure look like it's falling over, unless that is the effect you are looking for.

▶ **Avoid backlighting.** If the building you are photographing is backlit you will lose detail in the structure and the background will appear too bright. Try to take your picture when the sun is shining on the part of the building you want to photograph.

▶ **Be aware of lens distortion.** Different lenses can introduce distortion. Wide-angle lenses often suffer from barrel distortion that can cause the straight lines of the structure that are near the edge of the frame to appear bowed out. Either avoid placing straight lines near the edge of the frame or be sure to correct for the distortion in post-processing.

Concert Photography

This type of photography can be the most difficult to deal with. The lighting is erratic at best and can throw your meter off resulting in over- or underexposed images. The performers are often moving around, necessitating a fast shutter speed to freeze them but the light is low so the ISO needs to be cranked up in order to get a fast-enough shutter speed. This represents all of the worst shooting conditions that you can encounter in photography rolled into one!

For the most part, with concert photography the lighting comes from the stage lights. If you're shooting at a larger venue or concert usually the stage lighting is wonderful and you can get amazing images using relatively low ISO settings. Unfortunately, when starting out you are likely to be in places with less-than-perfect lighting. You may need to crank up the ISO all the way to 3200 when using the kit lens. However I don't recommend going above ISO 1600. For these situations, I suggest using the Auto ISO feature. For example, if I know that I may need to use high ISO for some shots but not all of them, rather than waste my time switching ISO settings all through the show, I set the ISO sensitivity auto control to On / Maximum sensitivity 1600 / Minimum shutter speed 1/250. You can set the Auto ISO in the Shooting menu under the ISO sensitivity settings option. Using a minimum shutter speed of 1/250 allows me to hand hold the camera and freeze the action of the band members so that they aren't blurry.

8.10 Spot metering on James Hetfield of Metallica allowed me to get a good exposure on the subject while ignoring the background lighting of flashing lasers that would have confused the Matrix metering. Taken at f/2.8, 1/200 second, ISO 1600, Nikon 17-55mm f/2.8 lens at 37mm.

For concerts I almost exclusively use Spot metering and set the exposure for the performer's face because I'm not usually concerned about the background. Often it's preferable to lose detail in the background because it brings out the subject of the image much better. I occasionally switch to Matrix metering when shooting a daylight

event, when I want to include some background details in the image, or if the lighting is constant, but for flashing and moving lights I recommend staying away from Matrix metering because the moving lights thoroughly confuse the metering system resulting in widely varying exposures.

Most of the time the lighting is fairly dim and you need to shoot with the widest aperture available, and setting the camera to Aperture Priority allows you to set the aperture and let the camera decide the shutter speed. Using a wide aperture also allows you to throw the background out of focus to get rid of distracting elements in the background.

Because performers are usually in motion, even if it's just the motion of strumming a guitar, I always set the Focus mode to Continuous AF (AF-C) with the AF area mode set to Dynamic. This allows the camera to track the performer if he should happen to move in the frame.

This type of photography is ideally done with a fast lens of f/2.8 or better. This allows

you to keep your ISO settings relatively low for the best image quality. Unfortunately, at this time there are few affordable options for fast lenses that allow the D3100 to AF. The one exception is the new Nikon 35mm f/1.8G. This is a good normal lens and can get you good shots as long as you're not too far away. A standard focal-length zoom lens is what I recommend for this type of photography, the Nikon 17-55mm f/2.8 being my preferred lens. The kit lens can be used, but you'll be pushing the limits of the ISO settings to get a fast-enough shutter speed.

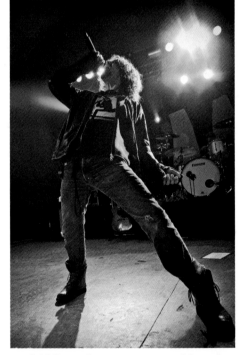

Inspiration

A good way to get started with concert photography is to find out when a favorite band or performer is playing and bring your camera. Smaller clubs

8.11 Capturing a great pose with perfect lighting is the key to getting a great concert shot. Chris Cornell of Soundgarden, taken at f/2.8, 1/320 second, ISO 1600, Nikon 14-24mm f/2.8 lens at 16mm.

are usually better places to take good close-up photos simply because you are more likely to have closer access to the performers. Most local bands, performers, and regional touring acts don't mind having their photos taken. You can also offer to e-mail the performers some images to use on their Web site. This is beneficial for both them and you, as lots of people will see your photos. I spent a lot of time honing my craft in smaller clubs and venues for lesser-known bands before I had a good-enough portfolio to get me access to the national touring acts at the larger venues.

Unfortunately, most large touring acts don't allow dSLR cameras into the venue. There are exceptions, but this is generally the rule (the good news is that these techniques also work with higher-end compact cameras which you can bring into most venues. You may be able to obtain a photo pass for larger events by offering your services to a local publication, which can then contact the band's publicist to request a pass for you.

Concert photography practice

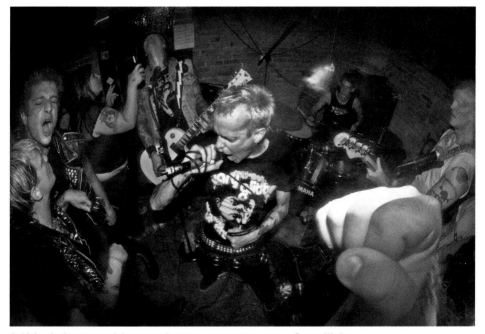

8.12 In dark venues it's sometimes necessary to use a Speedlight.

Table 8.4 Taking Concert Pictures

Setup	**Practice Picture:** Figure 8.12 is an example of a pretty common shot that you will find at most small venues with limited lighting capabilities. I offer this shot because it's fairly typical although I suggest using flash only in extreme circumstances. During this show for a local Austin, Texas, punk band, the Lower Class Brats, I was in the middle of a slamdancing pit and I was holding the camera over my head to take the shots. This is some-times known as a "Hail Mary" shot because you can't exactly be sure what you're going to get. Personally, I enjoy these smaller intimate shows because shooting large concerts can be quite cut and dry whereas in the smaller venues you have a lot more freedom to experiment. **On Your Own:** Starting out in concert photography you will likely run across very bad lighting. Overcoming the challenges is the key to getting good shots. The most important things are to have fun while you're doing it, and be sure to keep a good hold on your camera — I usually wrap my camera strap around my wrist to prevent my camera from being knocked out of my hand.
Lighting	**Practice Picture:** For this shot I was shooting at a venue with very low light. I couldn't get a good exposure with a relatively fast f/2.8 lens even at Hi 1 (ISO 3200) so I had to use a flash. I popped up the built-in flash and set it to TTL and dialed down the Flash Exposure Compensation down to −1EV to avoid it looking overly flashed. Using Slow sync helped get some background exposure with ambient light. I also used a Lumiquest SoftScreen diffuser to soften the flash output. **On Your Own:** Bouncing your flash, using a diffuser, and getting the flash off-camera are essential to making the lighting work. Straight on-camera flash isn't recommended, as it can look flat and obvious. You can also try using Slow sync to capture some ambient light.
Lens	**Practice Picture:** Nikon 10.5mm f/2.8 fisheye lens. I used the fisheye lens to add perspective distortion as well as to try to fit the whole band in the shot because this show was in extremely cramped conditions. **On Your Own:** Using a fast lens allows you to capture all the available light. The more light you can get the less likelihood there will be of need-ing to use the flash.
Camera Settings	**Practice Picture:** I chose Manual exposure in this situation because I was using flash. I generally experiment using different shutter speeds to get dif-ferent effects until I find a setting I'm happy with. The settings often depend on the band as well. Oftentimes I'll drag the shutter (use a slow shutter speed) to add ambient light, sometimes introducing a ghosting effect. **On Your Own:** Experimentation is part of the process of shooting bands. Changing your settings, especially when using flash, can have interesting results.
Exposure	**Practice Picture:** ISO 400 at f/11 for 1 second. I chose a very small aper-ture because the Nikon 10.5mm fisheye is a manual focus lens and hav-ing a small aperture ensured that most of the shot would be in focus without having to physically check the focus for every shot. **On Your Own:** Your settings can vary widely depending on your lighting. For the most part, you will find that you need to open up your aperture and use a relatively high ISO setting for most venues.
Accessories	I used a Lumiquest SoftScreen to diffuse the built-in flash.

Concert photography tips

▶ **Experiment.** Don't be afraid to try different settings and long exposures. Slow Sync flash enables you to capture much of the ambient light while freezing the subject with the short, bright flash.

▶ **Call the venue before you go.** Be sure to call the venue to ensure that you are able to bring your camera in.

▶ **Bring earplugs.** Protect your hearing. After spending countless hours in clubs without hearing protection, my hearing is less than perfect. You don't want to lose your hearing. Trust me.

Flower and Plant Photography

One of the great things about photographing plants and flowers, as opposed to other living things, is that you have almost unlimited control with them. If they are potted or cut, you can place them wherever you want, trim off any excess foliage, sit them under a hot lighting setup, and you never hear them complain.

Some other great things about photographing plants and flowers are the almost unlimited variety of colors and textures you can find them in. From reds and blues to purples and yellows, the color combinations are almost infinite. Plants and flowers are abundant, whether purchased or wild, so there is no shortage of subjects. Even in the dead of winter, you can find plants to take photos of. They don't have to be in bloom to have an interesting texture or tone. Sometimes the best images of trees are taken after they have shed all their foliage.

Flower and plant photography also offers a great way to show off your macro skills. Flowers especially seem to look great when photographed close up.

Flowers and plants don't necessarily need elaborate lighting setups or special lenses. For figure 8.13, I photographed this Black-eyed Susan growing wild in my backyard on an overcast day, which made the light very soft. I used a Lensbaby 2.0 selective focus lens for the soft focus look, which gave the shot a soft, ethereal appearance. Lensbabies are very cool flexible lenses that allow you to bend the lens to change to focus point to get special effects. I highly recommend them if you like to experiment with your photography. Not only are these lenses great for flowers and plants, they work for almost every kind of photography, from portraits to landscapes and more. Check them out on the Web at lensbaby.com.

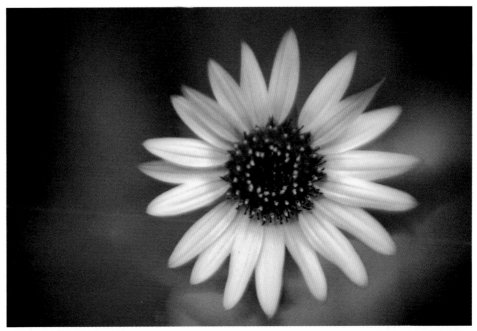

8.13 The Lensbaby 2.0 adds a cool effect to your images. Taken at f/2.0, 1/80 second, ISO 800.

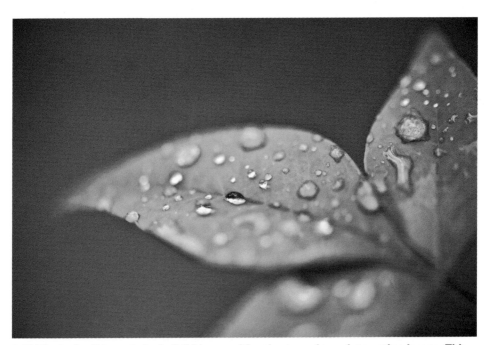

8.14 Plants don't have to be in full bloom with color to make an interesting image. This photo is of a shrub in my backyard just after a quick rainstorm. Taken at f/4.5, 1/1250 second, ISO 1600, Nikon 18-105mm f3.5-4.5G lens with a +10 close-up filter.

Inspiration

Flowers and plants have been inspiration for artists down through the centuries. Many artists chose flowers and plants not only because of their beauty but also presumably because you don't have to pay them to model! Many famous artists such as Van Gogh have found inspiration in the beauty of plants; some of Van Gogh's most treasured paintings are the sunflowers, irises, and the many paintings he did in Arles of the wheat fields and cypress trees.

It's not only painters who have derived inspiration from plants and flowers, but many photographers down through the years have used plants and flowers as subjects. Edward Weston regularly photographed different succulents such as the Agave cactus as well as fruits and vegetables. His image of the pepper taken in 1930 is one of his most famous works.

Flower and plant photography practice

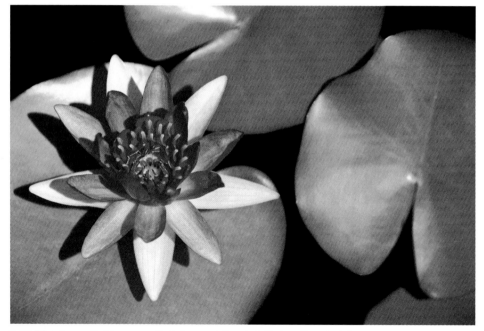

8.15 Direct sun light can really bring out the details in a floral picture.

Table 8.5 Taking Flower and Plant Pictures

Setup	**Practice Picture:** Figure 8.15 is a photo of a lotus taken at the Zilker Park Botanical Garden in Austin, Texas.
	On Your Own: Parks and botanical gardens are a great place to find flowers and such. You can also pick up floral arrangements from your local florist.
Lighting	**Practice Picture:** This shot was lit by the afternoon sun. Direct sunlight usually doesn't work well for most subjects, but for flowers it can really help the colors have an almost glowing effect. In the bright sunlight use the contrast to your advantage. Keep an eye on your shadows and make sure that they work with the composition.
	On Your Own: For soft lighting bring your subject indoors near a window or find a subject in the shade. You can also wait for a cloudy day. Backlighting sometimes works pretty well on flowers. The translucent flower petals allow some light to shine through, giving them a nice glow.
Lens	**Practice Picture:** Nikon 18-105mm f/3.4-4.5G (the D90's kit lens). I often use this lens because of the extra reach it offers above the 18-55mm kit lens that comes with the D3100. You can find these lenses used fairly easily because a lot of D90 users upgrade and sell them relatively cheap. I highly recommend this lens as a good walking-around lens as it's light, has a great reach, and is sharp.
	On Your Own: You can use any type of lens to take flower and plant shots, from wide angles to get a cool perspective to macro lenses to focus in on the details.
Camera Settings	**Practice Picture:** I chose Aperture Priority to control the depth of field. I wanted a slightly out-of-focus effect for the background while keeping the flower sharp. I used Matrix metering to get a good, even exposure.
	On Your Own: Controlling your aperture is key in focusing on the details in the image. You may want to use a wide aperture to blur unwanted elements from the background or a narrow aperture to be sure that the whole scene is in sharp focus.
Exposure	**Practice Picture:** ISO 200 at f/4.5 for 1/1600 second. I used a wide aperture to blur the background to draw attention to the flower.
	On Your Own: Your settings can vary widely depending on your lighting. As I mentioned before, your aperture setting is important on controlling how much of the image is in focus.

Flower and plant photography tips

▶ **Shoot from different angles.** Shooting straight down on a flower seems like the obvious thing to do, but sometimes shooting from the side or even from below can add a compelling perspective to the image.

▶ **Try different backgrounds.** Photographing a flower with a dark background can give you an image with a completely different feel than photographing that same flower with a light background.

▶ **Try using complementary colors.** Adding different flowers or using backgrounds with complementary colors to your composition can add a little interest to your image. Adding a splash of yellow into a primarily purple composition can make the image pop.

Landscape Photography

Landscape photography can incorporate any type of environment — desert scenes, mountains, lakes, forests, city skylines, or just about any terrain. You can take landscape photos just about anywhere, and one nice thing about them is that you can return to the same spot, even as little as a couple of hours later, and the scene will look different according to the position of the sun and the quality of the light. You can also return to the same scene months later and find a completely different scene due to the change in seasons.

8.16 This an example of an abstract landscape image. I photographed the dried-up, cracking mud on a cliff overlooking the ocean in southern California. I used the MC Picture Control and made a Custom Picture Control with the contrast and sharpening turned all the way up to accentuate the lines and cracks in the mud. Taken at f/5, 1/30 second, -1EV, ISO 200, Tamron 17-50mm f/2.8 VC lens at 17mm.

There are three distinct styles of landscape photography:

▶ **Representational.** This is a straight landscape; the "what you see is what you get" approach. This is not to say that this is a simple snapshot; it requires great attention to details such as composition, lighting, and weather.

▶ **Impressionistic.** With this type of landscape photo, the image looks less real due to filters or special photographic techniques such as long exposures. These techniques can give the image a mysterious or otherworldly quality.

▶ **Abstract.** With this type of landscape photo, the image may or may not resemble the actual subject. The compositional elements of shape and form are more important than an actual representation of the scene.

One of the most important parts of capturing a good landscape image is understanding *quality of light.* Simply defined, quality of light is the way the light interacts with the subject. There are many terms to define the various qualities of light, such as soft or diffused light, hard light, and so on, but for the purposes of landscape photography, the most important part is knowing how the light interacts with the landscape at certain times of day.

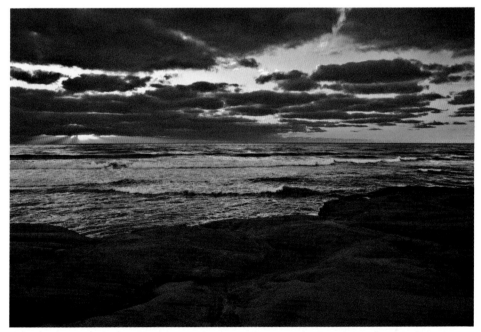

8.17 This is a representational landscape shot as the sun was starting to set giving the image a bit of a golden glow. This photo was taken at Sunset Cliffs in California, which is known for its beautiful sunsets. I under exposed the image to get a rich, deeply saturated color. Taken at f/8, 1/80 second, -0.3EV, ISO 100, Tamron 17-50mm f/2.8 VC lens at 17mm.

Infrared

One way to get interesting impressionistic landscape shots is to use an infrared (IR) filter to capture invisible infrared light. IR gives the green foliage (which reflects a lot of IR light) a white glow, while the skies and water (which don't reflect IR) are dark. IR light is invisible to the naked eye; however, CMOS sensors are sensitive to IR. IR light can have a detrimental effect on the standard images you create using visible light. For that reason Nikon installs an IR blocking filter in front of the sensor.

In order to capture an IR image, you first need to block visible light from reaching the sensor. An IR filter is used to do this. The most commonly used filter is the Hoya R72. You can find a Hoya R72 filter in most common filter sizes. The smaller ones (52mm or 55mm) are generally less expensive. Compose the shot with the filter off of the lens. After you compose the shot, you then must focus before placing the filter on the lens. Focusing can be a little tricky. Because IR light doesn't focus at the same point as visible light, you must make some adjustments. The best way to do this is to focus the camera, adjust the focus back just a little (turn the focus ring to the left), take a shot, and use the image review to check focus. If it's not in focus, continue to adjust focus. It's a bit of a trial-and-error process unless you're using an older Nikon lens that has in IR index mark. If you plan on doing a lot of IR shooting you may want to invest in an inexpensive, older Nikon manual focus lens that has an IR index, such as the 24mm f/2.8 AIS.

The exposure meter on your camera is all but useless for IR purposes so use Manual exposure and estimate the exposure and adjust until you get it. I generally start at f/5.6 for 10 seconds. Remember, because the visible light isn't coming through and the IR filter in front of the sensor blocks a lot of the IR your exposure times will be quite long, even on a bright, sunny day. You're definitely going to need a solid tripod for this type of photography.

IR images are usually converted to black and white in post-processing, but you initially get a color image. The color images can be quite interesting as well and there is a lot of information on different post-processing techniques available on the Internet. The photo on the left shows the image as it was recorded and the right is the image after conversion.

Inspiration

For the most part, the best time to photograph a landscape is just after the sun rises and right before the sun sets. The sunlight at those times of day is refracted by the atmosphere and bounces off of low-lying clouds, resulting in a sunlight color that is different, and more pleasing to the eye, than it is at high noon. This time of day is often referred to as the *golden hour* by photographers due to the color and quality of the light at this time.

This isn't to say you can't take a good landscape photo at high noon; you absolutely can. Sometimes, especially when you're on vacation, you don't have a choice about when to take the photo, so by all means take one. If there is a particularly beautiful location that you have easy access to, spend some time and watch how the light reacts with the terrain.

Landscape photography practice

8.18 This is an impressionistic shot of the Toad Pond in the Lost Pines State Park in Bastrop, Texas.

Table 8.6 Taking Landscape Pictures

Setup	**Practice Picture:** Figure 8.18 is an example of an impressionistic landscape image of the Toad Pond in the Lost Pines State Park in Bastrop Texas. I used the reflection of the scene in the pond to add a surreal effect. To make things even more interesting I actually flipped the image upside-down in Photoshop. If you look closely at the "sky" in the top of the image you can see leaves floating in it. **On Your Own:** Using unorthodox techniques can give your images a cool and/or surreal effect.
Lighting	**Practice Picture:** This was shot on a typical summer day with the bright sunlight overhead, but the majority of the sunlight was filtered out by the tall pines. **On Your Own:** Generally shooting landscapes using sidelighting when the sun is low yields the best results, but sometimes breaking rules can work in your favor.
Lens	**Practice Picture:** I used a Nikon 10-24mm f/3.5-4.5 to capture an extremely wide field of view. I placed the horizon line right in the middle so that the distortion was kept to a minimum. **On Your Own:** A wide-angle lens is usually preferred for landscape photography, although with a telephoto lens you can zoom in on an aspect that may be particularly far away.
Camera Settings	**Practice Picture:** I generally use Aperture Priority mode to control the depth of field, I also keep an eye on the shutter speed and if it falls below an acceptable shutter speed for hand-holding I bump up the ISO a bit. **On Your Own:** When shooting landscapes, it's generally advisable to set your aperture so Aperture Priority or Manual exposure is the best option.
Exposure	**Practice Picture:** ISO 400 at f/6.3 for 1/160 second. I chose a small aperture to ensure that all the details were in focus from the front of the frame to the back. **On Your Own:** Your aperture setting should be small to help ensure a nice, sharp image.
Accessories	A good tripod is something every landscape photographer should have.

Landscape photography tips

▶ **Bring a tripod.** When you're photographing landscapes, especially early in the morning or at sunset, the exposure time may be quite long. A tripod can help keep your landscapes in sharp focus.

▶ **Scout out locations.** Keep your eyes open; even when you're driving around you may see something interesting.

▶ **Be prepared.** If you're out hiking looking for landscape shots, don't forget to bring the essentials such as water and a couple of snacks. It's also a good idea to be familiar with the area you're in, or at the very least bring a map.

Macro Photography

Macro photography is one of the most popular and interesting types of photography out there. Sometimes you can take the most mundane object and give it a completely different perspective just by moving in close. Ordinary objects can become alien landscapes. Insects take on a new personality when you can see the strange details of their faces, especially their multifaceted eyes.

One of the most technically challenging aspects of macro photography is getting the enough of the subject in focus. The closer you are to the subject, the less depth of field you get. For this reason, you usually want to use as narrow an aperture you can (depending on the lighting situation). I say "usually" because a shallow depth of field can also be very useful in bringing attention to a specific detail.

8.19 When you get close up, the depth of field decreases exponentially. This macro shot of a Monarch butterfly was taken at a relatively small aperture of f/10 and the background is an indistinct blur. Notice also the complementary colors give the butterfly a nice separation from the background. Taken at f/10, 1/125 second, ISO 720 (Auto-ISO on), Nikon 105mm f/2.8G VR lens.

Macro photography requires special lenses or filters to allow you to get closer to your subject. Most lens manufacturers offer lenses that are designed specifically for this

purpose. These macro lenses give you a reproduction ratio of 1:1, which means that the image projected onto the sensor is exactly the same size as the physical subject. Some other lenses that can be used to do macro photography are actually telephoto lenses. Although you can't actually get close to the subject with a telephoto, the extra zoom gives you a close-up perspective. Telephoto lenses usually have a reproduction ratio of 1:4, or one-quarter size.

An inexpensive alternative to macro lenses are *close-up filters*. A close-up filter is like a magnifying glass for your lens. It screws onto the end of your lens and allows you to focus closer to your subject. There are a variety of magnifications, and they can be *stacked* or screwed together to increase the magnification even more. Although using close-up filters is an inexpensive way to get started, the image quality is going to be a little less sharp than when using a dedicated macro lens.

8.20 This simple macro photograph of a strawberry took only minutes to set up. Taken at f/22, 1/60 second, ISO 400, SB-600 handheld off-camera with an SC-27 TTL cord, Nikon 105mm f/2.8G VR lens.

Another relatively inexpensive way to get started in macro photography is by using a *reversing ring*. Reversing rings are adapters that have a lens mount on one side and filter threads on the other. The filter threads are screwed into the front of a normal

lens like a filter, and you attach the lens mount to the camera body. The lens is then mounted to the camera backward. This allows you to closely focus on your subject. One thing to be careful of when using reversing rings is damaging the rear element of your lens; special care should be taken when using one of these.

Not all lenses work well with reversing rings. The best lenses to use are fixed focal-length lenses that have aperture rings for adjusting the f-stop. Zoom lenses simply do not work well, nor do lenses that have no manual aperture control (Nikon G lenses). You must also realize that when using one of these adapters you have no autofocus capabilities nor does your camera's light meter function. You have to choose all of your settings in Manual exposure mode.

Inspiration

There are many subjects you can choose from when doing macro photography. From insects to flowers to coins and stamps, almost anything can make an interesting macro shot. One of the best things about macro photography is that you aren't limited to shooting in one type of location. You can do this type of photography indoors or out.

Macro photography practice

8.21 Insects such as this Blue Dasher dragonfly make interesting macro subjects.

Table 8.7 Taking Macro Pictures

Setup	**Practice Picture:** Figure 8.21 is an image of a Blue Dasher dragonfly that I captured at the Zilker Park Botanical Gardens in Austin, Texas. **On Your Own:** Subjects for macro pictures abound even in the most mundane areas. I often kill time wandering around my backyard snapping macro shots of whatever insects I happen to find. Keep your eyes open for insects or objects with interesting textures.
Lighting	**Practice Picture:** This image was taken with available light. **On Your Own:** Often the easiest way is simply to use available light, but sometimes using a flash can make your images stand out. Getting an off-camera TTL cord for your flash and holding the flash right up next to your lens is an easy technique that works very well.
Lens	**Practice Picture:** Micro-Nikkor 105mm f/2.8G VR. This is Nikon's top macro lens. It's pretty expensive, but the image quality is unparalleled. Nikon now offers an 85mm f/3.5G VR macro lens made especially for DX cameras that retails for about half the price of the 105mm. **On Your Own:** Using a dedicated macro lens is the best option, but using close-up filters is a good option to start out.
Camera Settings	**Practice Picture:** I chose Aperture Priority to control the depth of field. I used Matrix metering to be sure that I got a good, even exposure of both the subject and the background. **On Your Own:** Controlling your aperture is key in focusing on the details in the image. You may want to use a wide aperture to blur unwanted elements from the background or a small aperture to be sure that the whole scene is in sharp focus.
Exposure	**Practice Picture:** ISO 400 at f/22 for 1/125 second. I chose a small aperture to get as deep of a depth of field as I could. You will notice that even at a very small aperture of f/22 when shooting this close up, depth of field is still very shallow allowing only the dragonfly's face and eyes to be in sharp focus. To allow me to set an aperture that small while still getting a relatively fast shutter speed to avoid blur from camera shake, I used an ISO setting of 400. The VR was turned on to help with stabilization. **On Your Own:** Focusing close up magnifies the effect of camera shake when handholding the camera. Oftentimes you need to set your ISO rather high to be sure that you can get a fast shutter speed and a small aperture so that your images are razor sharp. Part of the appeal of Macro photographs are the sharpness of the minute details such as the eyes of the dragonfly, and a blurry image ruins this.
Accessories	A ring flash is a great accessory for getting even lighting with macro shots. This type of flash attaches to the front of the lens for on-axis lighting. The Phoenix RF-46N is an inexpensive (about $129) unit that works using Nikon's iTTL flash metering.

Macro photography tips

▶ **Use a remote shutter release.** If using a tripod, using a remote shutter release can also help reduce blur from camera shake. The Nikon ML-L3 Wireless Remote Control is a very inexpensive option. You can also use the self-timer.

▶ **Use side lighting.** To bring out the texture of your subject, be sure that the subject is being lit from the side.

▶ **Try using a tripod.** Using a tripod is a very good idea when doing macro photography to combat camera shake. Of course, when photographing living creatures, it may be a hindrance.

Night and Low-Light Photography

When the sun goes down and the light gets low, a whole new world of photography opens up. You can capture many different aspects and portray the world in a different light, so to speak. Taking photographs in low light brings a whole different set of challenges that are not present when you take pictures during the day. The exposures become significantly longer, making it difficult to hand hold your camera and get sharp images. Your first instinct may be to use the flash to add light to the scene, but as soon as you do this, the image loses its nighttime charm.

Almost any type of photography can be accomplished in low light from landscapes to portraits. Each type of photography has slightly different techniques and accessories, but the goal is the same: to get enough light to make a good exposure and to capture the delicate interplay between light and dark.

Generally when doing this type of photography I use Manual exposure and I bracket my exposures. I do this for a couple of reasons. First, bracketing allows me to be sure that I get the exact exposure that I'm looking for, and if necessary I can combine elements of different exposures. For my base exposure, I set the metering mode to Matrix and look at the light meter in the viewfinder. I generally start my exposure settings where the meter says that it's 1 stop underexposed. I find that this is generally pretty close to the right exposure. I bracket five frames at 1-stop intervals from my base exposure. You can use smaller (1/3) or bracket more frames if you want more or less latitude in your exposures.

When doing night photography I generally use small apertures and slow shutter speeds. I use these settings mainly for a few different reasons. First of all the slow shutter

speeds allow anything that might be moving in the scene to not register. For example, when photographing a city street scene using a shutter speed of 30 seconds a person walking through the scene wouldn't register as long as he keeps moving. This also allows you to capture streaks from any moving light sources such as a car's or truck's headlights. I also like to use slow shutter speeds because when a metropolitan city is located near a river or lake, the reflection of the city in the water gets a glasslike appearance with the longer exposure.

I use small apertures for two specific reasons. The first is that smaller apertures require slower shutter speeds to make an exposure. Second, when using a small aperture, any points of light that are in the scene are rendered as starbursts due to the diffraction of the light from the aperture blades; the smaller the aperture, the more pronounced the points are.

8.22 Brightly lit buildings like the Paris Casino is Las Vegas make great subjects for night photography. Taken at f/2.8, 1/30 second, ISO 1600, Nikon 14-24mm f/2.8G lens at 14mm.

> **TIP** A fast lens is a great tool to add to your kit if you're planning on shooting a lot of low-light images where you need to keep up a relatively fast shutter speed. The Nikon 35 mm f/1.8 is a great inexpensive fast lens.

Inspiration

One of the easiest ways to do night photography is simply to grab a tripod and venture out into the night. Set up the camera on the tripod and shoot! The tripod stabilizes your camera so you don't have to worry about camera shake with long exposures. You can use the long exposures to create special effects like the streaks of lights from moving vehicles. One of my favorite things to do when I visit any city is to photograph the skyline at night. The multitudes of different-colored lights make these pictures

vibrant and interesting. Even though these are shot in the dark, there is actually plenty of light to be found. Cities take on a different and more interesting character when photographed at night.

One interesting trick that you can do when photographing lights at night is to use a slow shutter speed and zoom your lens out during the exposure. This very simple technique adds a pretty cool light trail effect to your image. For figure 8.23 I used a long shutter speed of 10 seconds and moved one of the rings on the playscape to add a ghostly effect. I used a tripod to be sure that the rest of the scene was in sharp focus. It's best to get a sturdy tripod for this type of work. A ball head on the tripod is also great for quickly composing your images. If you find yourself without a tripod don't fret. The VR lens allows you to hand hold the camera at slower shutter speeds while still getting relatively sharp images. You can also use wide-angle settings when shooting in low-light handheld. Wide-angle settings are easier to hand hold at longer shutter speeds without camera shake.

8.23 Using a slow shutter speed and moving the subject during the exposure is a cool trick that adds a ghostly element to your image. Taken at f/2.8, 10 seconds, ISO 200. Nikon 28mm f/2.8D lens.

Fireworks

One of the questions I get asked most about low-light photography is how to photograph fireworks. Most folks seem to think catching these brilliant displays is a very difficult process but nothing could be further from the truth. Catching fireworks is a pretty simple and straightforward process.

The first thing you need to do is to set up your camera on a tripod. Without a tripod your fireworks images will be a blurry mess. Once you get your camera set up on a tripod, you're going to need to figure out where the fireworks are blooming and aim your camera lens in this direction.

Using a wide-angle lens is generally preferable to be sure that you get all the bloom in the shot. Using a telephoto lens can allow you to get some cool detail shots, but this is the exception rather than the norm.

Focusing should be done manually. Generally focusing the lens to infinity will work fine. Take a look at your images and adjust if necessary.

Use a low ISO setting and set your exposure manually. The aperture should be set to f/8 or f/11 and your shutter speed will need to be about as long as the fireworks explosion. The best way to control the shutter is to use the Bulb setting, which allows you to hold the shutter open as long as the Shutter Release button is pressed and held down.

When the fireworks are launched open the shutter; when the bloom is over shut it. It's as simple as that. You may find you need to adjust your ISO and/or aperture setting a bit depending on the brightness of the fireworks as well as the amount of ambient light in the scene.

Night and low-light photography practice

8.24 Light trails and starbursts are some of my favorite effects in night photography. This image combines them both along with leading lines ending in a vanishing point to make a really cool image.

Table 8.8 Taking Night and Low-light Pictures

Setup	**Practice Picture:** Figure 8.24 is a night shot of the upper and lower decks of Interstate 35 where it runs through central Austin, Texas. **On Your Own:** Light trails make very interesting subjects and are very easy to get with a long exposure and a tripod.
Lighting	**Practice Picture:** This photo was taken using available light. **On Your Own:** Generally, night photography is done using available light. Adding flash to the scene often kills the ambience of the image, although using Slow sync can add a cool effect.
Lens	**Practice Picture:** Nikon 10-24mm f/3.5-4.5G **On Your Own:** You can use almost any type of lens to take night/low-light images. Faster lenses help you capture all the light that you can. VR lenses are an immense help when handholding your camera in low light.

Camera Settings	**Practice Picture:** I set the exposure manually because I was bracketing as I usually do when shooting these types of images. I captured the image in RAW to be able to adjust the white balance in post-processing.
	On Your Own: Aperture priority works pretty well at night because you'll want to control your aperture setting either to open it up to get a faster shutter speed or to close it down to get a slow shutter speed. Shooting in RAW is a good idea because there are so many different light sources at night. You can adjust it to whatever looks good to you.
Exposure	**Practice Picture:** ISO 100 at f/22 for 30 seconds. I chose a small aperture to ensure that all the details were in focus from the front of the frame to the back and to add a starburst effect to the points of light.
	On Your Own: For shots like these, a slow shutter speed is generally used. It's not always necessary to use a high ISO setting especially when using a tripod, When handholding the camera a fast shutter speed is needed so a wide aperture and high ISO setting must be used.
Accessories	I used a tripod to achieve a sharp focus during the long exposure.

Night and low-light photography tips

▶ **Be patient.** Sometimes you will have to take many photos before you get one you like. It can be a trial-and-error process to find the exposure that works.

▶ **Show up early.** To get a good spot for shooting fireworks you may need to show up pretty early.

▶ **Turn on the VR.** The VR feature of your kit lens will help reduce vibration caused by handholding the lens at slower shutter speeds.

Pet Photography

A lot of pet owners love to snap photos of their pets. Pets make great models, they're usually cute, they don't talk back, and they're always around. If you happen to not have a pet, finding someone else's pet to photograph usually isn't too hard, especially if you offer to give them some pictures. It could even lead to paying jobs because most pet owners simply don't know these few simple tricks for taking great pet photos.

8.25 Even a turtle can have a good portrait taken! Taken at f/10, 1/160 second, ISO 1600, Nikon 80-200mm f/2.8D AF-S lens.

Photographing pets is easy if your pet is well behaved. The key to getting a great pet portrait is capturing the right expression on the animals face. It would be a safe assumption that most of you will be taking photos of dogs or cats, although snakes, lizards, and turtles are pretty common pets as well. You can see in figure 8.25 the picture of a Gulf Coast box turtle that became my pet after I found it wandering through my backyard (I eventually released him back into the wild in a more-fitting habitat). The way to get a

8.26 You never know when a great pet photo op may happen, so be prepared! Taken at f/1.8, 1/20 second, ISO 3200, Nikon 35mm f/1.8G lens.

good portrait from any pet, be it reptile or mammal, is to get down to eye level as I did with Franklin here.

Inspiration

Another consideration to make when photographing pets is lighting. Just as with human portraits, lighting is important. Soft light is usually the best and window lighting works as wonderfully with pets as it does with people.

Keep an eye out for interesting lighting and funny or cute poses. Figure 8.26 looks like it may have an elaborate studio lighting setup complete with strobes and softboxes, but in reality it's nothing more than the television. I was watching a documentary on wolves and my dog Maddie was fascinated with the howling. As she sat in rapt attention, I grabbed my camera and snapped this shot.

Pet photography practice

8.27 White poster board makes an affordable backdrop for studio quality photos.

Table 8.9 Taking Pet Pictures

Setup	**Practice Picture:** For figure 8.27, I had my Boston terrier, Henrietta, at my studio, so I decided to do some portraits of her. As I was snapping the shot, she caught sight of the mailman passing by and struck this pose. **On Your Own:** Although standard shots are great, odd or unusual poses often make the most interesting shots. You don't necessarily need a full studio setup to get a shot like this. If you're pet is small enough, a large piece of white posterboard can act as a seamless backdrop simply by taping the top to a wall and curving it to the floor and taping it down (use gaffers or painter's tape so that you don't leave any residue when you peel it off).
Lighting	**Practice Picture:** For this shot, I used an SB-800 fired wirelessly from the D3100 by using an SU-800. The SB-800 was mounted on a stand and fired through a medium softbox to provide even and diffused lighting. The Speedlight was placed to the right of the camera. The SU-800 was set to fire the SB-800 using TTL. There was a silver reflector camera left to bounce some light in to the left side to fill in the shadows evenly. **On Your Own:** It's not always necessary or convenient to use an elaborate lighting setup. Using natural light can be the best for shooting pets. It allows you to concentrate on the composition without worrying about your lighting setup.
Lens	**Practice Picture:** Nikkor 18-55mm kit lens zoomed to 45mm. **On Your Own:** A good wide-angle to medium zoom like the kit lens is invaluable for pet photography. This type of lens allows you the freedom to try many different compositions, from wide-angle shots to close-ups.
Camera Settings	**Practice Picture:** I chose Aperture Priority for this shot to keep a deep depth of field for sharpness. I used Matrix metering for this shot. **On Your Own:** Programmed Auto can work fine when photographing pets. It frees you from worrying about the exposure and allows you to concentrate on dealing with the animal.
Exposure	**Practice Picture:** ISO 100, f/8 for 1/60 second. **On Your Own:** Your exposures may vary depending on the setting that your subject is in. Using a wide aperture can help blur out distracting background details. A fast shutter speed can also help to keep your subject sharp in case of any movement.

Pet photography tips

▶ **Be patient.** Animals aren't always the best subjects; they can be unpredictable and uncooperative. Have patience and shoot plenty of pictures. You never know what you're going to get.

▶ **Bring lots of treats.** The best way to get a pet's attention is usually with a treat.

▶ **Get low.** Because most of you have pets that are smaller than you, you tend to shoot down at them. Try getting down low and shooting from the animal's perspective. This can make your picture much more interesting.

▶ **Use Red-Eye Reduction.** If you're going to use the flash, using Red-Eye Reduction is a must, although sometimes it doesn't completely remove the glare.

Portrait Photography

Portrait photography can be one of the easiest or one of the most challenging types of photography. Almost anyone with a camera can do it, yet it can be a complicated endeavor. Sometimes simply pointing a camera at someone and snapping a picture can create an interesting portrait; other times elaborate lighting setups may be needed to create a mood or to add drama to your subject.

Photographing Children

When taking pictures of children, all the techniques covered earlier still apply. But photographing children, while not completely different than photographing teens or adults, has its own set of difficulties. For one, children tend to move around a lot more than bigger folks, and they are much shorter than the average adult. These two qualities make the most problems for photographers.

The first issue, moving around, is pretty easily dealt with. Generally you want to shoot with a faster shutter speed to ensure that you get good, sharp images even if they're squirming around. The second issue, being short, is something that you must keep in mind. Most people, when taking snapshots, shoot down at children. This causes the child to be looking up and also gives him or her an odd look due to perspective distortion. The heads look big and the bodies look too small, which isn't flattering. The key is to remember to get down to the child's level. Like in this photo of little Sebastian taken during a backyard BBQ (don't worry he was under close supervision). When you look children in the eye you get much more personal and therefore better portraits.

A *portrait,* simply stated, is the likeness of a person — usually the subject's face — whether it is a drawing, a painting, or a photograph. A good portrait should go further than that. It should go beyond simply showing your subject's likeness and delve a bit deeper, hopefully revealing some of your subject's character or emotion also.

You have lots of things to think about when you set out to do a portrait. The first thing to ponder (after you find your subject, of course) is the setting. The setting is the background and surroundings, the place where you shoot the photograph. You need to decide what kind of mood you want to evoke. For example, if you're looking to create a somber mood with a serious model, you may want to try a dark background. For something more festive, you may need a background with a bright color or multiple colors. Your subjects may also have some ideas about how they want the image to turn out. Keep an open mind and be ready to try some ideas that you may have not considered.

There are many ways to evoke a specific mood or ambience in a portrait image. Lighting and background are the principal ways to achieve an effect, but there are other ways. Shooting the image in black and white can give your portrait an evocative feel. You can shoot your image so that the colors are more vivid, giving your photo a live, vibrant feeling, or you can tone down the colors for a more ethereal look.

Indoor

Indoor portraits are exactly what they sound like: a portrait shot indoors. One of the biggest obstacles you run into when shooting indoors is that you don't often have enough light to make a good exposure. There are a couple of options you can use to get great indoor shots.

8.28 Window lighting is a great way to easily get nice lighting. Taken at ISO 100 at f/1.8, 1/500 second with a 35mm f/1.8G lens.

▶ **Use a fast lens.** One of the easiest things you can do is buy a lens with a fast aperture. The 35mm f/1.8G is a great inexpensive fast lens that works well for portraits and all-around photography. The

lens I'd recommend the most is the 50mm f/1.4G. The 50mm focal length is perfect for shooting portraits and the wide aperture is the fastest you can get with Nikon lenses.

▶ **Window lighting.** Probably the best way you can get great lighting is simply place your subject next to a window. Sunlight filtering through the window is very diffused and makes perfect lighting for portraits. This is a tried-and-true method that many photojournalists and wedding photographers swear by.

▶ **Use a Speedlight.** This is usually my last option, but it works well if you use the Speedlight with care. Using bounce flash and a diffuser is essential. If you're planning on using the built-in flash, a diffuser is required or your portrait will come out looking like a snapshot with harsh, flat lighting and bad shadows.

Outdoor

Shooting portraits outdoors has a separate set of difficulties. Unless you're shooting on a completely cloudy day, generally the light is often too bright resulting in either blown-out highlights, blocked-up shadows, or in the worst-case scenario, both.

There are a few simple ways to deal with harsh lighting when shooting photos outdoors.

▶ **Find some shade.** Placing your subject out of the direct sun, such as under an overhang or under a tree, can give you the nice soft light that you need. If using a tree, be sure that the coverage is complete as trees can often give you dappled light.

▶ **Use a Speedlight.** I know that this sounds counterintuitive; you're probably thinking, "If I have too much light, why should I add more?" Using the flash in the bright sunlight fills in the dark shadows, resulting in a more evenly exposed image. This technique is known as *fill flash*.

8.29 Bringing the model onto the veranda from the outside provided soft yet directional lighting for this shot. Taken at f/1.4, 1/500 second, ISO 100, Nikon 50mm f/1.4G lens.

▶ **Use a diffusion panel.** Another way to combat images that have too much contrast when you're shooting outdoors is to have someone hold a diffusion panel. The diffuser blocks the direct sunlight and acts as a softbox, providing you with a nice, soft light for your portrait. Using a reflector to direct some light into the shadow areas of the face works really well, also.

Portrait photography practice

8.30 Using a Speedlight you can get studio-quality portraits even outdoors.

Table 8.10 Taking Portrait Pictures

Setup	**Practice Picture:** Figure 8.30 is a night portrait I shot in downtown Austin, Texas.
	On Your Own: Part of creating an interesting portrait is having a good background. You can choose to either soften the background or use deep focus to create texture in the image.

Lighting	**Practice Picture:** For this picture I used an off-camera SB-900 controlled by an SU-800. The SB-900 was mounted to a stand and fired through an umbrella. Firing through the umbrella (rather than bouncing) softened the light just a bit so that it retained a relatively hard and directional quality, which was what I was trying to achieve for the retro-noir look of this image. **On Your Own:** Using an off-camera Speedlight can really make your portraits stand out and look professional. Using an off-camera TTL cord and an inexpensive SB-400 can get your images looking more like the pros than if you use the flash on-camera.
Lens	**Practice Picture:** Nikon 50mm f/1.4G **On Your Own:** For portraits you generally want to stay in the longer focal lengths to compress the model's features; anywhere from 50 to 105 is recommended. My personal favorite for portraits with a DX camera is the 50mm f/1.4G, at less than $500 it's a pro-quality lens that won't break the bank. If you don't mind manual focus you can pick up a 50mm f/1.8D for about $100.
Camera Settings	**Practice Picture:** I chose Aperture Priority to control the depth of field. I used Spot metering to be sure that some shadow detail was retained. I captured the image in RAW to be able to completely control the conversion to black and white without losing any shadow or highlight detail. **On Your Own:** Controlling your aperture is key in focusing on the details in the image. You may want to use a wide aperture to blur unwanted elements from the background or a small aperture to be sure that the whole scene is in sharp focus.
Exposure	**Practice Picture:** ISO 200 at f/5.6 for 1/60 second. I chose a medium aperture to ensure that some of the details of the wall in the background were in focus. **On Your Own:** When using a Speedlight to shoot portraits, setting your shutter speed anywhere from 1/60 to 1/200 second is recommended. Try to shoot at lower ISO settings to keep as much detail in your image as possible.
Accessories	A small 24-inch umbrella was used to modify the light from the flash.

Portrait photography tips

▶ **Plan some poses.** Take a look at some photos in fashion magazines or even on the Internet and find some poses that you like. Have these in mind when photographing your models.

▶ **Shoot both horizontal and vertical.** Try framing your images in both landscape (horizontal) and portrait (vertical) orientation.

▶ **Try Slow sync flash.** Using Slow sync flash at night can give your images a cool effect.

Wildlife Photography

Photographing wildlife is a fun and rewarding pastime that can also be intensely frustrating at times. If you want to photograph out in the wild, it can mean standing out in the freezing cold or blazing heat for hours on end, waiting for the right animal to show up. But when you get that one shot you've been waiting for, it's well worth it.

Fortunately these days, it's not necessary for amateur wildlife photographers to trek out into the wilds to capture cool images (although that's an attractive option to some). Wildlife can be found at many different places: zoos, wildlife preserves, and animal sanctu-

8.31 Green anole lizard. Taken at f/22, 1/100 second, ISO1600, Nikon 105mm f/2.8G VR lens.

aries to name a few. One of the easiest ways to capture wildlife photos is to be where you know the animals are.

Opportunities to take wildlife pictures can occur when you're hiking in the wilderness, or maybe when you're sitting out on your back porch enjoying the sunset. With a little perseverance and luck, you can get some great wildlife images, just like the ones you see in *National Geographic*.

I was relaxing in my backyard enjoying a pleasant late summer afternoon when I spotted this green Anole lizard among the bushes. I happened to have my trusty 105mm macro lens on my camera and I crept up and grabbed just this one shot before he bolted into the underbrush.

Even in the city or urban areas, you may be able to find wildlife, such as songbirds perched on a power line or hawks in trees near roadsides. A lot of cities have larger parks where you can find squirrels or other smaller animals as well. For example, I've photographed the animals at a park near my studio where you can see peacocks and armadillos running around.

Because I don't often get to go on wildlife safaris, I often go to the zoo to get my wildlife photography fix. In figure 8.32 I was photographing in the primate area at the zoo in Ft. Worth, Texas. I spotted this brightly colored Mandril and instantly knew it would be a great shot. I snapped quite a few shots before I got one of him looking forward.

Even though you can get closer to the animals in the zoo than you normally would in the wild, using a telephoto lens is essential for the most part because the animals will be some distance away and a long lens allows you to get portraits such as this one. For this shot I used a Nikkor 80-200mm f/2.8D AF-S lens and using a monopod was necessary to ensure a sharp shot. The shot was matrix metered for an exposure of 1/320 @ f/2.8 ISO 400.

The wide aperture of a fast telephoto zoom lens comes in handy in zoo situations for a number of reasons. First

8.32 This mandril was quite a ways off, but using a telephoto lens allows you to figuratively bring the animal closer. Taken at f/2.8, 1/320 second, ISO 400, Nikon 80-200mm f/2.8D AF-S lens.

and foremost a fast lens gathers a lot of light allowing you to shoot at faster shutter speeds to reduce the effect of camera shake at longer focal lengths and/or allows you to shoot at a lower ISO setting to reduce noise. One of the main reasons I like a wide aperture lens at the zoo is for the shallow depth of field. Having a shallow depth of field allows you to blur out the background details that can make you pictures look like they were shot at the zoo. Of course they were shot at the zoo, but you don't really want it to look like that. The shallow depth of field also comes in handy when photographing animals through fences. Getting the lens close to the fence and opening up the aperture make the fence almost disappear.

Wildlife photography practice

8.33 Wildlife exists everywhere and can pop up unexpectedly, so be prepared.

Table 8.11 Taking Portrait Pictures

Setup	**Practice Picture:** Figure 8.33 is a pelican I ran across while scouting for surf spots near San Diego.
	On Your Own: You never know when a photo op is going to present itself so be prepared. Always have your camera on hand!
Lighting	**Practice Picture:** For this shot the pelican had the sun shining on him, with a hard frontlight, which from my angle was actually sidelighting bringing out the textures of his feathers quite nicely. This wasn't the best lighting option, being midafternoon, but the opportunity was there so I took it.
	On Your Own: Generally, with wildlife photography, you take what you can get, but waiting for opportune times such as the golden hour yields better lighting results. In some instances you may be able to use a little fill flash, but I generally don't recommend using a flash with wild animals.

Lens	**Practice Picture:** Nikon 80-200mm f/2.8D AF-S.
	On Your Own: Usually longer focal lengths are used to present the view as much closer than it actually is.
Camera Settings	**Practice Picture:** I chose Aperture Priority to control the depth of field.
	On Your Own: Controlling your aperture is key in focusing on the details in the image. You may want to use a wide aperture to blur unwanted elements from the background or a small aperture to be sure that the whole scene is in sharp focus.
Exposure	**Practice Picture:** ISO 100 at f/2.8 for 1/1250 second. I used a wide aperture to blur the background to provide separation.
	On Your Own: Using a wide aperture allows you to separate the subject from the background and using a small aperture can show the animal's surroundings. Use your discretion to decide what is best for the image. A good habit to get into is shooting it both ways.

Wildlife photography tips

▶ **Use a telephoto lens.** This allows you to remain inconspicuous to the animal, enabling you to catch it acting naturally.

▶ **Seize an opportunity.** Even if you don't have the lens zoomed to the right focal length for capturing wildlife, snap a few shots anyhow. You can always crop them later if they aren't perfect. It's better to get the shot than not.

▶ **Be patient.** It may take a few hours, or even a few trips, to the outdoors before you have the chance to see any wild animals. Keep the faith; it will happen eventually.

▶ **Keep an eye on the background.** When photographing animals at a zoo, keep an eye out for cages and other things that look man-made — and avoid them. It's best to try to make the animal look like it's in the wild by finding an angle that shows foliage and other natural features.

Viewing and In-camera Editing

With the D3100's large, bright, 3-inch, 230,000-dot VGA LCD monitor, you can view your images. What's even better, you can use the in-camera editing features to allow you to save some time in post-processing and give you the option to fine-tune your images for printing without ever having to download your images to a computer. Nikon has made enhancing your photos much more simple and fun!

The Retouch menu allows you to edit your images without a computer.

Viewing Your Images

The Nikon D3100 offers three ways to view your images while the SD card is still inserted in the camera. You can view the images directly on the LCD monitor on the camera or you can hook up your camera to a standard TV using the Nikon EG-D100 video cable that's available separately from Nikon. You can find the EG-D100 cable at most camera shops or online for around $10. The D3100 also has an HDMI output. With a Type C mini HDMI connector (available separately at most electronics stores) you can view your photos or even your HD video in full High Definition right on your HDTV.

When viewing through an external device such as a TV, the view is the same as would normally be displayed on the LCD monitor. The camera's buttons and dials function exactly the same.

Standard TV

Before connecting the camera to a standard television, you need to set the Video out mode. There are two video interface types: PAL and NTSC. These modes control how the electronic signal is processed. In NTSC mode, 30 frames are transmitted each second with each frame being made up of 525 scan lines. PAL mode transmits 25 frames per second with each frame being made up of 625 scan lines. For the most part none of this really matters to you personally; I include the information here as just basic fact. These two different video modes are used in different parts of the world. Most of North and South America use the NTSC mode while Asia and Europe use the PAL video system. If you're unsure whether your TV accepts NTSC or PAL, you should check the owner's manual of your TV.

To set the Video mode

1. **Turn the camera on.**

2. **Press the Menu button.**

3. **Use the multi-selector to highlight the Setup menu.**

4. **Use the multi-selector to highlight Video mode, and then press the OK button.**

5. **Use the multi-selector to highlight NTSC (or PAL).**

6. **Press the OK button to save settings.**

For more information on playing back images, see Chapter 3.

To connect your camera to a standard TV

1. **Turn the camera off.** This can prevent damage to your camera's electronics from static electricity.

2. **Open the connector cover.** The connector cover is on the left side of the camera when the lens is facing away from you.

3. **Plug in the EG-D100 video cable.** The cable is available separately from Nikon. Plug the cable into the Video out jack. This is the connection at the bottom.

4. **Connect the EG-D100 to the input jack of your television or VCR.**

5. **Set your TV to the video channel.** This may differ depending on your TV. See the owner's manual if you are unsure.

6. **Turn on the camera, and press the Playback button.**

HDTV

Being able to view your images and videos straight from the camera on your HDTV is a really nice feature. You can set up a slide show to show all of your friends the photos you shot that day or you can edit your photos using the Retouch menu straight from the camera while being able to view the images larger than life. If your HDTV is device control compatible (HDMI-CEC) you can also use the remote control to browse the images and camera menus. Isn't technology great?

 If you're HDTV is HDMI-CEC compatible the camera displays CEC in place of the number of remaining frames.

Attaching the camera to you HDTV is a pretty simple affair:

1. **Turn the camera off.** This can prevent damage to your camera's electronics from static electricity.

2. **Open the connector cover.** The connector cover is on the left side of the camera when the lens is facing away from you.

3. **Plug in the type C mini-pin HDMI cable.** The cable is available separately from almost any electronics or camera store. Plug the cable into the HDMI out jack. This is the second connection up from the bottom. It's clearly labeled on the rubber cover.

4. **Connect the HDMI cable to the input jack of your HDTV.**

5. **Set your HDTV to the HD in setting.** This may differ depending on your TV. See the owner's manual if you are unsure.

6. **Turn on the camera, and press the Playback button.** The playback functions exactly the same as if you were looking at the LCD monitor.

 When connected to an HDMI-CEC device the camera is not able to record video or still images.

Downloading Images

After you finish taking your pictures, you're probably going to want to download them to your computer for further image editing and tweaking or so you can post them to the Web or send them off to your friends and family.

Downloading your images is a fairly simple process, and there are a couple of ways to do this. The most common way is to remove the memory card from the camera and insert it into a card reader that is connected to your computer. This is probably the easiest way to get started. The other option is to use the USB cable supplied with the D3100 and connect the camera directly to the computer. Depending on your computer and the software you have installed, a program might pop up and offer to transfer the image for you. For example, Mac users might find that iPhoto recognizes the camera and opens up once the camera is connected to the computer via the USB cable.

 When downloading directly from the camera the battery may be depleted quicker.

Another option for downloading is using the Nikon Transfer 2 software that was included with the Nikon ViewNX2 software CD. The Nikon Transfer 2 software is very easy to learn and works well, and I encourage you to use Nikon Transfer if you don't have a card reader or prefer to plug your camera directly into the computer.

The Retouch Menu

The Nikon D3100 has a very handy Retouch menu. These in-camera editing options make it simple for you to print straight from the camera without downloading it to your computer or using any image-editing software.

One great feature of using the Retouch menu is that the camera saves the retouched image as a copy so you don't lose the original image. This can be beneficial if you decide that you would rather edit the photo on your computer or if you simply aren't happy with the outcome. There are two ways to access the Retouch menu.

The first and quickest method

1. **Press the Play button to enter Playback mode.** Your most recently taken image appears on the LCD screen.

2. **Use the multi-selector to review your images.**

3. **When you see an image you want to retouch, press the OK button to display the Retouch menu options.**

4. **Use the multi-selector to highlight the Retouch option you want to use.** Depending on the Retouch option you choose, you may have to select additional settings.

5. **Make adjustments to the image if necessary.**

6. **Press the OK button to save.**

The second method

1. **Press the Menu button to view menu options.**

2. **Use the multi-selector to scroll down to the Retouch menu.** It's the fourth menu down and appears as an icon with a paintbrush.

9.1 The Retouch menu

3. **Press the multi-selector right, and then use the multi-selector up and down buttons to highlight the Retouch option you want to use.** Depending on the Retouch option you select, you may have to select additional settings. Once you have selected your option(s), thumbnails appear.

4. **Use the multi-selector to select the image to retouch, and then press the OK button.**

5. **Make the necessary adjustments.**

6. **Press the OK button to save.**

Retouch Menu Options

There are a few options you can select when using the Retouch menu. The options vary from cropping your image to adjusting the color balance to taking red-eye out of your pictures and even to processing RAW images.

D-Lighting

This allows you to adjust the image by brightening the shadows. This is not the same as Active D-Lighting. D-Lighting uses a curves adjustment to help to bring out details in the shadow areas of an image. This option is for use with backlit subjects or images that may be slightly underexposed.

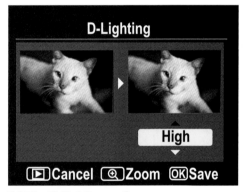

9.2 The D-Lighting option

When the D-Lighting option is chosen from the Retouch menu, you can use the multi-selector to choose a thumbnail and the Zoom in button to get a closer look at the image. Press the OK button to choose the image to retouch, and two thumbnails are displayed; one is the original image, and the other is the image with D-Lighting applied.

You can use the multi-selector up or down to select the amount of D-Lighting: Low, Normal, or High. The results can be viewed in real time and compared with the original before saving. Press the OK button to save, the Playback button to cancel, and the Zoom in button to view the full-frame image.

Red-eye correction

This option enables the camera to automatically correct for the red-eye effect that can sometimes be caused by using the flash on pictures taken of people. This option is only available on photos taken with flash. When choosing images to retouch from the Playback menu by pressing the OK button during preview, this option is grayed out and cannot be selected if the camera detects that a flash was not used. When attempting to choose an image directly from the Retouch menu, a message is displayed stating that this image cannot be used.

Once the image has been selected, press the OK button; the camera then automatically corrects the red-eye and saves a copy of the image to your SD card.

If an image is selected that flash was used on but there is no red-eye present, the camera displays a message stating that red-eye is not detected in the image and no retouching will be done.

Trim

This option allows you to crop your image to remove distracting elements or to allow you to crop closer to the subject. You can also use the Zoom in and Zoom out buttons to adjust the size of the crop. This allows you to crop closer in or back it out if you find that you've zoomed in too much.

Use the multi-selector to move the crop around the image so you can center the crop on the part of the image that you think is most important. When you are happy with the crop you have selected, press the OK button to save a copy of your cropped image or press the Playback button to return to the main menu without saving.

Rotating the Command dial allows you to choose different aspect ratios for your crop. You can choose the aspect ratio to conform to different print sizes. The options are

- ▶ **3:2.** This is the default crop size. This ratio is good for prints sized 4 × 6, 8 × 12, and 12 × 18.

- ▶ **4:3.** This is the ratio for prints sized 6 × 8 or 12 × 16.

- ▶ **5:4.** This is the standard size for 8 × 10 prints.

- ▶ **1:1.** This gives you a square crop.

- ▶ **16:9.** This is what's known as a cinematic crop. This is the ratio that movie screens and widescreen televisions use.

Monochrome

This option allows you to make a copy of your color image in a monochrome format. There are three options:

▶ **Black-and-white.** This changes your image to shades of black, white, and gray.

▶ **Sepia.** This gives your image the look of a black-and-white photo that has been sepia toned. Sepia toning is a traditional photographic process that gives the photo a reddish-brown tint.

▶ **Cyanotype.** This option gives your photos a blue or cyan tint. Cyanotypes are a form of processing film-based photographic images.

When using the Sepia or Cyanotype, you can use the multi-selector up and down buttons to adjust the lightness or darkness of the effect. Press the OK button to save a copy of the image or press the Playback button to cancel without saving.

The Monochrome Picture Control offers more flexible settings than simply retouching the images using the Retouch menu. You may want to consider shooting your images using the Picture Control rather than using this option.

9.3 An image converted to black-and-white

9.4 An image converted to sepia

9.5 An image converted to cyanotype

Filter effects

Filter effects allow you to simulate the effects of using certain filters over your lens to subtly modify the colors of your image. There are seven filter effects available:

▶ **Skylight.** A skylight filter is used to absorb some of the UV rays emitted by the sun. The UV rays can give your image a slightly bluish tint. Using the skylight filter effect causes your image to be less blue.

▶ **Warm filter.** A warming filter adds a little orange to your image to give it a warmer hue. This filter effect can sometimes be useful when using flash because flash can sometimes cause your images to feel a little too cool.

▶ **Red intensifier.** This adds a red colorcast to your image. You can use the multi-selector up or down to lighten or darken the effect.

▶ **Green intensifier.** This adds a green colorcast to your image. You can use the multi-selector up or down to lighten or darken the effect.

▶ **Blue intensifier.** This adds a blue colorcast to your image. You can use the multi-selector up or down to lighten or darken the effect.

▶ **Cross screen.** This effect simulates the use of a star filter. A star filter creates a star-shaped pattern on the bright highlights in your image. If your image doesn't have any bright highlights, the effect will not be apparent. Once an image is selected for the cross screen filter, you are shown a submenu with a few options that you can adjust. You can choose the number of points on the stars: 4, 6, or 8. You can also choose the amount; there are three settings that give you more or fewer stars. You can choose three angle settings, which control the angle at which the star is tilted. You also have three settings that control the length of the points on the stars.

▶ **Soft.** This applies a soft glow to your images. This effect is mostly used for portraiture but can also be used effectively for landscapes as well.

After choosing the desired filter effect, press the OK button to save a copy of your image with the effect added.

9.6 Cross screen filter effect

Color balance

You can use the color balance option to create a copy of an image on which you have adjusted the color balance. Using this option, you can use the multi-selector to add a color tint to your image. You can use this effect to neutralize an existing color tint or to add a color tint for artistic purposes.

Press the multi-selector up to increase the amount of green, down to increase the amount of magenta, left to add blue, and right to add amber.

A color chart and color histograms are displayed along with an image pre-view so you can see how the color balance affects your image. When you are satisfied with your image, press the OK button to save a copy.

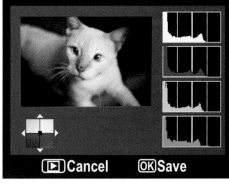

9.7 Color chart and histograms using the color balance option

Small picture

This is a handy little option that allows you to make a copy of your images that are a smaller size. These smaller pictures are more suitable for e-mailing to friends and family.

The first thing you need to do when creating a small picture is to select the Choose size option from the Small picture submenu. You have three sizes to choose from: 640 × 480, 320 × 240, or 160 × 120. After you decide on what size you want your small pictures copied, go to the Select picture option. When the Select picture option is chosen, the LCD displays thumbnails of all of the images in the current folder. To scroll through your images, use the multi-selector left or right. To select or deselect an image, use the multi-selector up or down. You can select as many images as you have on your memory card. When all the images that you want to make a small copy of are selected, press the OK button to make the copies.

Image overlay

This option allows you to combine two RAW images and save them as one. This menu option can only be accessed by entering the Retouch menu using the Menu button (the longer route); you cannot access this option by pressing the OK button when in Playback mode.

To use this option, you must have at least two RAW images saved to your memory card. This option is not available for use with JPEG.

To use this option

1. **Press the Menu button to view the menu options.**

2. **Use the multi-selector to scroll down to the Retouch menu, and press the multi-selector right to enter the Retouch menu.**

3. **Use the multi-selector up or down to highlight Image Overlay.**

4. **Press the multi-selector right.** This displays the Image Overlay menu.

5. **Press the OK button to view RAW image thumbnails.** Use the multi-selector to highlight the first RAW image to be used in the overlay. Press the OK button to select it.

6. **Adjust the exposure of Image 1 by pressing the multi-selector up or down.** Press the OK button when the image is adjusted to your liking.

7. **Press the multi-selector right to switch to Image 2.**

8. **Press the OK button to view RAW image thumbnails.** Use the multi-selector to highlight the second RAW image to be used in the overlay. Press the OK button to select it.

9. **Adjust the exposure of Image 2 by pressing the multi-selector up or down.** Press the OK button when the image is adjusted to your liking.

10. **Press the multi-selector right to highlight the Preview window.**

11. **Press the multi-selector up or down to highlight Overlay to preview the image, or use the multi-selector to highlight Save to save the image without previewing.**

NEF (RAW) processing

This option allows you to do some basic editing to images saved in the RAW format without downloading them to a computer and using image-editing software. This option is limited in its function but allows you to fine-tune your image more precisely when printing straight from the camera or memory card.

You can save a copy of your image in JPEG format. You can choose the image quality and size that the copy is saved as, you can adjust the white balance settings, fine-tune the exposure compensation, and select a Picture Control setting to be applied.

To apply RAW processing

1. **Enter the NEF (RAW) Processing menu through the Retouch menu.** Press the OK button to view thumbnails of the images stored on your card. Only images saved in RAW format are displayed.

2. **Use the multi-selector left or right to scroll through the thumbnails.** Press the OK button to select the highlighted image. This brings up a screen with the image adjustment submenu located to the right of the image you have selected.

3. **Use the multi-selector up or down to highlight the adjustment you want to make.** You can set image quality, image size, white balance, exposure compensation, and optimize the image. You can also use the Zoom in button to view a full screen preview.

4. **When you have made your adjustments, use the multi-selector to highlight EXE and press the OK button to save changes or the Playback button to cancel without saving.** EXE sets the changes and saves a copy of the image in JPEG format at the size and quality that you have selected. The camera default saves the image as a Large, Fine JPEG.

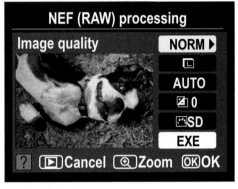

9.8 NEF (RAW) processing menu screen

 For more information on image size, quality, white balance, and exposure compensation, see Chapter 2.

Quick retouch

The Quick retouch option is the easiest option. The camera automatically adjusts the contrast and saturation making your image brighter and more colorful, perfect for printing straight from the camera or memory card. In the event that your image is dark or backlit, the camera also automatically applies D-Lighting to help bring out details in the shadow areas of your picture.

Once your image has been selected for Quick retouch, you have the option to choose how much of the effect is applied. You can choose from High, Normal, or Low. The LCD monitor displays a side-by-side comparison between the image as shot and the image retouched to give you a better idea of what the effect looks like.

Once you decide how much of the effect you want, press the OK button to save a copy of the retouched image or you can press the Playback button to cancel without making any changes to your picture.

Straighten

This handy little feature allows you to fix images that may have been shot at a slight angle. When an image is selected, use the multi-selector left and right to adjust the tilt amount. A grid overlay is displayed over the image so you can use it to align with the horizon or other straight object in the photo.

Distortion control

As discussed in Chapter 5, some lenses are prone to distortion. This retouch option allows you to correct for lens distortion right in-camera. There are two options, Auto and Manual. Auto automatically applies any needed corrections and with Manual you can apply the effect yourself using the multi-selector. Press the multi-selector right to reduce barrel distortion (wide-angles) and press the multi-selector left to reduce pincushion distortion (telephoto).

Fisheye

This option does the opposite of what distortion control does — it adds barrel distortion to the image to make it appear like it was taken using a fisheye lens. Press the multi-selector to the left to add to the effect and to the right to decrease it. I'd suggest using this option sparingly at most.

Color outline

The color outline feature takes the selected image and creates an outline copy that can be opened using image-editing software, such as Photoshop or Corel Paintshop Pro, and colored in by hand.

This option works best when used on an image with high contrast. It's a pretty

9.9 Color outline

cool effect and the image can even be used straight from the camera, which gives it the look of being a drawing.

Miniature effect

This effect is modeled after a technique that some people call (erroneously) the "tilt-shift effect" because it can be achieved optically with a tilt-shift lens. Quite simply what this effect does is simulate the shallow depth of field normally present in macro shots. This tricks the eye into seeing something large as something very tiny. The effect only works with very far-off subjects and works better when the vantage point is looking down. It's a pretty cool effect, but only works with limited subjects, so use this effect with that in mind.

9.10 An overhead shot of the Bonnaroo music festival grounds with the Miniature effect applied

Edit Movie

This option allows you to make basic edits to videos that you shoot with the D3100. You have three options: Choose the Start frame, choose the End frame, and grab a

still image from the video. Each edit you make is saved as a new file so there's no need to worry about making any permanent changes to your original file. To edit your video

1. **Press the Menu button.** Use the multi-selector to select the Retouch menu.

2. **Select Edit Movie.** Press the OK button or multi-selector right to view menu options.

3. **Choose the edit you want to make.** The options are Choose start point, Choose end point, or Save selected frame. Press the OK button or multi-selector right to see the menu with all videos that are saved to the current card.

4. **Select the video.** Use the multi-selector to scroll through the available videos. The selected video is highlighted in yellow. Press the OK button when your video is selected.

5. **Play the video.** Press the OK button to begin playback. Press the multi-selector up at the moment you want to make the edit. You can use the multi-selector down button to stop playback and the left and right to go back or forward in the video clip.

6. **Make the edit.** Press the multi-selector up to make the cut. I prefer to actually pause the movie by pressing the multi-selector down so I can be absolutely sure I stopped where I want the edit to be. The movie is automatically saved.

Before and after

This option allows you to view a side-by-side comparison of the retouched image and the original copy of the image. This option can only be accessed by selecting an image that has been retouched.

To use this option

1. **Press the Play button and use the multi-selector to choose the retouched image to view.**

2. **Press the OK button to display the Retouch menu.**

3. **Use the multi-selector to highlight Before and after, and then press the OK button.**

4. **Use the multi-selector to highlight either the original or retouched image.** You can then use the Zoom in button to view closer.

5. **Press the Play button to exit the Before and after comparison and return to Playback mode.**

Accessories

There are a number of accessories as well as a variety of additional equipment available for the Nikon D3100. These accessories range from batteries and flashes to tripods and camera bags. They can enhance your shooting experience by providing you with options that aren't immediately available with the purchase of the camera alone.

MC-DC2 Remote Release Cord

This handy little device allows you to remotely trigger the D3100 shutter without pressing the Shutter Release button. This can be an asset when doing timed exposures with a tripod so that your images don't suffer from blur caused by camera shake from the vibration of pressing the Shutter Release button manually.

You can also use this device for the Bulb setting on the camera. This allows you to keep the shutter open for periods longer than 30 seconds. Press and hold the button to open the shutter and release the button to close the shutter. The MC-DC2 also features a lock mechanism to lock the button down, keeping the shutter open.

Image courtesy of Nikon, Inc.

AA.1 The MC-DC2 Remote release cable

Tripods

One of the most important accessories you can have for your camera, whether you're a professional or just a hobbyist, is a tripod. The tripod allows you to get sharper images by eliminating the shake caused by handholding the camera in low-light situations. A tripod can also allow you to use a lower ISO, a longer shutter speed, and a smaller aperture or any combination of the three, thereby reducing the camera noise and resulting in an image with better resolution.

There are literally hundreds of types of tripods available, ranging in size from less than 6 inches to one that extends all the way up to 6 feet or more. In general, the heavier the tripod is, the better it is at keeping the camera steady. The Nikon D3100 is a relatively small camera, so you may not need a heavy-duty tripod. A smaller lightweight tripod can suffice for most shooting conditions.

While you can spend $500 or more on a state-of-the-art carbon-fiber tripod with a magnesium pistol-grip ball head, you may not need all these bells and whistles. Just remember, however, that you get what you pay for — in the long run if you buy a better tripod, you will be much happier than if you just buy a $20 flimsy tripod. For quite a few years when I was starting out, I used cheap lightweight aluminum tripods. I was always disappointed and annoyed to say the least. When I finally broke down and bought a new, fairly expensive tripod and head, I was surprised to find that I didn't mind bringing the tripod with me because it was much quicker and easier to use while being sturdier as well. The bottom line is, don't skimp when buying a tripod; a good sturdy tripod will last you for many years.

There are many different features available on tripods, but the standard features include

▶ **Height.** This is an important feature. The tripod should be the right height for the specific application for which you are using it. If you are shooting landscapes most of the time and you are 6 feet tall, using a 4-foot-tall tripod forces you to bend over to look into the viewfinder to compose your image. This may not be the optimal-size tripod for you.

▶ **Head.** Tripods have several types of heads. The most common type of head is the *pan/tilt* head. This type of head allows you to rotate, or *pan*, with a moving subject and also allows you to tilt the camera for angled or vertical shots. The other common type of head on a tripod is the *ball* head. The ball head is the most versatile. It can tilt and rotate quickly into nearly any position. In addition there are also different types of ball heads: a standard ball that has a simple locking mechanism that screws down, or a pistol grip that has a grip and a lever that you squeeze to quickly move the head and simply release to lock it into place. I prefer a pistol-grip ball head.

▶ **Plate.** The plate is what attaches the camera to the tripod. The Nikon D3100 has a threaded socket on the bottom. Tripods have a type of bolt that screws into these sockets, and this bolt is on the plate. Most decent tripods have what is called a *quick-release* plate. You can remove a quick-release plate from the tripod and attach it to the camera and then reattach it to the tripod with a locking mechanism. If you're going to be taking the camera on and off of the tripod frequently, this is the most time-efficient type of plate to use. The other type of plate, which is on some inexpensive tripods, is the standard type of plate that is attached directly to the head of the tripod. It still has the screw bolt that attaches the camera to

AA.2 A tripod ball head with a pistol grip

the plate, but it is much more time-consuming to use when you plan to take the camera on and off a lot. You must screw the camera to the plate every time you want to use the tripod, and you must unscrew it when you want to remove it from the tripod.

Which tripod is right for you?

Because there are so many types of tripods, choosing one can be a daunting experience. Add to that all the many features and functions available in a tripod and it can be nearly overwhelming. Here are some things to think about when you're looking into purchasing one that should help you sort out what is best for you:

▶ **Price.** Tripods can range in price from as little as $5 to as much as $500 or more. Obviously, the more a tripod costs, the more features and stability it's likely to have.

▶ **Features.** There are dozens of different features available in any given tripod. Some tripods have a quick-release plate, some have a ball head, some are small, and some are large. Again, you need to decide what your specific needs are.

► **Weight.** This can be a very important factor when deciding which tripod to purchase. If you are going to use the tripod mostly in your home, a heavy tripod may not be a problem. On the other hand, if you plan on hiking, a 7-pound tripod can be an encumbrance after awhile. Some manufacturers make tripods that are made out of carbon fiber. While these tripods are very stable, they are also extremely lightweight. On the downside, carbon-fiber tripods are also very expensive.

Monopods

An option you may want to consider is a *monopod* instead of a tripod. A monopod connects to the camera the same way as a tripod, but it only has one leg. Monopods are excellent for shooting sports and action when using long lenses because they allow you the freedom to move along with the action while providing support to keep your camera steady. The figure here shows a photographer using a monopod to photograph racecars.

Photo © Destry Jaimes – nine2fivephotography.com

► **Locking mechanism.** There are a couple types of locking mechanisms found on today's tripods. The two most common are the twist-lock and the lever-lock. The twist-lock functions by twisting a collar that allows the leg to telescope. The lever-lock functions by simply flipping a lever up to release the telescoping leg and down again to lock the leg. Personally, I prefer the lever-lock types for the ease and quickness with which they operate.

Tripods have legs made from different types of materials. Each tripod has its own features that make it useful for specific purposes. Which type of material you choose in a tripod is worth considering. Some types of materials include

▶ **Wood.** Wooden tripods aren't seen very much anymore. These were the tripods of choice for photographers from the past who used large, heavy, boxlike view cameras or field cameras. These wood tripods are often heavy, but they support quite a bit of weight and are also good at dampening vibrations, which can cause camera shake.

▶ **Aluminum.** Most of the tripods on the market today are made from aluminum. Aluminum is a lightweight and durable material that's fairly low in cost. This is the most cost-effective type of tripod, although depending on the feature set of the tripod, some can get pretty expensive.

▶ **Carbon fiber.** These tripods are made from layers of cross-plied carbon fiber, which is a great material. Carbon fiber is significantly (20 to 30 percent) lighter than aluminum and dampens vibrations much better than wooden tripods do. Tripods with carbon-fiber legs are some of the most expensive ones, but they are very durable and are perfect for when you're hiking because of their light weight.

▶ **Exotic materials.** Some tripod manufacturers, such as Giotto's and Gitzo, use materials such as basalt, which comes from molten lava, to make their tripod legs. The basalt is crushed, melted, and then drawn into fibers similar to carbon fiber.

Video accessories

Now that dSLR cameras are offering HD video many people are starting to get serious with shooting video. This means that along with all of the photo accessories now there are some other gadgets that you can buy to make the best of the HD video feature.

Steadi-cam

One of the most important things you can have for shooting video, especially if you're planning on shooting action, is a steadi-cam. This allows you to move the camera around much more smoothly than if you held it in your hand. Even with VR enabled, handholding can often give you shaky results.

There are many different steadi-cams at all different price points. There are also a lot of do-it-yourself alternatives to buying a steadi-cam. For example, I converted a Stroboframe flash bracket to serve as a steadi-cam and I find that it works great. A quick Internet search for "DIY Steadi-cam" yields a lot of useful results.

AA.3 My DIY steadi-cam adapted from a Stroboframe flash bracket

If you would rather purchase a steadi-cam, a reasonably priced and very good one is the CamCaddie Scorpion. This steadi-cam can be found for about $60 and has additional accessories allowing you to mount microphones or lights (although the D3100 doesn't support external mics).

Lighting

When shooting video, you can't use a flash if you need an additional light source when shooting in low light. The easiest way to add light is to use an LED light panel that mounts in your camera's hot shoe and is powered by its own AA batteries. To purchase an inexpensive LED light panel is likely to cost you nearly as much as an SB-400 speedlight, and a good one costs about as much has an SB-900 speedlight, or even more, but these lights can actually replace a speedlight in a lot of circumstances. Most of these LED light panels come with filters to match them to the ambient lighting. The great thing about LEDs is that they are bright, use very little energy, and are cool to the touch. If you plan on doing any amount of video in low light, I highly recommend getting one. Most of the big Internet camera retailers such as B&H, Adorama, and Cameta Camera carry a full line of LED light panels.

The Litepanels company also has a hybrid light that includes a flash feature as well as continuous lighting.

AA.4 Litepanels MicroPro Hybrid

Fluid tripod head

Tripods were covered earlier in this appendix, but video shooting requires a different type of tripod head than when shooting still photos (unless you plan on shooting static video scenes). To move and pan smoothly for video requires a fluid tripod head, which is designed to allow you to move the camera smoothly or fluidly. As with most specially designed equipment, these types of heads aren't cheap. Expect to pay about $200 for a basic one.

Camera Bags and Cases

Another important accessory to consider is the bag or carrying case you choose for your camera. These can provide protection not only from the elements but also from impact. Camera bags and cases exist for any kind of use you can imagine, from simple cases to prevent scratches to elaborate camera bags that can hold everything you may need for a week's vacation. Being a freelance photographer, I get jobs that require different amounts of gear so I have quite a few camera bags. Some of the bag and case types available include the following:

▶ **Hard cases.** These are some of the best cases you can get. These cases are generally made to take heavy abuse and are commonly used for shipping camera equipment. The most recognizable name in hard cases is the Pelican brand. The Pelican hard cases are watertight, crushproof, and dustproof. They are unconditionally guaranteed forever. If you are hard on your cameras or do a lot of outdoor activities or travel quite a bit, you can't go wrong with these.

▶ **Shoulder bags.** These are the standard camera bags you can find at any camera shop. They come in a multitude of sizes to fit almost any amount of equipment you can carry. Reputable makers include Tamrac, Domke, and Lowepro. Look them up on the Web to peruse the various styles and sizes. I use a couple of different shoulder bags depending on the job. For traveling with my camera gear and a laptop I use the Naneu Pro Tango, but if I'm only carrying camera gear, the Correspondent C330 usually fits everything I need.

▶ **Backpacks.** Some camera cases are made to be worn on your back just like a standard backpack. These also come in different sizes and styles, and some even offer laptop-carrying capabilities. The type of camera backpack I use when traveling is a Naneu Pro Alpha. It's designed to look like a military pack, so thieves don't know you're carrying camera equipment. When traveling, I usually pack it up with two Nikon dSLR camera bodies, a wide-angle zoom, a long telephoto, a couple of prime lenses, two Speedlights, a reflector disk,

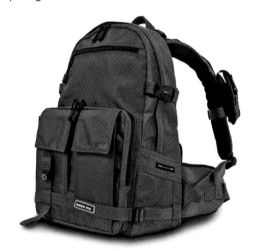

Image courtesy of NaneuPro

AA.5 Naneu Pro Alpha backpack

and all the chargers, batteries, and other accessories that go along with my gear. And, with all that equipment packed away, there is space left over for a lunch. Lowepro and Tamrac also make some very excellent backpacks.

▶ **Messenger bags.** Recently, more camera bag manufacturers have started to offer messenger bags — resembling bags that a bike messenger uses. They have one strap that goes over your shoulder and across your chest. The bag sits on your back like a backpack. The good thing about this bag is that you can just grab it and pull it around to the front for easy access to your gear. With a backpack, you

have to take it off to get to your camera. I have a messenger-style bag for use when I'm traveling light. My messenger bag is the Echo made by Naneu Pro. You may want to consider Crumpler for a messenger style-bag as it makes some excellent bags that are very highly regarded within the photo community.

▶ **Holster-type bags.** The holster-type camera bag is a bare-bones camera holder. It's made to carry one camera with a lens attached and a few accessories, such as batteries and flash cards. In my opinion, the best holster-type bag is the Lowepro Toploader. Lowepro makes several types of holsters to accommodate different cameras and lens combinations. These bags are great for protecting your gear when you're traveling with a small amount of equipment on a day trip.

How to Use the Gray Card and Color Checker

Have you ever wondered how some photographers are able to consistently produce photos with such accurate color and exposure? It's often because they use gray cards and color checkers. Knowing how to use these tools helps you take some of the guesswork out of capturing photos with great color and correct exposures every time.

The Gray Card

Because the color of light changes depending on the light source, what you might decide is neutral in your photograph, isn't neutral at all. This is where a gray card comes in very handy. A gray card is designed to reflect the color spectrum neutrally in all sorts of lighting conditions, providing a standard from which to measure for later color corrections or to set a custom white balance.

By taking a test shot that includes the gray card, you guarantee that you have a neutral item to adjust colors against later if you need to. Make sure that the card is placed in the same light that the subject is for the first photo, and then remove the gray card and continue shooting.

 When taking a photo of a gray card, de-focus your lens a little; this ensures that you capture a more even color.

Because many software programs enable you to address color-correction issues by choosing something that should be white or neutral in an image, having the gray card in the first of a series of photos allows you to select the gray card as the neutral point. Your software resets red, green, and blue to be the same value, creating a neutral mid-tone. Depending on the capabilities of your software, you might be able to save the adjustment you've made and apply it to all other photos shot in the same series.

If you'd prefer to make adjustments on the spot, for example, and if the lighting conditions will remain mostly consistent while you shoot a large number of images, it is advisable to use the gray card to set a custom white balance in your camera. You can do this by taking a photo of the gray card filling as much of the frame as possible. Then, use that photo to set the custom white balance.

The Color Checker

A color checker contains 24 swatches which represent colors found in everyday scenes, including skin tones, sky, foliage, etc. It also contains red, green, blue, cyan, magenta, and yellow, which are used in all printing devices. Finally, and perhaps most importantly, it has six shades of gray.

Using a color checker is a very similar process to using a gray card. You place it in the scene so that it is illuminated in the same way as the subject. Photograph the scene once with the reference in place, and then remove it and continue shooting. You should create a reference photo each time you shoot in a new lighting environment.

Later on in software, open the image containing the color checker. Measure the values of the gray, black, and white swatches. The red, green, and blue values in the gray swatch should each measure around 128, in the black swatch around 10, and in the white swatch around 245. If your camera's white balance was set correctly for the scene, your measurements should fall into the range (and deviate by no more than 7 either way) and you can rest easy knowing your colors are true.

If your readings are more than 7 points out of range either way, use software to correct it. But now you also have black and white reference points to help. Use the levels adjustment tool to bring the known values back to where they should be measuring (gray around 128, black around 10, and white around 245).

If your camera offers any kind of custom styles, you can also use the color checker to set or adjust any of the custom styles by taking a sample photo and evaluating it using the on-screen histogram, preferably the RGB histogram if your camera offers one. You can then choose that custom style for your shoot, perhaps even adjusting that custom style to better match your expectations for color.

Glossary

Active D-Lighting A camera setting that preserves highlight and shadow details in a high-contrast scene with a wide dynamic range.

AE (Autoexposure) A function of a camera where the camera selects the aperture and/or shutter speed according to the camera's built-in light meter. See also *Aperture Priority, Shutter Priority, and Programmed Auto.*

AE/AF (Autoexposure/Autofocus) Lock A camera control that lets you lock the current metered exposure and/or autofocus setting prior to taking a photo. This allows you to meter an off-center subject and then recompose the shot while retaining the proper exposure for the subject. The function of this button can be altered in the setup menu under the Buttons heading.

AF-assist illuminator An LED light that's emitted in low-light or low-contrast situations. The AF-assist illuminator provides enough light for the camera's AF to work in low light.

ambient lighting Lighting that naturally exists in a scene.

angle of view The area of a scene that a lens can capture, which is determined by the focal length of the lens. Lenses with a shorter focal length have a wider angle of view than lenses with a longer focal length.

aperture The opening of the lens similar to the iris of an eye. The designation for each step in the aperture is called the f-stop. The smaller the f-stop (or f-number), the larger the actual opening of the aperture, and the higher-numbered f-stops designate smaller apertures, letting in less light. The f-number is the ratio of the focal length to the aperture diameter.

Aperture Priority An exposure mode setting where you choose the aperture and the camera automatically adjusts the shutter speed according to the camera's metered readings. Aperture Priority is often used by a photographer to control depth of field.

aspect ratio The ratio of the long edge of an image to the short edge as printed, displayed on a monitor, or captured by a digital camera.

autofocus The capability of a camera to determine the proper focus of the subject automatically.

backlighting A lighting effect produced when the main light source is located behind the subject. Backlighting can be used to create a silhouette effect or to illuminate translucent objects. See also *frontlighting* and *sidelighting*.

barrel distortion An aberration in a lens in which the lines at the edges and sides of the image are bowed outward. This distortion is usually found in shorter focal-length (wide-angle) lenses.

bounce flash Pointing the flash head in an upward position or toward a wall so that it bounces off another surface before reaching the subject, which softens the light reaching the subject. This often eliminates shadows and provides smoother light for portraits.

bracketing A photographic technique in which you vary the exposure over two or more frames. By doing this, you ensure a proper exposure in difficult lighting situations where your camera's meter can be fooled.

broad lighting When your main light is illuminating the side of the subject that's facing toward you.

camera shake Camera movement, usually at slower shutter speeds, which produces a blurred image.

catchlight Highlights that appear in the subject's eyes.

center-weighted meter A light-measuring device that emphasizes the area in the middle of the frame when you're calculating the correct exposure for an image.

colored gel filters Colored translucent filters that are placed over a flash head or light to change the color of the light emitted on the subject. Colored gels can be used to create a colored hue of an image. Gels are often used to match the flash output with the ambient light as well as to change the color of a background when shooting portraits or still lifes by placing the gel over the flash head and then firing the flash at the background.

compression Reducing the size of a file by digital encoding, which uses fewer bits of information to represent the original subject. Some compression types, such as JPEG, actually discard some image information, while others, such as RAW (NEF), preserve all the details in the original.

Continuous Autofocus (AF-C) A camera setting that allows the camera to continually focus on a moving subject.

contrast The range between the lightest and darkest tones in an image. In a high-contrast image, the shades fall at the extremes of the range between white and black. In a low-contrast image, the tones are closer together.

dedicated flash An electronic flash unit, such as the Nikon SB-900, SB-800, SB-700, SB-600, or SB-400, designed to work with the auto exposure features of a specific camera.

depth of field (DOF) The portion of a scene from foreground to background that appears sharp in the image.

diffuse lighting A soft, low-contrast lighting.

D-Lighting A function within the camera that can fix the underexposure that often happens to images that are backlit or in deep shadow. This is accomplished by adjusting the levels of the image after it's been captured. Not to be confused with Active D-Lighting.

DX Nikon's designation for digital single-lens reflex cameras (dSLRs) that use an APS-C–sized (23.6mm × 15.8mm) sensor.

equivalent focal length A DX-format digital camera's focal length, which is translated into the corresponding values for 35mm film or the FX format.

exposure The amount of light allowed to reach the sensor, which is determined by the ISO setting, the amount admitted by the aperture of the lens, and the length of time determined by the shutter speed.

exposure compensation A technique for adjusting the exposure indicated by a photographic exposure meter, in consideration of factors that may cause the indicated exposure to result in a less-than-optimal image.

exposure mode Camera settings that control how the exposure settings are determined. The D3100 also offers scene modes, which are automatic modes that adjust the settings to predetermined parameters, such as a wide aperture for the Portrait. See also *Aperture Priority, Shutter Priority,* and *Programmed Auto.*

fill flash A lighting technique where the Speedlight provides enough light to illuminate the subject to eliminate shadows. Using a flash for outdoor portraits often brightens the subject in conditions where the camera meters light from a broader scene.

fill lighting The lighting used to illuminate shadows. Reflectors or additional incandescent lighting or electronic flash can be used to brighten shadows. One common outdoor technique is to use the camera's flash as a fill.

flash An external light source that produces an almost instant flash of light to illuminate a scene. Also known as electronic flash.

Flash Exposure Compensation (FEC) Adjusting the flash output. If images are too dark (underexposed), you can use FEC to increase the flash output. If images are too bright (overexposed), you can use FEC to reduce the flash output.

flash modes Modes that enable you to control the output of the flash by using different parameters. Some of these modes include Red-Eye Reduction and Slow Sync.

flash output level The output level of the flash as determined by one of the Flash modes used.

Front-curtain sync Front-curtain sync causes the flash to fire at the beginning of this period when the shutter is completely open in the instant that the first curtain of the focal plane shutter finishes its movement across the film or sensor plane. This is the default setting. See also *Rear-curtain sync*.

frontlighting The illumination coming from the direction of the camera. See also *backlighting* and *sidelighting*.

f-stop See *aperture*.

histogram A graphic representation of the range of tones in an image.

hot shoe The slot located on the top of the camera where the flash connects. The hot shoe is considered hot because it has electronic contacts that allow communication between the flash and the camera.

ISO sensitivity The ISO (International Organization for Standardization) setting on the camera indicates the light sensitivity. In digital cameras, lower ISO settings provide better quality images with less image noise; however, a lower ISO setting requires more exposure time.

JPEG (Joint Photographic Experts Group) This is an image format that compresses the image data from the camera to achieve a smaller file size. The compression algorithm discards some of the detail when closing the image. The degree of compression can be adjusted, allowing a selectable tradeoff between storage size and image quality. JPEG is the most common image format used by digital cameras and other photographic image-capture devices.

Kelvin A unit of measurement of color temperature based on a theoretical black body that glows a specific color when heated to a certain temperature. The sun is approximately 5500 K.

lag time The length of time between when the Shutter Release button is pressed and the shutter is actually released; the lag time on the D3100 is so short, it's almost imperceptible. Compact digital cameras are notorious for having long lag times, which can cause you to miss important shots.

leading line An element in a composition that leads a viewer's eye toward the subject.

lens flare An effect caused by stray light reflecting off the many glass elements of a lens. Lens shades typically prevent lens glare, but sometimes you can choose to use it creatively by purposely introducing flare into your image.

lighting ratio The proportion between the amount of light falling on the subject from the main light and the secondary light, such as 2:1 — a ratio in which one light is twice as bright as the other.

macro lens A lens with the capability to focus at a very close range, enabling extreme close-up photographs.

manual exposure Bypassing the camera's internal light meter settings in favor of setting the shutter and aperture manually. Manual exposure is beneficial in difficult lighting situations where the camera's meter doesn't provide correct results. When you switch to manual settings, you may need to review a series of photos on the digital camera's LCD to determine the correct exposure.

Matrix metering The Matrix meter (Nikon exclusive) reads the brightness and contrast throughout the entire frame and matches those readings against a database of images (more than 30,000 in most Nikon cameras) to determine the best metering pattern to be used to calculate the exposure value.

metering Measuring the amount of light by using a light meter.

NEF (Nikon Electronic File) The name of Nikon's RAW file format.

noise Pixels with randomly distributed color values in a digital image. Noise in digital photographs tends to be more pronounced with low-light conditions and long exposures, particularly when you set your camera to a higher ISO setting.

noise reduction (NR) A technology used to decrease the amount of random information in a digital image, often caused by long exposures and/or high ISO settings.

pincushion distortion A lens aberration in which the lines at the edges and sides of the image are bowed inward. It is usually found in longer focal-length (telephoto) lenses.

Programmed Auto (P) A camera setting where shutter speed and aperture are set automatically.

RAW An image file format that contains the unprocessed camera data as it was captured. Using this format allows you to change image parameters, such as white balance saturation and sharpening. Although you can process RAW files in-camera, the preferred method requires special software, such as Adobe Camera Raw (available in Photoshop), Adobe Lightroom, or Nikon's Capture NX2 or View NX. See also *NEF*.

Rear-curtain sync Rear-curtain sync causes the flash to fire at the end of the exposure an instant before the second, or rear, curtain of the focal plane shutter begins to move. With slow shutter speeds, this feature can create a blur effect from the ambient light, showing as patterns that follow a moving subject, with the subject shown sharply frozen at the end of the blur trail. This setting is usually used in conjunction with longer shutter speeds. See also *Front-curtain sync*.

red-eye An effect from flash photography that appears to make a person's eyes glow red or an animal's yellow or green caused by light bouncing from the retina of the eye. It is most noticeable in dimly lit situations (when the irises are wide open) as well as when the electronic flash is close to the lens and, therefore, prone to reflect the light directly back.

Red-Eye Reduction A Flash mode controlled by a camera setting that's used to prevent the subject's eyes from appearing red in color. The Speedlight fires multiple flashes just before the shutter is opened, with the intention of causing the subject's iris to contract, therefore reflecting less light from the retina to the camera.

self-timer A mechanism that delays the opening of the shutter for several seconds after the Shutter Release button has been pressed.

short lighting When your main light is illuminating the side of the subject that's facing away from you.

shutter A mechanism that allows light to pass to the sensor for a specified amount of time.

Shutter Priority In this camera mode, you set the desired shutter speed and the camera automatically sets the aperture for you. It's best used when you're shooting action shots to freeze the subject's motion by using fast shutter speeds.

shutter speed The length of time the shutter is open to allow light to fall onto the imaging sensor. The shutter speed is measured in seconds or, more commonly, fractions of seconds.

sidelighting Lighting that comes directly from the left or the right of the subject. See also *frontlighting* and *backlighting*.

Single Autofocus (AF-S) A focus setting that locks the focus on the subject when the Shutter Release button is half-pressed. This allows you to focus on the subject and then recompose the image without losing focus as long as the Shutter Release button is half-pressed.

Slow Sync A Flash mode that allows the camera's shutter to stay open for a longer time to allow the ambient light to be recorded. The background receives more exposure, which gives the image a more natural appearance.

Speedlight A Nikon-specific term for its accessory flashes.

spot meter A metering system in which the exposure is based on a small area of the image. On the D3100 the spot is linked to the AF point.

TTL (Through-the-Lens) A metering system where the light is measured directly through the lens.

vanishing point The point at which parallel lines converge and seem to disappear.

Vibration Reduction (VR) A function of the lens in which the lens elements are shifted by a mechanism in the lens to reduce the effects of camera shake.

white balance A setting used to compensate for the differences in color temperature from different light sources. For example, a typical tungsten light bulb is very yellow-orange, so the camera adds blue to the image to ensure that the light looks like standard white light.

Index

Guides to go.

Colorful, portable *Digital Field Guides* are packed with essential tips and techniques about your camera equipment. They go where you go; more than books—they're *gear*. Each $19.99.

978-0-470-56508-7

978-0-470-45405-3

978-0-470-52127-4

978-0-470-53490-8

978-0-470-58207-7

978-0-470-64863-6

Also available

Canon EOS Rebel XSi/450D Digital Field Guide • 978-0-470-38087-1
Nikon D40/D40x Digital Field Guide • 978-0-470-17148-6
Sony Alpha DSLR A300/A350 Digital Field Guide • 978-0-470-38627-9
Nikon D90 Digital Field Guide • 978-0-470-44992-9
Nikon D300 Digital Field Guide • 978-0-470-26092-0
Canon 50D Digital Field Guide • 978-0-470-45559-3

Available wherever books are sold.

Now you know.

Wiley and the Wiley logo are registered trademarks of John Wiley & Sons, Inc. and/or its affiliates.
All other trademarks are the property of their respective owners.